YVES SAINT LAURENT

THE SCANDAL COLLECTION
1971

ABRAMS, NEW YORK

1 Ensemble de jour. Manteau de lainage à carreaux noir et blanc. Robe de crêpe de Chine imprimé bleu et marron.

2 Robe de soir de mousseline noire.

3 Tailleur. Veste sans manches de serge noir. Robe de crêpe de Chine imprimé marron et noir.

4 Smoking de lainage noir.

5 Tailleur-pantalon de gabardine noir. Blouse de crêpe georgette rouge.

6 Tailleur-pantalon de serge rayé roux et beige. Blouse de satin vert.

7 Tailleur-pantalon de serge rayé marine et bordeaux. Blouse de mousseline imprimée bordeaux à pois blancs.

8 Robe habillée de crêpe de Chine imprimé marron et noir.

9 Robe habillée de crêpe de Chine imprimé marbre roux.

10 Ensemble habillé. Veste de gabardine beige gansée marine. Robe de crêpe de Chine imprimé marine et blanc.

11 Robe habillée de jersey de soie noir.

12 Robe habillée de crêpe de Chine imprimé jaune et noir.

13 Ensemble habillé. Manteau de velours noir brodé. Robe de jersey de soie et velours noirs.

14 Ensemble de jour. Manteau de lainage blanc. Robe de voile blanc.

15 Robe de soir de mousseline vert brodée de lierre.

16 Robe de crêpe marine.

17 Robe habillée de crêpe noir.

18 Ensemble de jour. Veste sans manches de lainage blanc gansé marine. Robe de voile marine.

19 Ensemble de jour. Imperméable beige. Robe de crêpe de Chine imprimé bleu à pois blancs.

20 Robe de soir de mousseline écossais.

21 Tailleur. Veste de gabardine jaune gansée noir. Robe de crêpe de Chine imprimé jaune et blanc.

22 Robe d'après-midi de crêpe de Chine imprimé rouge et noir.

23 Robe habillée de jersey de soie noir.

24 Robe habillée de crêpe noir brodé.

25 Tailleur. Veste de gabardine noir. Jupe de flanelle vert. Blouse de crêpe de Chine terre cuite.

26 Tailleur. Veste de gabardine marine gansée bordeaux. Jupe de flanelle naturel. Pull de jersey de soie marine.

27 Robe habillée de crêpe noir.

28 Robe habillée de jersey de soie terre cuite.

29 Robe d'après-midi de crêpe marine.

30 Tailleur. Veste de gabardine marron. Robe de crêpe de Chine imprimé marron et mauve.

31 Ensemble de soir. Veste sans manches de velours noir. Robe de mousseline rouge.

32 Robe de soir court de mousseline bleu vif.

33 Robe de soir de mousseline violet. Manches de fleurs.

34 Robe de soir de crêpe de Chine marron à pois blancs.

35 Ensemble habillé. Manteau de lainage noir gansé beige. Robe de crêpe de Chine à carreaux marron et noir.

36 Robe d'après-midi de crêpe de Chine imprimé vert et beige.

37 Robe habillée de crêpe noir brodé d'or.

38 Robe de soir de mousseline imprimée jaune et bleu.

39 Robe de soir de jersey de soie violet. Corselet brodé.

40 Robe habillée de crêpe noir brodé d'or.

41 Robe de soir de crêpe de Chine écossais jaune et rose.

42 Tailleur. Veste de serge marine gansée blanc. Robe de crêpe de Chine imprimé marine et blanc.

43 *Ensemble de jour. Manteau de flanelle terre cuite gansé beige. Robe de voile sable.*

44 *Ensemble de jour. Maillot Van Dongen de jersey marine. Blouse de serge marine gansée blanc.*

45 *Tailleur-pantalon de gabardine noir gansé beige.*

46 *Robe de soir de mousseline imprimée orange.*

47 *Tailleur-pantalon de gabardine beige. Blouse de mousseline imprimée marron à pois blancs.*

48 *Robe de soir court de mousseline vert menthe.*

49 *Tailleur. Veste sans manches de gabardine noir gansée blanc. Robe de crêpe de Chine imprimé noir et blanc.*

50 *Robe habillée de crêpe noir et mousseline jaune.*

51 *Ensemble de soir. Smoking de satin bleu et noir brodé.*

52 *Robe de soir de crêpe de Chine imprimé marbre marron et noir.*

53 *Robe d'après-midi de crêpe de Chine écossais.*

54 *Robe de soir de mousseline imprimé mauve et vert.*

55 *Robe de soir de mousseline imprimé vert et noir.*

56 *Robe de soir de mousseline imprimé vert et roux.*

57 *Tailleur. Veste sans manches de gabardine rouge gansée de noir. Robe de crêpe de Chine imprimé rouge et blanc.*

58 *Robe de soir de mousseline marine.*

59 *Robe d'après-midi de surah bleu.*

60 *Robe habillée de mousseline imprimée.*

61 *Robe habillée de jersey de soie marron.*

62 *Ensemble habillé. Manteau de daim rouge. Robe de jersey de soie noir. Ceinture de daim rouge.*

63 *Robe habillée de jersey de soie marine.*

64 *Maillot Van Dongen de jersey de soie noir.*

65 *Robe d'après-midi de crêpe noir.*

66 *Robe de soir de crêpe de Chine imprimé marbre vert.*

67 *Ensemble de jour. Veste sans manches de lainage noir et blanc. Short de gabardine noir. Blouse de crêpe de Chine imprimé noir et blanc.*

68 *Ensemble de jour. Blazer de serge marine. Short de flanelle blanc. Bain de soleil de jersey de soie marine.*

69 *Ensemble habillé. Veste d'alpaga noir. Short plissé de crêpe de soie noir. Bain de soleil de jersey de soie noir.*

70 *Robe habillée de crêpe satin noir. Corselet brodé.*

71 *Ensemble habillé. Veste sans manches de velours violet. Robe de crêpe de Chine imprimé mauve et noir.*

72 *Tailleur. Veste de jersey noir gansé vert. Robe de crêpe de Chine imprimé vert et blanc.*

73 *Robe de soir grecque de crêpe de Chine imprimé sépia et noir.*

74 *Robe de soir grecque de crêpe de Chine imprimé terre cuite et noir.*

75 *Robe de soir grecque de crêpe de Chine imprimé terre cuite et noir.*

76 *Robe de soir grecque de crêpe de Chine imprimé bleu et noir.*

77 *Robe de soir grecque de crêpe de Chine imprimé bleu vif et noir.*

78 *Robe de soir grecque de crêpe de Chine imprimé terre cuite et noir.*

79 *Robe d'après-midi de crêpe noir.*

80 *Robe de soir de mousseline imprimé rouge.*

81 *Ensemble de jour. Manteau de whipcord crème. Jupe de gabardine beige. Blouse de crêpe de Chine noir.*

82 *Robe d'après-midi de crêpe de Chine imprimé marbre marron et vert.*

83 *Robe habillée de crêpe de Chine imprimé roux et blanc.*

84 *Robe de mariée.*

FOURRURES

85 *Manteau de renard argenté.*

86 *Boléro d'ocelot et de renard.*

87 *Boléro de renard blanc.*

88 *Boléro de renard argenté.*

89 *Manteau de renard blanc.*

90 *Manteau de renard vert.*

91 *Boléro de singe.*

92 *Manteau de zibeline.*

93 *Boléro de renard argenté.*

Les bijoux d'or-galvanique sont de
CLAUDE LALANNE

Chaussures Yves Saint Laurent

Parfum et Eau de Toilette
" Y " et " Rive Gauche "
d'Yves Saint Laurent
Maquillages Charles of the Ritz
créés par Yves Saint Laurent
Chapeaux Yves Saint Laurent
Foulards Yves Saint Laurent
Bijoux Yves Saint Laurent
Sacs Yves Saint Laurent
Bas Yves Saint Laurent
Coiffures Alexandre

YvesSaintLaurent

3o bis, rue Spontini, Paris 16ᵉ

Pierre Bergé dedicates this exhibition to Paloma Picasso and warmly thanks all those who contributed to its creation and the creation of this catalog:

Olivier Saillard, exhibition curator, assisted by Alexandre Samson.

Nathalie Crinière, set designer, assisted by Hélène Lecarpentier.

Anouschka, Musée d'Art et d'Industrie de Saint-Étienne, and the Palais Galliera—Musée de la Mode de la Ville de Paris: lenders.

As well as:

Olivier Saillard, Alexandre Samson, and Dominique Veillon, authors of the catalog text; Amélie Boutry, graphic designer; Sophie Laporte, Colette Taylor-Jones, and Delphine Montagne at Éditions Flammarion; Sophie Carre, Anne Pichon, and Valérie Frossard for the photographs of the designs; Leslie Veyrat and Davide Cascio for the installation of the mannequins; Véronique Belloir, Marie-Ange Bernieri, Corinne Dom, Marie Dubois, and Flore Girard de Langlade at the Palais Galliera—Musée de la Mode de la Ville de Paris; Donzelina Barroso, Gabrielle Busschaert, Jean-Pierre Derbord, Dominique Deroche, Elsa Faúndez-Dodero, Annie Ferrari, Connie Uzzo, and Willy Van Rooy.

And colleagues at the Fondation Pierre Bergé–Yves Saint Laurent:

Philippe Mugnier, Olivier Ségot, Olivier Flaviano, and Pascal Sittler.

In Conservation: Sandrine Tinturier, Alice Coulon, Émilie Énard, Lola Fournier, Catherine Gadala, Zoé Imbert, Laurence Neveu, Mireille Prulhière, Baptiste de Quay, Célia Thibaud, Leslie Veyrat, Pauline Vidal, Catherine Zeitoun, Martial Chateauvieux, Matias Coelho, and Antoine Ferron.

In Communications: Laetitia Roux and Simon Freschard.

In Art Management: Valérie Mulattieri and Joséphine Théry.

In Exhibitions: Stephen Dupuich, Laetitia Forel, and Morgane Pouillot.

And the entire foundation team.

The Fondation Pierre Bergé–Yves Saint Laurent board of directors:

Yves Saint Laurent, Honorary President
Pierre Bergé, President
Madison Cox, Vice President
Louis Gautier, Treasurer
Jean-Francis Bretelle, Secretary

Alain Coblence, Antoine Godeau, Alain Minc, Philippe Mugnier, Mustapha Zine, Patricia Barbizet, representing the A.R.O.Y.S.L. (Association for the Promotion of the Works of Yves Saint Laurent). Françoise Laplazie, government commissioner, representing the minister of the interior.

The foundation is recognized by decree 0200278D for promoting public interest, dated December 5, 2002, and documented within the *Journal officiel* (The Official Gazette of the Republic of France) on December 12, 2002.

This catalog was published as part of the exhibition *Yves Saint Laurent 1971, la collection du scandale*, presented at the Fondation Pierre Bergé–Yves Saint Laurent in Paris from March 19 to July 19, 2015.

Program for the Yves Saint Laurent 1971 Spring–Summer haute couture collection, presented January 29, 1971, in the couture house salons at 30 *bis*, rue Spontini, 16th arrondissement, Paris

Yves Saint Laurent in front of his models, rue de Babylone, 7th arrondissement, Paris, 1971. Photographed by Bruno Barbey

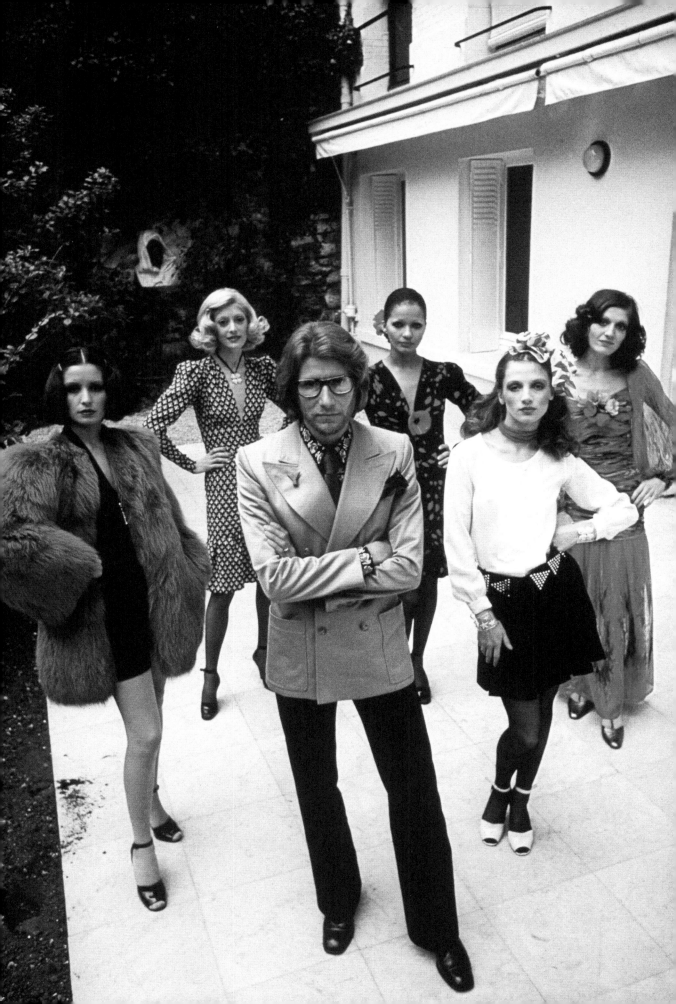

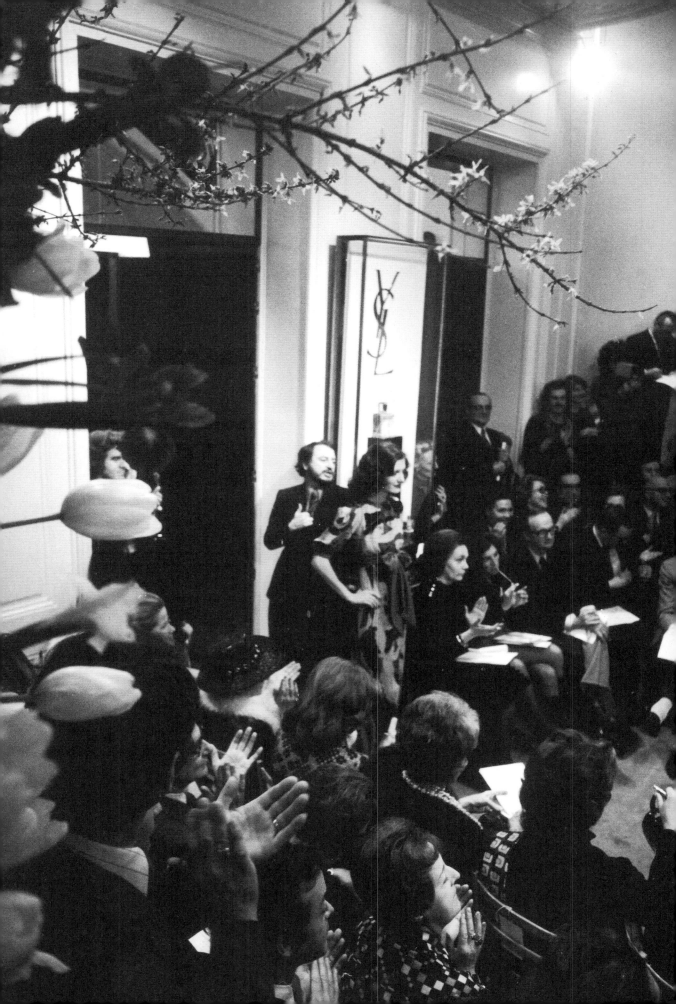

When Yves Saint Laurent showed his *collection du scandale* in 1971, did we realize that this show would fundamentally alter the course of fashion and play such a major role in its future? Definitely not! Yves himself could not have foreseen it. And yet. . . Although haute couture was not influenced by this show, and Saint Laurent himself did not refer to it again, the general public enthusiastically embraced its approach. Now, more than forty years later, we grasp its significance. When I told Olivier Saillard that I was willing to give him carte blanche, he immediately chose this collection, and I endorsed and encouraged his decision without hesitation.

Everyone knows that Yves Saint Laurent had already announced it would be very sad if haute couture existed only for the wealthy few. In 1966 he had created ready-to-wear when he opened a boutique on the Left Bank in Paris, appropriately under the name "SAINT LAURENT *rive gauche*." Note that he dropped the "Yves."

Yves had recently met Paloma Picasso in 1971. She was fond of dressing in clothing she had unearthed in flea markets, and that day she was wearing a turban and platform shoes that reminded him of the outfits women had worn during the war. This "aesthetic shock wave" gave rise to the *collection du scandale*, which embodied Saint Laurent's conviction that fashion really represents an encounter between a woman and her time. We would be correct in asserting that Paloma was the only woman who directly inspired one of Saint Laurent's collections.

This collection was to address the woman of the future even more than the woman of Saint Laurent's era. Its influence over contemporary fashion is obvious. Yves paved the way for freedom of expression, a cause he had always espoused. It was his supreme gift to women. Fashion no longer existed to dictate what was acceptable or not, as it had in the past. The tired debate over hemlines now seems laughable. All those couturiers sequestered in their ivory towers, who once mandated fashion trends, seem absurd today.

Yves Saint Laurent took a prophetic step with his 1971 collection. His vision gave fashion the freedom to step out into the real world of the city streets. And to remain there. That's reason enough for us to pay tribute to Yves Saint Laurent today.

Pierre Bergé,
President of the Fondation Pierre Bergé-Yves Saint Laurent

FASHION SHOW

80 appearances, of which...

4 were canceled

180 seats

6 models

1h10 duration

DOCUMENTS

87 original sketches

74 rejected sketches

90 atelier's specification sheet

41 canceled atelier's specification sheet

8 collection boards

147 handling records

DESIGNS

134 items (including furs)

16 fabric accessories (bobs, flower barrettes, scarves, and so on)

7 fur accessories (wraps)

6 783 hours of work in the ateliers

38 garments from the atelier of M. Jean-Pierre

34 garments from the atelier of Mme Esther

28 garments from the atelier of Mme Blanche

17 garments from the atelier of Mme Catherine

15 garments from the atelier of M. Georges

1 garment from the atelier of M. Gaby

1 garment from the atelier of M. Gil

8 hats from the atelier of Mme Germaine

SUPPLIERS

21 fabric suppliers

5 embroideries by the house of Mesrines

4 embroideries by the house of Lesage

1 embroidery by the house of Lemarié

SUPPLIES

791 buttons

86 zippers

42 fabric references from the house of Abraham

1 fabric reference from the house of Brossin de Méré

5 fabric references from the house of Besson

7 fabric references from the house of Bianchini Férier

1 fabric reference from the house of Bucol

1 fabric reference from the house of Carlotto

1 fabric reference from the house of Charles Étienne

12 fabric references from the house of Dormeuil

3 fabric references from the house of Fournier

12 fabric references from the house of Gandini

1 fabric reference from the house of Garigue

3 fabric references from the house of Moreau

1 fabric reference from the house of Perceval-Sekers

2 fabric references from the house of Pétillault

4 fabric references from the house of Prudhomme

13 fabric references from the house of Racine

1 fabric reference from the house of Rodolphe Simon

2 fabric references from the house of Sache

5 fabric references from the house of Scolaine

1 fabric reference from the house of Staron

SALES

91 clients

304 sold items

906 dollars for a day dress

906 dollars for a coat

1,087 dollars for a pantsuit

1,087 dollars for a tuxedo with Bermuda shorts

1,359 dollars for a gown

1,450 dollars for an embroidered coat

3,625 dollars for a fox coat

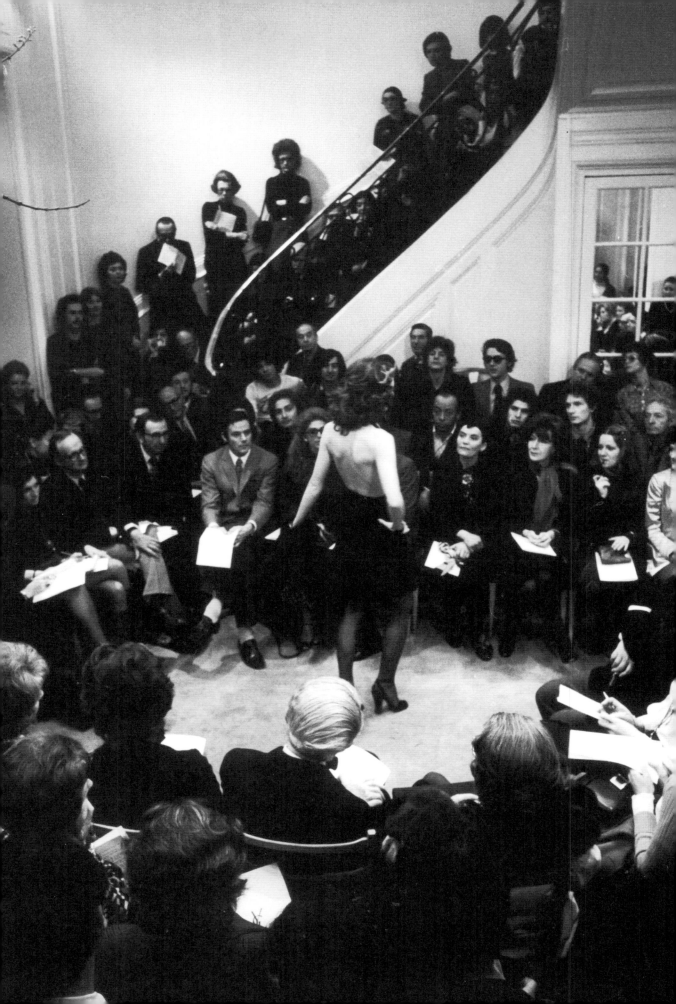

Olivier Saillard

YVES SAINT LAURENT
SPRING-SUMMER 1971 HAUTE COUTURE

THE COLLECTION THAT CREATED A SCANDAL

"Saint Laurent has been martyred, booed, and mocked, but he's taken revenge on his detractors with the general public's enthusiastic response to his backward glance at the war years. . . . It's not the first time that Yves Saint Laurent, shunned by fashion professionals, has turned the situation around with the backing of the street."[1]

The press archives are sequestered in their own room in the headquarters of this legendary couture house that has held sway over the realm of fashion for decades. Closely guarded, these identical folders arranged in black cases have patiently bided their time, witnesses to a life dedicated to design. Chronologically arranged in orderly ranks, they are a refuge for the memorabilia of the great couturier. Beginning with his inaugural 1962 collection, deft, devoted hands meticulously filed away the accounts written by journalists and chroniclers after each of Yves Saint Laurent's shows. Encompassing the history of twentieth-century fashion, these documents, bound between moleskin covers, attest to a stubborn determination to document a lifetime's work. With the tireless concentration of historians, heedless of both flattery and ridicule, archivists have labored to preserve such records of the past. These press cuttings from faded newsprint might seem to be orphans of their time. But the scraps of paper unfold to reveal a passionate, heated debate that remains just as compelling today. These columns of text and strings of words gathered by the Agence Française d'Extraits de Presse are like archaeological records from the events of a single day. Here we find fierce disputes on skirt lengths, fabrics—chiffon or crêpe—and incendiary colors. These

1. Jean-Michel Castel, "L'Air de Paris," *Le Méridional–La France*, April 25, 1971.

The fashion show in the salons on rue Spontini, January 29, 1971

issues were raised in a fashion world that was on the brink of chaos. Some of these writers are forgotten now, while others remain famous, but they all bring back memories of a time when fashion was considered far too important to be consigned to the back pages. Ten years after the founding of Saint Laurent's couture house—or several feet down the first wall of archives—we discover 3 files out of a horde of 1,530 dedicated to a single topic. The researcher, undaunted by that imposing wall of files, must climb up a few rungs on the librarian's ladder to grasp the scope of these records. The ring binders are filled with plastic sleeves containing harshly critical articles with scornful headlines, printed on flimsy newsprint unscathed by time: "Yves Saint Laurent Insults Fashion," "Sad Reminder of Nazi Days," "Saint Laurent's Uglies," "Saint Laurent: Une triste occupation [a regrettable occupation]," "Designer Yves Saint-Laurent Draws Fire in Fashion World," "Press Scandalized by Saint Laurent Show," "Collection Attacked." All this abuse was directed at the 1971 Spring–Summer haute couture collection.

On January 29, 1971, six models[2] nonchalantly stalked the runway, showcasing eighty styles. The garments on view triggered acute agitation in the audience on rue Spontini. Yves Saint Laurent and Pierre Bergé had established their couture house in 1962 and used the salons for all their shows. About 180 seats had been reserved for clients, buyers, and international journalists. Initially their reactions varied. Some made no effort to conceal their revulsion, expressing disgust when faced with the spectacle of a collection they considered hideous. The source of this dismay was the designer's claim that he had drawn inspiration from the elegance of the war years and the Occupation. The press, which had viewed Saint Laurent as the sole legitimate heir to the grand tradition of French haute couture, could not forgive the padded shoulders, knee-length skirts, and platform heels; they all evoked the long years of privation and scarcity endured by so many French citizens. Articles unanimously condemned the incomprehension of a couturier "who is nostalgic for that era . . . and has the excuse of not having lived in it."[3]

The so-called "Libération" collection represented a fundamental shift in the couturier's direction. Widely rejected at the time, and generally ignored by the broader public who preferred the designer's "Opéra–Ballets russes"[4] collections, these styles came to be passionately admired by future generations of designers. Fashion burst onto the contemporary stage, making a tremendous impact. The collection ultimately led to the obliteration of the walls that divided haute couture from ready-to-wear, and it consigned traditional standards of elegance to the dusty shelves of obsolescence. The 1971 collection also represented an abrupt shift in Yves Saint Laurent's own career. It was the manifesto of a couturier who wished to be seen as an arbiter of ambiguities and also a foretaste of the master's mature oeuvre. Drawing inspiration from the recent past, the collection took a new and radically different approach to incorporating historical references into the creative process. The 1971 collection was a template for the retro styles that were to dominate the second half of the twentieth century. The show served as a mirror that shifted its view from a world that was fast receding to reflect a fresh vision of the

2. Dominique Pommier, Elsa Faúndez-Dodero, Barbara, Jacqueline Ragonaux, Annie, and Marie-Thérèse.
3. M.-A. Dabadie, "Saint Laurent: Une triste occupation," Le Figaro, January 30–31, 1971.
4. 1976 Fall–Winter haute couture collection.

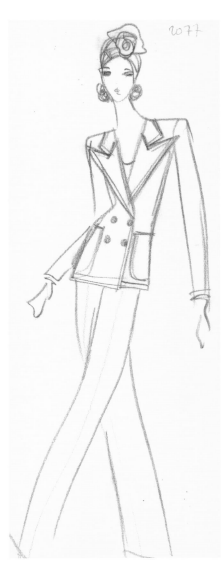

Original sketch of outfit 47

generation to come.

"'Who's that girl who shops in flea markets for clothes to wear when she visits Yves Saint Laurent?' International journalists were intrigued when confronted with the young woman sporting a red velvet turban trimmed with beige feathers and a three-quarter-length black fox coat over a black pleated dress. Her shoes reminded them of streetwalkers on the rue Saint-Denis in the 1940s. The answer to the question: Paloma Picasso, daughter of the legendary painter and one of Saint Laurent's most recent models."[5]

"Number 1. Daytime Ensemble. Black-and-white checked woolen coat. Dress in blue and brown printed crêpe de Chine. Number 2. Evening gown of black silk chiffon. Number 3. Suit. Sleeveless black serge jacket. Dress in black and brown printed crêpe de Chine. Number 4. Tuxedo in black wool. And so on."

The press kit, which replaced the announcer of the previous twenty years, served as the show's program. It offered a kind of silent commentary for clients and reporters. Simply printed with the season and the year, the press kit for the 1971 collection was a prologue to the fashions of the decade to come. The cover, featuring the distinctive logo designed by the graphic designer Cassandre, opened onto a two-page spread. Eighty-four styles were listed using fashion's distinctive terminology.[6] Suits, afternoon and evening dresses, daytime and formal ensembles were nameless, untitled performers in a show that played out in silence, without any background music. The ephemeral, factual poetry of these descriptions included the style numbers, fabrics, colors, and prints. Black jerseys, tartans, and polka dots were all reduced on paper to a mere hint of what was to come—and the scandal these creations would provoke.

Eight collection boards demonstrate how Saint Laurent organized his clothing into categories with a sure hand. A bevy of models are sketched in pencil on sheets of grid paper. Their attenuated silhouettes—faces shown frontally or in profile—are surmounted by pinned swatches of fabric. The figures seem to have sprung from Saint Laurent's imagination in a tangle of long legs and well-kept secrets; they invade the pages like warriors poised for battle. The sections are broken down into Suits, Coats, Pantsuits, Formal Wear (two collection boards), Short Evening Wear, and Evening (two collection boards).

This fashionably posed throng of figures, hair in an updo or flowing loose, would follow a different order on the day the actual show was presented. The collection was worn on the very real bodies of six models hired for the event. Observers on January 29, 1971, the date of the show on rue Spontini, noted that the models presenting the collection had strikingly pale faces. Their makeup was reminiscent of an actor in a Japanese Noh play, applied in strident colors. Their faces, set off by brimmed hats worn low over the forehead, presented a paradoxical juxtaposition of the new and the nostalgic. Striking forms set the tone as the models wended their way through the couturier's salons, circulating between the audience and the staircase. The sleeveless jackets featured "pagoda"

5. Dabadie, "Saint Laurent: Une triste occupation."
6. Four outfits were eliminated during the show.

or "wing" shoulders. Blazers sported similar flourishes. All jackets featured collars of exaggerated size. Braided trim emphasized the lines, a bold stroke that came across as almost aggressive. The printed crêpe de Chine dresses that sporadically emerged on the runway seemed to be incongruous additions. A sense of aristocratic disdain emanated from these styles as Saint Laurent made irreverent connections among the designs. This cavalier approach to elegance triggered audible expressions of displeasure. The collection heralded the revival of the 1940s look, and many judged it to be in bad taste.

Short day and evening dresses (it was hard to tell the difference) swathed the waist in suggestive drapery. One of these, made from a camouflage motif fabric especially commissioned from the Lyonnais textile firm Maison Abraham, did not conceal its intentions. Made of chiffon with long, narrow sleeves, the dress featured a draped panel that hung down suggestively between the legs. A conspicuously oversized flower marked the hips. Other offerings were equally provocative. A dress in black tonalities was set off with a flamboyant jeweled ornament that Claude Lalanne had set with a disturbing degree of naturalism.

Embroidered detail featuring loosened ribbons, painted lips, alarming flames, and celluloid flowers proclaimed the designer's fateful rendezvous with bad taste. All this unpleasantness was encompassed in a new term: "kitsch." The models vamped across the salon carpets and stalked the runway on arrogantly high platform shoes. Even the colors of their tights displayed a relentless quest for gaudy effects: bright blues, canary yellows, and shameless pinks covered the models' legs with colors so intense they seemed to have been squeezed straight out of paint tubes. Yves Saint Laurent added the finishing touches to an outrageous collection that some interpreted as an attempt at a historical reconstruction. There were fur pieces around the neck, shaggy fur boleros, jackets, and short coats, the most extraordinary of which was made of green fox worn over a black jersey jumpsuit.

A few long pleated gowns slipped stealthily into the show. They were equally censured: "For evening wear, printed men in priapic poses encircle the dresses as they might a Greek vase. Presumably an evocation of Nazi virility?"[7]

Were these soldiers of the Trojan War and helmeted gladiators gripping their shields, all printed in ocher on a background of black crêpe, mounting a defense against critical assaults? Were these athletes and Dionysians emerging from their bacchanals, together with fantastical creatures, actors in a delirious spectacle that would appeal to a contemporary audience? The dresses were distinctive and seemingly ill suited to the show's general theme. Each gown was high-waisted and distinctively cut, only adding to the mystifying nature of the collection. These dresses transformed the professional models into vestal virgins and turned the show into a virtual battleground. Even the bridal gown featured an Etruscan motif that seemed intended to ward off evil. It would not have been surprising to see a bow and arrow brandished on high in retaliation for all the invectives directed their way.

Observers were astonished when Yves Saint Laurent, who had mandated pants for every woman, included only five examples

7. Pierre-Yves Guillen, "Yves Saint-Laurent: L'Apprenti sorcier," *Combat*, February 1, 1971.
8. Interview by Aline Mosby, "Yves Saint Laurent Blasts Critics," *Reading Eagle*, February 18, 1971. ("For years, the eye was used to a boyish girl without breasts, waist or hips. I never thought the appearance of a true woman would provoke such a scandal.")

Original sketch of outfit 51

in this collection. Worn with highly revealing chiffon blouses, or partnered with provocatively masculine jackets, the pants were a discreet presence in a collection dedicated to redefining sexual stereotypes.

Weary of explaining himself for a show he viewed as a tribute to youth, Yves Saint Laurent claimed he was surprised by the reactions. He added that he had never imagined that the appearance of a real woman would incite such outrage.[8]

There was indeed controversy swirling around these new female bodies. And around new attitudes as well. The consternation reflected in the press arose from Saint Laurent's provocative, rebellious approach to fashion. His looks were inspired by the 1940s, and women of that era used their wardrobes as a means to confront the occupying power. They might cut a skirt out of an old curtain, wear the jacket of an absent spouse, or defiantly conceal their hair beneath a turban. The couturier was harshly judged for looking back to that period; it was a time when the necessity of "just getting by" radically changed the definition of elegance, which now had to take scarcity into account. The most malicious articles went so far as to call the designer "Yves Saint Debacle." The hastily written accusations—"carnage of good taste," "charnel house of elegance," "crematory of prestige"—may have expressed the viewpoint of a disappointed journalist.[9] However, these phrases also demonstrate the genuine mystification of an audience that was too close to events to be able to discern the collection's true objective.

Presaging the changing body images of the 1970s, the show also rejected the aesthetic ideal of the previous decade. Throughout the 1960s, fashion was heavily influenced by the Courrèges revolution, which had eliminated traditional feminine body types. Hips and breasts disappeared beneath tunics and short, boxy coats.

Originally a fresh page in the history of fashion, André Courrèges's futuristic style was appropriate only for the very youngest women. By the late 1960s it had lapsed into a kind of stylistic suffocation. Yves Saint Laurent himself had once endorsed the androgynous body. He borrowed a number of garments from the male wardrobe that became cult components of female attire. But in 1965 the creator of the "Mondrian" dress declared himself weary of "making dresses for blasé billionairesses."[10]

In his 1970 Fall–Winter collection, Yves Saint Laurent had once again demonstrated his longing to liberate himself from the constraints of pop culture. He had recently met Paloma Picasso at the home of the landscape architect Mark Rudkin. Pierre Bergé recounts that this meeting had such a profound aesthetic impact on Saint Laurent that he fundamentally altered his aspirations for fashion. Bergé also claimed that Paloma Picasso was the only woman who ever played the role of muse for Yves Saint Laurent, particularly at this turning point in his career.

An article in *Elle* describing this contemporary young woman

9. Guillen, "Yves Saint-Laurent: L'Apprenti sorcier."
10. *Le Journal du dimanche*, August 15, 1965, quoted in Farid Chenoune, (ed.), *Yves Saint Laurent*, exh. cat., Petit Palais, Paris, March 9–August 29, 2010 (Paris: La Martinière, 2010), p. 201.
11. "Deux filles à la mode choisissent leur mode," *Elle*, March 1, 1971, p. 124 (unsigned article).

Original sketch of outfit 63,
pinned fabric sample

lingered over Paloma Picasso's influence on the couturier: "He [Yves Saint Laurent] designs dresses with her in mind. And over the last few months, many young women have begun to copy her look. Like her, they're going to the flea market to buy the dresses and 'platform' shoes that their mothers threw out twenty-five years ago. Like her, they paint their lips bright red and look like they're thirty-five years old when they're actually just twenty. Like her, they're discovering the delights of kitsch, having sampled the joys of pop. And what is kitsch? Anything that's in bad taste, provided that it's perceived as 'taken to the next level.'"[11]

When Paloma Picasso was questioned about the *collection du scandale*, and the distinctive look that made her its source and inspiration, she reflected:

"I was genuinely amazed that my style could make such a powerful impression on Yves Saint Laurent, especially because I wasn't really thinking in terms of fashion. It was more a matter of giving rein to a sense of whimsical self-expression like any girl at some point in her life. I certainly wasn't in a position to dress in haute couture, and would never have dreamed it possible. I remember thinking it was incredible that the show could cause such a scandal. The idea of making references to the war years and showing the potential beauty in those clothes was a real shock that disoriented clients and journalists. As far as I was concerned, putting together what we call a 'look' or a 'style' today was just a spontaneous, almost crazy urge. I never imagined there'd be any consequences. Flea markets had appealed to me for years. Sometimes I'd dress in surplus American clothes, and sometimes in finds from secondhand stores. I felt myself developing a real passion for these things. We preferred clothes that had been lived in, used, and individualized over anything that could be bought new. From the age of thirteen, fourteen years old, I would spend hours at the Cinémathèque and other art-house theaters that regularly scheduled 1940s black-and-white movies as well as 1950s musicals. I went to these screenings all the time, like a lot of other people. Of course I appreciated the film education I received, but I was also crazy about the glamorous women they depicted; they appealed to me a lot more than the androgynous stick figures of the 1970s. The exaggerated shoulders, striking cuts, and nipped-in waists—I had an easier time picturing myself in a wardrobe based on 1940s styles than on those of my own era. A lot of girls used foundation to conceal the fullness of their lips, but I did the opposite. I loved the vivid colors of the lipsticks that I could find only in flea markets because they weren't being made anymore.

"Before I was able to find shades released only in the United States, such as Revlon's 'Love That Red' and 'Certainly Red', my favorites, I remember I'd buy old ones. Some of them were rancid, they were so old! Anyway, I wanted that intense red that ran completely counter to current trends. I must have been wearing that lipstick the first few times I met Yves Saint Laurent. I was also wearing a dress I'd found in Portobello Road and a pink wool turban trimmed with gray feathers that one of my mother's friends had given me. I knew Yves Saint Laurent's work, and I'd have loved to wear his safari looks or one of those tuxedos modeled by fashion icon Betty Catroux that I'd seen in fashion magazines.

But I'd never gone to one of his shows. I was invited to the 1970 Spring–Summer collection. My presence was commented upon in a very odd way. Eugenia Sheppard, the famous *International Herald Tribune* journalist, described the collection of the moment and then concluded her article with the words: 'And Paloma Picasso was wearing the wrong thing.' I was actually wearing a long, bright yellow satin coat, red and yellow platform shoes, and a four-leaf clover made of red plastic, as red as my lips. I was the equivalent of a bomb explosion in that staid bourgeois gathering where everyone knew how to behave. I was neither surprised nor hurt by these comments, because the collection that followed was a sort of prelude to what was to come in 1971. Some of its styles featured satins in loud colors that seemed to vindicate me. When I saw the 1971 Spring–Summer collection, which incited the scandal we all know about, I almost felt like I was opening my own closets—and those of other girls my age who shared a taste for the styles of a period we'd experienced through watching films. Yves Saint Laurent turned our irrational impulses into the fashion of the moment and an even more audacious symbiosis that he proclaimed to be a manifesto of youth. Several times—and not because we always consulted each other (Yves Saint Laurent and I are both very shy)—I was amazed to watch these shows and share the feeling that I was already wearing clothes that caught the spirit of the collection. We'd both discovered our favorite era, but we were unaware that we were in fact creating an archetype to illustrate it."[12]

Five trendsetting styles in the 1970 Fall–Winter collection—including the bridal gown—testified to the encounter between the couturier and his newfound muse. The appearance of turbans, broad-shouldered silhouettes, and platform shoes disconcerted observers but was initially judged as inconsequential, something like a "schoolboy prank."[13] The curious bride's coat, appliquéd with words cut from velvet,[14] turned out to be a prelude and a foreshadowing of the next collection: It featured styles that were generally considered to be the most hideous in history.

"What do I want to do? Shock people, make them stop and think. What I'm doing is closely related to what's going on in contemporary American art. . . . Young people have no memories."[15] Yves Saint Laurent's comments were published in *Vogue*'s article on his notorious collection, featuring photographs by Helmut Newton. Only the most talented designer could have delivered such a stinging refusal: the refusal to accept the honorary title of "crown prince of haute couture" that had been conferred on him by the establishment.[16]

When asked the question, "Why did you decide to shock with the 'retro' look instead of something new?" Yves Saint Laurent replied: "What can we really call 'new' in fashion? Whether it's a peplum or tights, it's all been done a hundred times before. The hippie look was borrowed from the East, and shorts came from the sports arena. Yet these are considered fresh ideas in fashion. And nothing

12. Interview with the author, January 27, 2015.
13. *Evening Standard*, July 24, 1970.
14. The front of the coat is appliquéd with "Love me forever" and the back with "or never."
15. Quoted in *Vogue Paris*, March 1971.
16. In an interview, Yves Saint Laurent added, "But I also am very stimulated by this scandal." See Mosby, "Yves Saint Laurent Blasts Critics."

comes out of haute couture. Haute couture has nothing to offer but nostalgia and taboos. Like an old lady. I just laugh when pleated or draped dresses suggest 1940s styles to a traditional audience. What matters is that young women, who have no preconceived idea about these styles, want to wear them. Others will just have to copy them later. If haute couture is no longer good for anything but providing fabric to buyers on the lookout for a new sleeve setting or a new dart along the bustline, then it's not long for this world."[17]

This brief conversation highlighted three very contemporary topics deserving further consideration. The first noted that the inspiration of the past stimulates creativity, but it also creates dissonance in a discipline that is oriented toward the future. The second addressed the frontiers that were redefining haute couture. The third established Yves Saint Laurent's standing in the fashion world, which was experiencing remarkable generational and economic shifts as the popularity of ready-to-wear surged.

It is actually strange that Saint Laurent was reproached for a practice that had been ubiquitous in haute couture from its origins in the late nineteenth century and throughout subsequent eras. Historicism, the nostalgic return to the past, was a well-established phenomenon that had begun with the designer Charles Frederick Worth. The creator of the art of haute couture surprised everyone by dictating a return to the crinolines of the early 1850s in a world that had become accustomed to late nineteenth-century tastes. Paul Poiret eliminated corsets for women, but he later shocked his public with hobble skirts that seemed to be in conflict with the modernity he had formerly embraced. Elsa Schiaparelli and Cristóbal Balenciaga created a sensation in 1939 with collections that included bustles: awkward padded accoutrements that evoked the nineteenth century. Christian Dior made no secret of his passion for the silhouettes of the Belle Époque: They inspired his curvaceous New Look. His evening gowns of the 1950s were unabashed homages to the panniered gowns and splendors of the eighteenth century.

Couturiers and designers have always mined the past for inspiration when creating their contemporary styles and collections. History demonstrates the impossibility of resisting this temptation; everyone gives in to it on occasion. And such research often provides a deeper understanding.

In contrast to his predecessors, who tended to quote from periods that were long past and remote, Yves Saint Laurent was criticized for trying to bring a too-recent era to the forefront of contemporary taste. What's more, it was an era that had traumatized those who had lived through it. He had dared to move the nostalgia clock too far ahead, up to the immediate past. This created a divide between an earlier generation of women, those who had renounced the fashions they had once worn, and their daughters. These younger women enthusiastically embraced these novel looks because they had not been compelled to experience the hardship that engendered them. This approach to fashion, which "sees its future in the past," ultimately prevailed and achieved widespread public acceptance.

17. Interview with Yves Saint Laurent by Claude Berthod, *Elle*, March 1, 1971, p. 62.

Viewed strictly from a stylistic point of view, the fashions of the 1940s had been reviled for far too long. The scorn heaped upon those looks was unjustified, motivated solely by bitter memories of an era that no one wished to revisit. In themselves, 1940s styles offered an undeniably modern and simplified look. More comfortable and easier to wear, garments were practical and well suited to the lifestyle of a woman whose routine professional activities had been disrupted by the adversities of a country at war. With a subdued, almost austere sense of elegance, these fashions were more timeless than they initially seemed. They prepared the way for ready-to-wear, which was simpler and better adapted to the contemporary lifestyle. Accessories, turbans, aggressively flirtatious hats, and extravagant shoes were a defiant reaction to the occupier's presence, a rebellious, confrontational fantasy that refused to yield to oppression.

"Never before had women in films and photographs seemed quite so alluring. Perhaps because of their liberated, decisive air. . . . Perhaps because they were looking forward to a future of marvelous tomorrows, and that anticipation lit up their eyes and made them click about lightheartedly on their high heels . . . They didn't give a damn what anyone thought."[18] These observations on the objectives of fashion during the 1940s suggested an entirely new way of life, a climate of independence and validation for women. Events had conspired to push them into the workforce and take responsibility for the challenges of daily life. This autonomy and empowerment were withdrawn with the war's end. In the fashion world the 1950s marked a retreat to the past. The female image was trapped in a gilded cage to which only fiancés, husbands, and lovers possessed the key. The corset was revived.

The demands made by the feminist movements of the 1970s increasingly recalled the responsibilities taken on by women during the 1940s. Admittedly, the landscape had shifted—the country was no longer at war. However, women now needed to cope in a world where they had to work, raise children, and handle everyday obligations when the man of the house was frequently absent.

It is interesting to observe how the wardrobes of these eras, which were separated by two decisive decades, had countless elements in common. "Practical" and "economical" were common bywords. "Skimpy," "short," "colorful," and "platforms"—terms formerly considered undesirable—now expressed liberating, antiestablishment values as ready-to-wear became accessible. *Elle* was on the mark when it ran a headline in 1971 proclaiming "Feminine Liberation by Yves Saint Laurent."[19]

Beginning with the early years, when he presided over the direction taken by the House of Dior, Yves Saint Laurent was seen as the sole heir of the traditions that were so integral to haute couture. Coco Chanel herself named him her rightful successor. He established his own firm in 1961, and his widely acclaimed models—"Mondrian" in 1965, "Smoking" in 1966, "Pop Art" in 1966, "Africaine" in 1967, and "Bambara" in 1968—established him unequivocally as the crown prince of fashion. Little by little the landscape of Parisian couture was undergoing significant change. Coco Chanel died in 1971, and Balenciaga, who had closed

18. Ibid.
19. Ibid.

his house in 1968, died in 1972. Elsa Schiaparelli had long since ceased her activities before her death in 1973.

These circumstances conspired to carve out a rather lonely territory for Yves Saint Laurent. Expectations were high and could even be oppressive. Saint Laurent was expected to embody an haute couture industry that was showing increasing signs of fatigue. New faces began to appear on the scene. Sonia Rykiel, Christiane Bailly, and Emmanuelle Khanh were pioneers of more democratically priced ready-to-wear, developing a look that was youthful, cheeky, and lighthearted. The Japanese designer Kenzo joined them in this endeavor, which was soon to mark a turning point in the world of fashion. Yves Saint Laurent opened his first *rive gauche* boutique in 1966, embracing the possibilities offered by ready-to-wear.

Ready-to-wear was an avenue for direct and contemporary communication with customers, something that haute couture had never offered. Its appeal was tremendous. For Saint Laurent, women were no longer just clients. They thought of themselves as friends or followers. And the designer abandoned the dated archetypes that traditionally distinguished his profession—the white smock, the baton, the pins—and posed nude like a rock star for the photographer Jeanloup Sieff.

The 1971 collection was significant in the designer's own process of liberation. Its audacity and shock value set him on a pedestal. Now the couturier-auteur could do anything he pleased. Haute couture, traditional in some houses, experimental in others, had reached a stylistic impasse for everyone. It became a forum for self-expression, the motivation behind Saint Laurent's declaration: "I'd rather be shocking than boring." The degree of expertise, the number of hours devoted to a garment in the atelier, and the technique involved no longer really mattered. Haute couture is to ready-to-wear what a poem is to a novel. A subtle art of carefully worked ideas, haute couture was entering into its own form of modernism, probably its final stage of life. Twice a year, couturiers continue to amaze with their collections, some lyrical and some reverently referential; all that matters is the subtle poetic vision offered to challenge the banality of contemporary life.

Beginning in 1971, Yves Saint Laurent occupied his own house of dreams, challenges, fantasies, and rebellion. He was the only one to choose this path. The distinctive features of his style were becoming increasingly abstract. He was preoccupied with contrasting colors, conflicting genres, and various ambiguities, rather than with themes and allusions. Saint Laurent became part of his own story. The vivid red, orange, and blue hues of his designs were like colored inks that lovingly sketched those who never vanished from his sight: real women.

20. Wallis Franken was a famous model whose career spanned the 1970s. Her physique and body language were the prototypes for the feminine look that was prized during that decade, and she inspired many designers and photographers. She was married to Claude Montana.

The 1971 collection was largely a commercial failure. The order book listed ninety-one customers. His most prominent clients—Catherine Deneuve, the Baronesse Guy de Rothschild, Zizi Jeanmaire, Elsa Schiaparelli, Hélène Rochas, Lauren Bacall, Madame Pierre Schlumberger, Her Imperial Majesty Farah Pahlavi,

Original sketch of outfit 66,
pinned fabric samples

Margot Fonteyn, and the viscountess de Ribes—remained faithful. The "bourgeois" clientele, of whom Saint Laurent had grown tired, retreated from the scene. Only 304 garments were sold, in contrast to the 729 from the preceding collection. It didn't take long for the daughters of those fugitive clients to come knocking on the doors of the rive gauche boutiques. They were heedless of the attacks by enraged journalists, and they were irresistibly attracted by a series of photographs by Helmut Newton and Hans Feurer: The provocative images they produced for the collection had become iconic. Anjelica Huston, who was modeling at the time, looked stunning wearing the styles in *Vogue Italia*. *Dim Dam Dom*, a popular TV news show produced by Daisy de Galard, often covered fashion topics and commissioned a short film exploring the furor aroused by Saint Laurent's collection.

Its director, Jean-François Jonvelle, decided to depict the entire realm of fashion in the form of a circus. The film mirrored that world, featuring a ringmaster surrounded by the contorted figures of models. It had aspects that were both frightening and horribly prophetic. The grimacing audience snickers, shouts, and boos from every direction surrounding the runway, where events unfold as if in an arena. The women's bodies, one of which was recognizable as the famous model Wallis,[20] have lost all resemblance to the figures of the 1960s, heralding instead the silhouette that would become fashionable at the very end of the twentieth century. The audience screams and embraces breathlessly, without troubling to notice the gracefulness of the styles being presented. The clowns are sad. The green fox coat, the brown suits with their fur neckpieces, the draped dress scattered with green and yellow flowers, liberated from all the polemics, regard one another as if they were "remnants of fashion."[21] To the attentive eye, these garments reveal a stylistic signature that would serve as inspiration for numerous couturiers who had originally been shocked by the 1971 collection. In future decades, allusions to the past, even the recent past, would become routine, acknowledged without surprise or defensiveness. The frenzied pace of consumer culture reflects the relentless pressures imposed by the headlong competition in fashion, where styles become outdated within moments of their creation. The retro look's political aspect, which Yves Saint Laurent embraced, corresponds to today's "vintage" look, the influence of which has spread through couture houses and fashion brands as well as the market at large. Saint Laurent's 1971 collection seems as contemporary as ever in the 2014–15 season. Observers have noted a resurgence of 1970s styles on the runways, which of course include implicit references to the 1940s. Few of these collections have anything to do with Saint Laurent, however. Women seek out styles that are genuinely irreverent and nonconformist. These two adjectives do not apply to the fashion machinations of today. They belong to the beleaguered role of auteur that Yves Saint Laurent so tirelessly defended.

21. Chenoune, *Yves Saint Laurent*, p. 204.

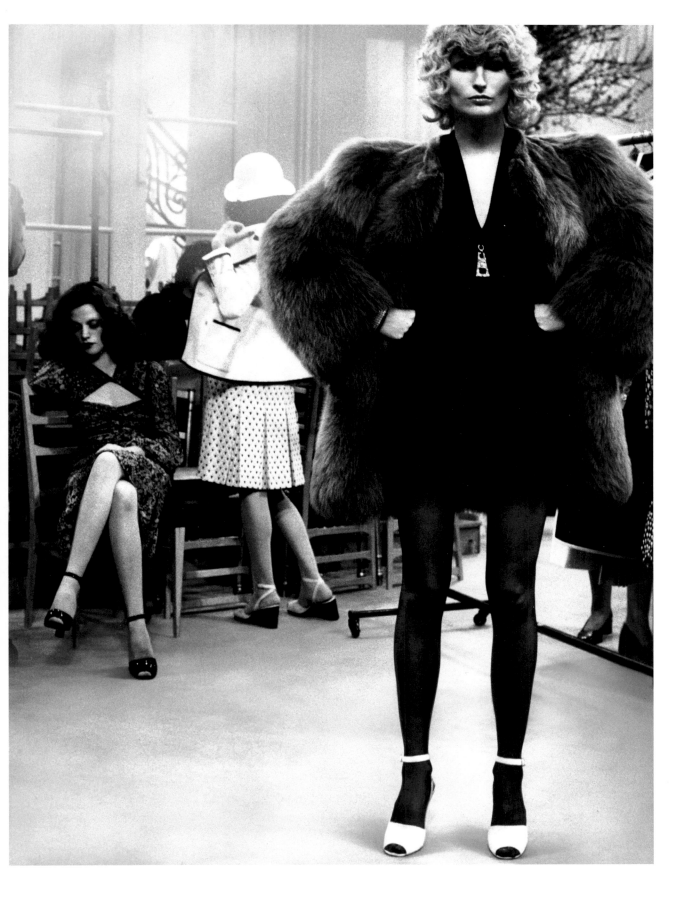

Photograph of Viviane Fauny
(foreground), with Annie
Ferrari and Elsa Faúndez-
Dodero (background), by
Helmut Newton, published in
Vogue Paris, March 1971

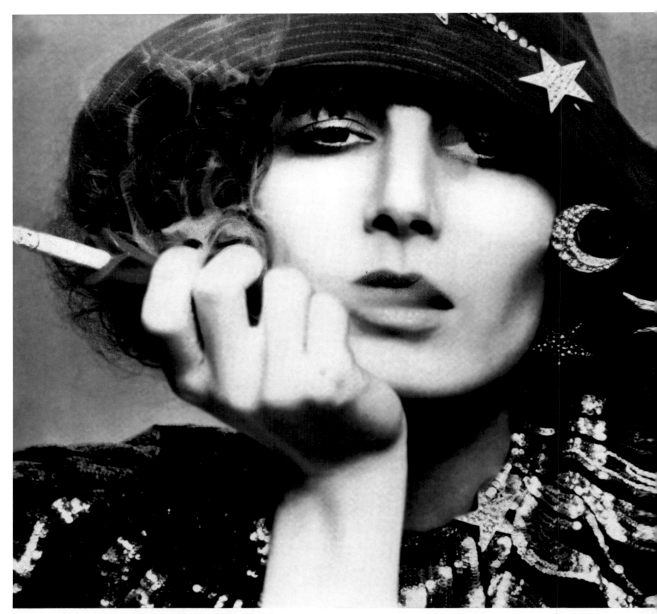

LA DONNA-DRAPPEGGIO, STILE ANNI '40

Dopo gli hot pants, quello che scotta di più nella moda-con-un-significato è il ‹drappeggio haute couture›, riscoperto da Yves Saint Laurent per la sua collezione di alta moda primavera-estate. Insieme alle spalle imbottite, all'orlo al ginocchio, agli scolli a trapezio, il drappeggio haute couture non segna soltanto nella moda un'inclinazione al gusto degli anni '40 – quando chi drappeggiava di più erano Alix, Schiaparelli, Lelong, Vionnet – ma è il barometro di una nuova donna-previsione. Il ‹drappeggio› così come lo vede Vogue in queste sei pagine segna infatti un nuovo preciso atteggiamento, la coscienza del proprio corpo come strumento di eleganza super-femminile e indica nella moda-tendenza un ritorno della vera ‹alta moda› intesa come nuova corrente.

88

"La Donna-drappeggio, stile anni '40," *Vogue Italia*, June 1971, Anjelica Huston, photographed by Bob Richardson

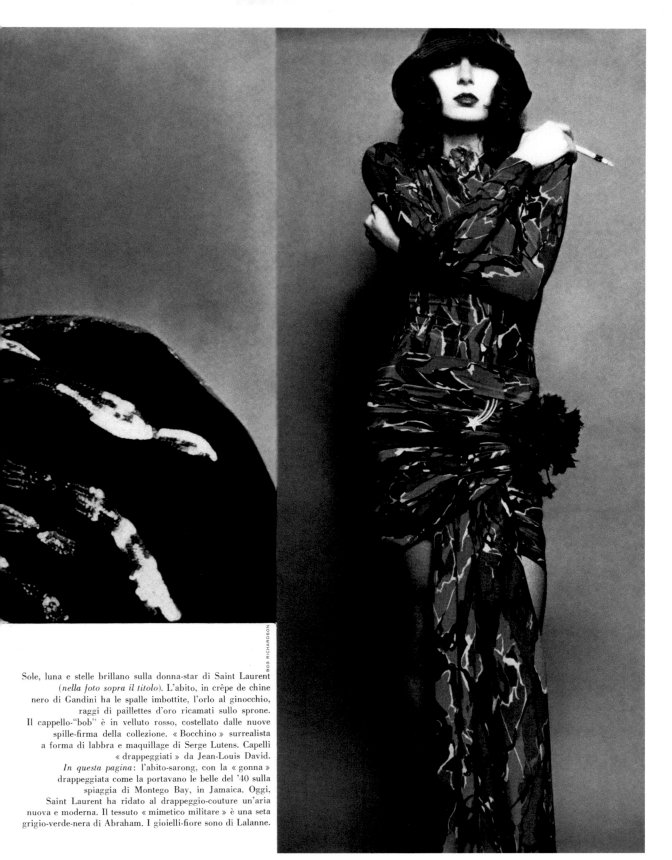

BOB RICHARDSON

Sole, luna e stelle brillano sulla donna-star di Saint Laurent (*nella foto sopra il titolo*). L'abito, in crêpe de chine nero di Gandini ha le spalle imbottite, l'orlo al ginocchio, raggi di paillettes d'oro ricamati sullo sprone. Il cappello-"bob" è in velluto rosso, costellato dalle nuove spille-firma della collezione. « Bocchino » surrealista a forma di labbra e maquillage di Serge Lutens. Capelli « drappeggiati » da Jean-Louis David.
In questa pagina: l'abito-sarong, con la « gonna » drappeggiata come la portavano le belle del '40 sulla spiaggia di Montego Bay, in Jamaica. Oggi, Saint Laurent ha ridato al drappeggio-couture un'aria nuova e moderna. Il tessuto « mimetico militare » è una seta grigio-verde-nera di Abraham. I gioielli-fiore sono di Lalanne.

**Fiori di plastica,
nodi di paillettes,
cuori trafitti,
maniche arricciate,
capelli
"drappeggiati":
l'"humour-couture"
di Yves Saint
Laurent**

In questa pagina.
Un giardino di plastica,
orientale-floreale,
fatto di fiori di pesco
e di foglie incredibilmente
verdi, sottolinea la struttura
'40 dell'abito nero,
al ginocchio in crêpe
di Gandini.
Le spalle sono imbottite,
lo scollo a V sottile,
le maniche rigonfie,
sopra il gomito,
la lunghezza scopre appena
il ginocchio. Il bracciale
nero è di Yves Saint
Laurent Rive Gauche,
il bracciale a fiori
di Le Point Rouge,
l'acconciatura di velluto
e rose è di Autran,
Marché aux Puces, con una
stella della collezione.
Il bocchino è di Marey.
Nella pagina accanto:
un nodo, motivo-previsione
per l'autunno-inverno '71,
è ricamato in paillettes
dorate sull'abito
nuova-lunghezza,
con puro spirito anni '40.
Bracciale nero e strass
di Saint Laurent,
bracciale in metallo dorato,
Le Point Rouge,
basco di paillettes di
Autran trafitto da un cuore
con freccia, il nuovo
gioiello di Saint Laurent
Rive Gauche
per l'autunno-inverno.
Pettinature
Jean-Louis David.
Maquillage di Serge Lutens.

90

"La Donna-drappeggio, stile
anni '40," *Vogue Italia*,
June 1971, Anjelica Huston,
photographed by Bob
Richardson

28

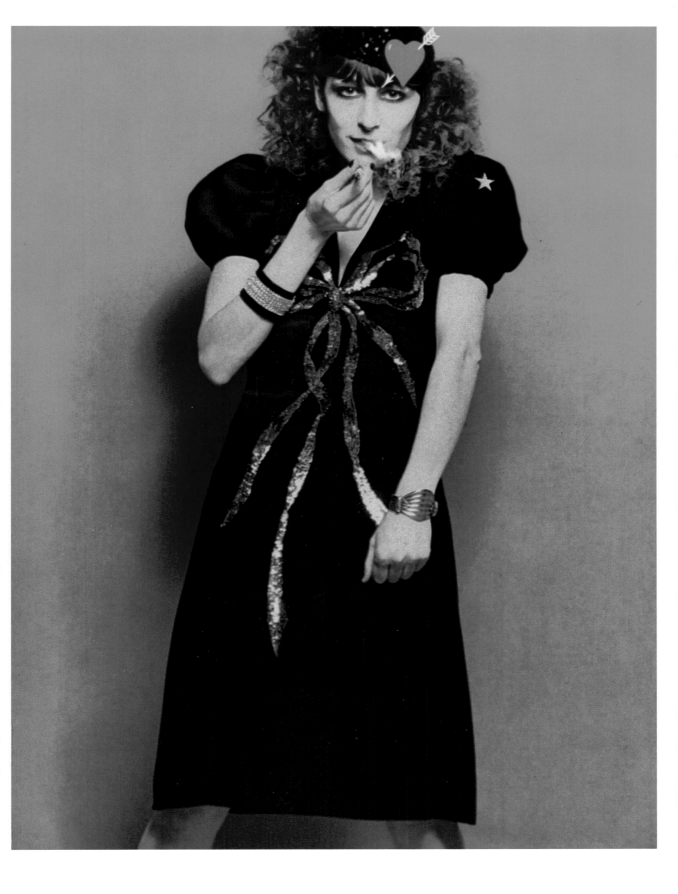

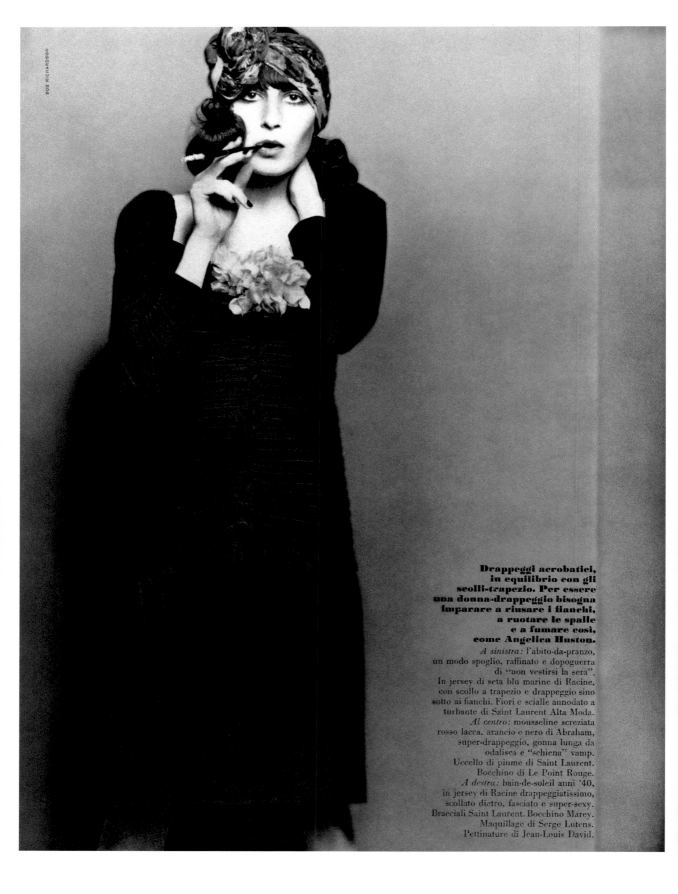

**Drappeggi acrobatici,
in equilibrio con gli
scolli-trapezio. Per essere
una donna-drappeggio bisogna
imparare a riusare i fianchi,
a ruotare le spalle
e a fumare così,
come Angelica Huston.**
A sinistra: l'abito-da-pranzo,
un modo spoglio, raffinato e dopoguerra
di "non vestirsi la sera".
In jersey di seta blu marine di Racine,
con scollo a trapezio e drappeggio sino
sotto ai fianchi. Fiori e scialle annodato a
turbante di Saint Laurent Alta Moda.
Al centro: mousseline screziata
rosso lacca, arancio e nero di Abraham,
super-drappeggio, gonna lunga da
odalisca e "schiena" vamp.
Uccello di piume di Saint Laurent.
Bocchino di Le Point Rouge.
A destra: bain-de-soleil anni '40,
in jersey di Racine drappeggiatissimo,
scollato dietro, fasciato e super-sexy.
Bracciali Saint Laurent. Bocchino Marey.
Maquillage di Serge Lutens.
Pettinature di Jean-Louis David.

"La Donna-drappeggio stile
anni '40," *Vogue Italia,*
June 1971, Anjelica Huston,
photographed by Bob
Richardson

30

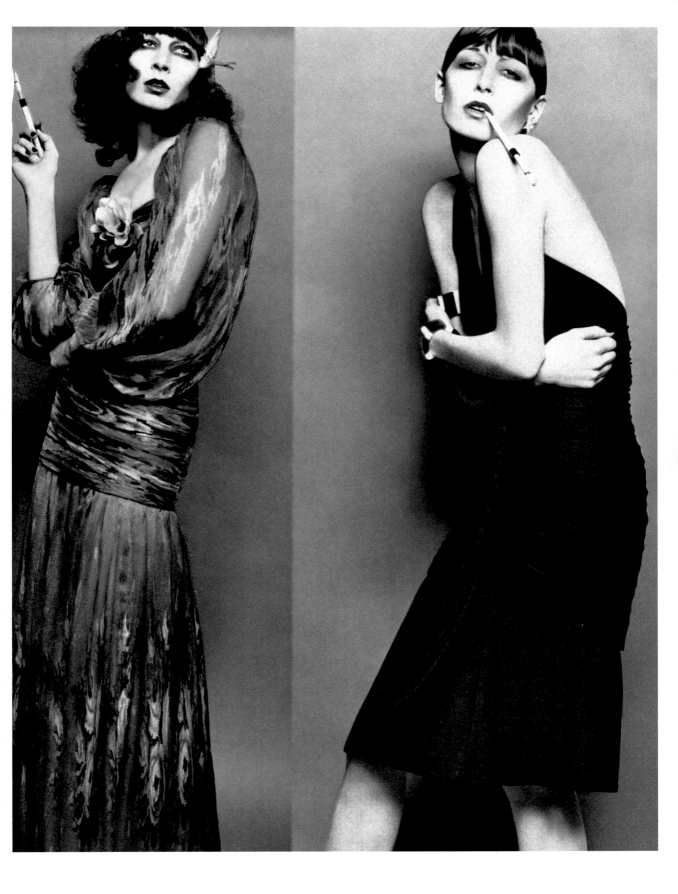

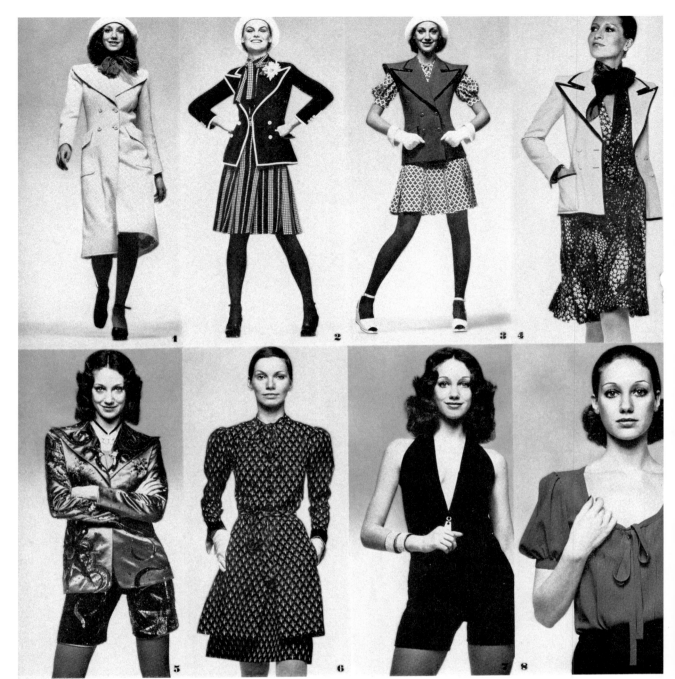

I MESSAGGI DI PARIGI

Saint Laurent: "tornate seduzione classica un colpo di spalle uno di tacco stop"

Nel '45 le donne riscoprivano il piacere di piacere: salivano sui tacchi, alzavano le spalle, accendevano le labbra. Dopo anni grigi riportavano alla ribalta la loro femminilità. Saint Laurent fa oggi per voi la stessa cosa, stimolato dalla pittura pop americana.

1. Classico mantello doppiopetto; ampi risvolti. Lana bianca: Garigue.
2. Inizia la serie dei blazers di lana su abiti corti a pieghe, in seta mini-stampata di Abraham. Qui lana blu bordata di bianco di Dormeuil.

3. Blazer scarlatto bordato di nero che sembra ritagliato nella carta.
4. Bordi neri anche per il blazer in gabardine beige di Fournier.
5. Per la sera blazer blu su shorts neri. In satin a ricami astrologici.
6. Ritorna l'abito a tunica. Crêpe de Chine bianco e nero: Abraham.
7. Jumpshorts in jersey nero di Racine con scollatura tira-e-molla.
8. La nuova blusa da tailleur. In seta rossa con le maniche a sbuffo.
9. E ora sotto la giacca del tailleur-pantaloni gessato, soltanto un fazzoletto di chiffon a pois, di Gandini, annodato al collo. Lana di Besson.
10. Su gambe alzate di 10 centimetri, mantello corto di volpe verde.
11. Tocco fatale su tailleur-pantaloni ultraclassico gessato: una volpe.

"I messaggi di Parigi," *Vogue Italia*, April 1971, Marisa Berenson, Katalin Kallay, and Jean Shrimpton, photographed by David Bailey

La mode Libération ? Celles qui l'ont connue se rappellent : des épaules carrées, des drapés, des jupes plissées, des turbans. Et, selon leur tempérament et leurs souvenirs, elles goûteront le charme un peu nostalgique des modèles de Saint Laurent ou elles hausseront avec agacement leurs épaules sans padding... Les autres ? Elles aimeront ou elles n'aimeront pas sans référence au passé, suivant leur humeur et leur style. Mais, comme l'explique Saint Laurent, une femme est toujours « plusieurs ». On change d'humeur et de style, et telle qui rit — ou rugit — en janvier...

CLAUDE BERTHOD. — Yves Saint Laurent, que pensez-vous de l'accueil fait à votre collection ? Nous sommes loin de l'enthousiasme habituel...

YVES SAINT LAURENT. — Je crois même que le mot scandale n'est pas trop fort... Je suis triste et flatté. L' « Olympia » de Manet a suscité le même genre de réactions : « On se moque de nous... »... « C'est une honte... » Ce n'est pas tant visuellement que moralement que les gens ont été choqués.

C. B. — Peut-être parce que des robes drapées, des semelles compensées, des couleurs stridentes, des maquillages agressifs, c'est le contraire de ce qu'on attend et de ce qu'on espère de vous. Avez-vous changé au point de renier tout ce que vous aimiez et d'aimer tout ce que vous détestiez ?

Y. S.L. — Ce n'est pas moi qui ai changé, c'est le monde. Et jamais plus il n'en finira de changer et nous sommes condamnés sans cesse à réajuster nos façons de voir, de sentir, de juger. Les certitudes, la tranquillité, la bonne conscience, c'est fini. L'élégance fait partie du même lot.......

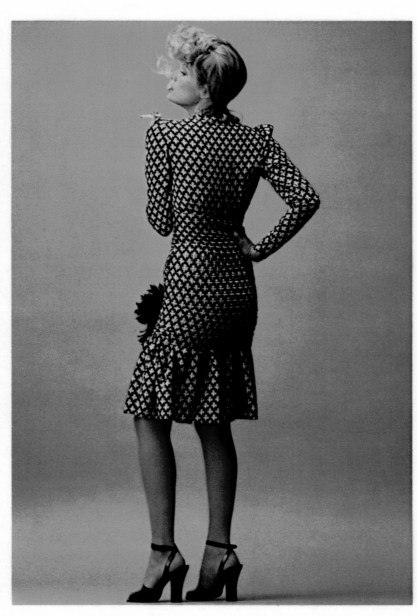

C'est le retour au drapé, au froncé, au décolleté, celui de cette robe est pointu. « C'est aussi, dit Saint Laurent, après des années de « belles maigres » le retour à la « femme à formes ». Crêpe de Chine d'Abraham.

61

"La Libération de la femme selon Saint Laurent," *Elle*, March 1, 1971, Willy Van Rooy, photographed by Hans Feurer

33

De quel droit une bande de vieilles barbes s'arroge-t-elle le droit de décréter, au nom de l'élégance, que telle chose est bien et telle chose mal ?

C.B. — Au nom, très souvent, des leçons que vous leur avez apprises : le dépouillement, le jersey, le noir, le marine, le pantalon, le trench-coat, les vêtements indémodables qu'on porte des années.

Y. S.L. — Cela reste parfaitement valable en ce qui concerne le quotidien. Et en ce qui concerne le prêt à porter qui exploite ces thèmes en long et en large.

On n'a plus besoin des couturiers pour ça. Moi je préfère encore choquer qu'ennuyer en ressassant.

C.B. — Pourquoi avez-vous choisi de choquer avec du « rétro » plutôt qu'avec du nouveau ?

Y. S.L. — Que peut-on appeler « nouveau » dans le costume ? Du peplum au collant, tout a été fait et refait cent fois. Le costume hippie, c'était emprunté à l'Orient, le short, c'est emprunté aux stades, et pourtant ce sont des apports nouveaux dans la mode. Et aucun ne vient

de la Haute Couture. La Haute Couture ne sécrète plus que des nostalgies et des interdits. Comme une vieille dame. Je me moque que mes robes plissées ou drapées évoquent pour les gens cultivés la mode des années 40. L'important, c'est que les filles jeunes qui, elles, n'ont jamais connu cette mode, aient envie de les porter. Les autres, après, auront forcément envie de les imiter. Si la Haute Couture n'est plus bonne qu'à fournir des toiles aux acheteurs à l'affût d'un nouveau montage de manche ou d'une nouvelle pince de poitrine, alors, elle n'en a plus pour longtemps...

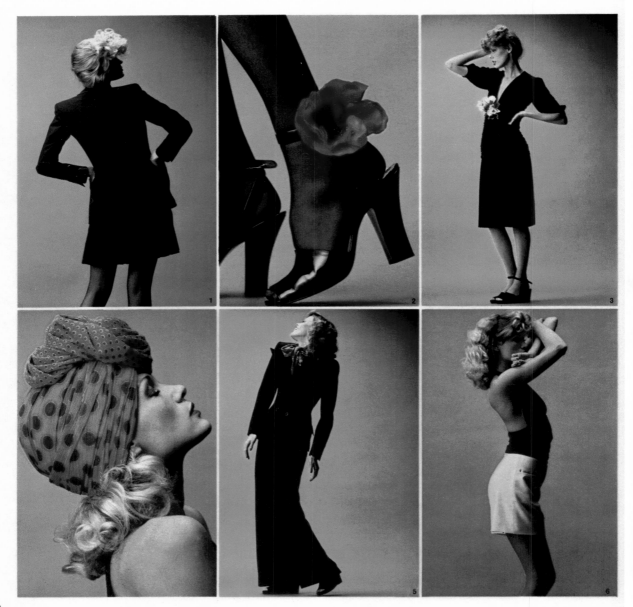

62

"La Libération de la femme selon Saint Laurent," *Elle*, March 1, 1971, Willy Van Rooy, photographed by Hans Feurer

34

C.B. — Que peut-elle apporter à des filles de vingt ans ?

Y. S.L. — Des sujets d'émerveillement, de polémique, de distractions, d'envies. Un couturier qu'on n'a pas envie de copier, ce n'est pas un créateur, c'est une couturière.

C.B. — Il y a deux ans vous aviez prévu, et vous aviez raison, qu'on allait vers l'androgynat, que garçons et filles avaient envie de s'habiller « pareil ». Et la rue s'est remplie de sahariennes, de pantalons et de trench-coats inspirés des vôtres. Or la mode que vous proposez aujourd'hui est hyper-sexuée. Vous ne gommez plus ni les seins ni les hanches, vous ne cachez plus les jambes. Tout est montré, moulé, souligné. Pourquoi ?

Y. S.L. — Je crois qu'après avoir un moment souhaité se fondre dans la masse, se réfugier dans l'anonymat d'un uniforme, les gens aujourd'hui désirent se singulariser, se mettre en scène chacun comme une vedette. Et exhiber leur « genre ». Les garçons ont envie de laisser pousser leur barbe et les filles d'exprimer leur féminité profonde. Jamais les filles jeunes n'ont été aussi maquillées et aussi violemment. Certaines ressemblent à des masques de Nô.

C.B. — Davantage que du Nô, on a parlé à propos de certains de vos mannequins et des modèles qu'elles présentaient, de Pigalle et de la rue Saint-Denis. Qu'en pensez-vous ?

Y. S.L. — Rien. Je ne connais pas ces endroits. Si j'ai subi une influence, c'est celle des peintres pop américains. Les bouches sanglantes, les jambes noires, les talons très hauts, je les ai découverts

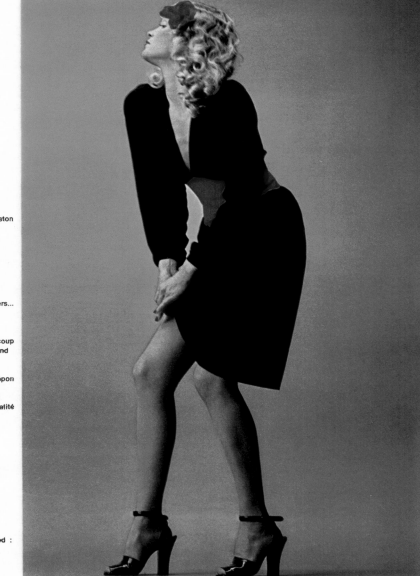

1. Le plus sophistiqué des shorts : plissé, en crêpe de soie de Staron, sous un veston cintré en alpaga de Dormeuil.

2. Ce qu'on aime ou qu'on déteste : les sandales vernies à bracelet. Coquelicot à la cheville. Ou au décolleté. Ou au revers...

3. Robe à la Piaf, en jersey de Racine. Peut donner un grand coup de charme. Ou un grand coup de vieux !

4. Turban drapé en crêpon à pois de Racine. Appelle un maquillage poussé et une personnalité sophistiquée. Sinon on a l'air de passer l'aspirateur.

5. Smoking noir en gabardine de Dormeuil. A noter : les épaules carrées, la taille marquée, la veste raccourcie. Très remarqué.

6. Tenue de piscine dans le style Hollywood : short en flanelle et bain-de-soleil drapé en jersey de soie. Tissus Perceval.

Une robe « fatale » : souligne la poitrine, la taille, les hanches. En jersey de soie de Racine, incrustée de veau velours. C'est celle que les hommes préfèrent.

63

et aimés sur les pin-ups d'Andy Warhol. Ce n'est pas « distingué » ? Et alors ? Je trouve que c'est séduisant. Agressif mais séduisant.

C.B. — Il est quand même difficile de s'imaginer partant pour le bureau dans cet équipage...

Y. S.L. — Mais il est aussi difficile de proposer aux gens, pour unique perspective, le travail, des vêtements pour le travail, une vie de travail. On est tous forcés d'en tenir compte, et moi aussi j'ai payé mon tribut aux réalités : tout ce que j'ai fait jusqu'à présent, c'étaient des vêtements « adaptés », sérieux, responsables. Mais ça ne suffit plus. On a besoin de gaieté, de légèreté, d'humour, de gratuité, de revanches. On a besoin de fêtes. La mode ça doit aussi être la fête, ça doit aider les gens à jouer. A changer. A s'évader. A compenser un peu le monde terrible, si gris, si dur, dans lequel ils sont condamnés à vivre. Il faut aussi habiller leurs rêves, leurs évasions, leurs folies. La libération de la femme ? Bravo. Mais la libération des esprits ça n'est pas mal non plus : être capable d'accueillir sans ricanements et sans aigreur ce qui dérange un peu. Et la mode « Libération », celle de 45, vous avez quelque chose contre ? Jamais les femmes, dans les films, sur les photos, n'ont été aussi attirantes. Peut-être parce qu'elles avaient l'air libre, décidé, heureux. Peut-être parce qu'elles attendaient de l'avenir des lendemains merveilleux et que ça leur allumait les yeux et que ça faisait claquer gaiement leurs hauts talons et qu'elles redécouvraient avec ravissement la soie, les couleurs, le plaisir de s'habiller, le plaisir de plaire, et qu'elles se fichaient royalement de la mode avec un grand M. Comme moi.

C. B.

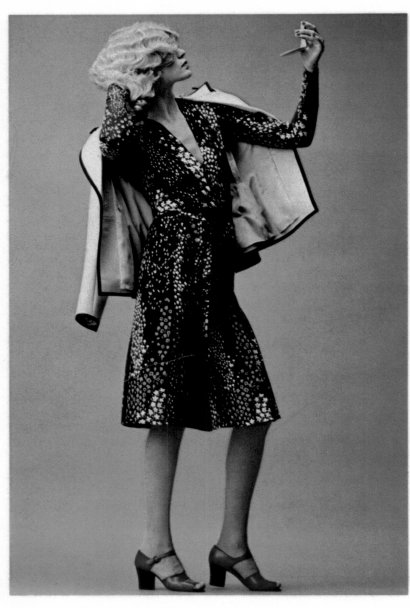

Ici, applaudissements unanimes : moins de vingt ans ou plus de quarante, toutes les femmes ont aimé. Robe en crêpe de Chine d'Abraham à plis piqués. Blazer gansé en gabardine de Fournier.

64

"La Libération de la femme selon Saint Laurent," *Elle*, March 1, 1971, Willy Van Rooy, photographed by Hans Feurer

Deux filles à la mode choisissent leur mode

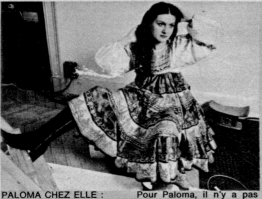

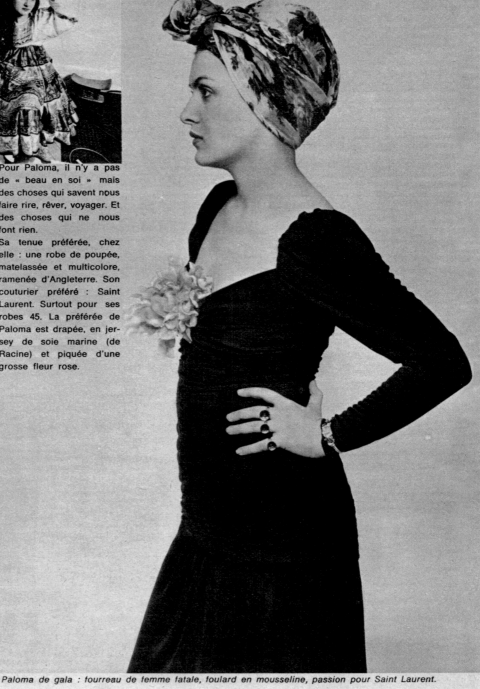

PALOMA CHEZ ELLE : ROBE DE POUPEE RUSSE

« J'aime la mode parce que c'est un jeu », dit Paloma. Petite, elle jouait aux couleurs comme d'autres jouent à la poupée. Elle est la fille de Picasso et de Françoise Gillot. Elle crée des bijoux pour Saint Laurent. Il crée des robes en pensant à elle. Parce que depuis quelques mois beaucoup de filles se sont mises à lui ressembler. Achètent comme elle aux Puces les robes et les chaussures « compensées » que leurs mères ont jetées il y a vingt-cinq ans. Aiment comme elle se peindre les lèvres en rouge foncé et se donner à vingt ans l'air d'en avoir trente-cinq. Découvrent comme elle, après les gaietés du style Pop, les délices du style Kitch. Le Kitch c'est quoi ? Tout ce qui est de mauvais goût, pourvu qu'on le regarde « au second degré ». Avec un clin d'œil plein d'humour et assez d'esprit pour ne pas prendre tout cela au sérieux. Exemples de Kitch : les broches représentant un petit chien en plastique, les objets souvenirs, les dînettes de poupées, les fleurs artificielles.

Pour Paloma, il n'y a pas de « beau en soi » mais des choses qui savent nous faire rire, rêver, voyager. Et des choses qui ne nous font rien.

Sa tenue préférée, chez elle : une robe de poupée, matelassée et multicolore, ramenée d'Angleterre. Son couturier préféré : Saint Laurent. Surtout pour ses robes 45. La préférée de Paloma est drapée, en jersey de soie marine (de Racine) et piquée d'une grosse fleur rose.

Paloma de gala : fourreau de femme fatale, foulard en mousseline, passion pour Saint Laurent.

"Deux filles à la mode choisissent leur mode," *Elle*, March 1, 1971, Paloma Picasso, photographed by Peter Knapp

41

Illustration by Chris
Mac-Evan, published in
La Dépêche de la mode,
February 1971

Photograph of Jean
Shrimpton by David Bailey,
published in *Vogue Italia* and
Vogue (US), March 1971

Agence Française d'Extraits de Presse

13, AVENUE DE L'OPERA, PARIS 1er — C.C.P. 5462-57 PARIS — TEL. : 742-45-83 (20 lignes groupées)

INTERNATIONAL HERALD TRIBUNE - PARIS
21, rue de Berri, 8ème

Date : 30 JANV 1971

FASHION

Saint-Laurent: Truly Hideous

By Eugenia Sheppard

PARIS, Jan. 29.—What a relief, at last, to write that a fashion collection is frankly, definitely and completely hideous. Since the collection is Yves Saint-Laurent's, it follows that it will also be considered frankly, definitely and completely chic, at least by the Saint-Laurent clique.

Yves started the whole powerful uglification trend in fashion, probably because he is the youngest of the Paris made-to-order designers. Pushed into fame in his early 20s when Dior died, he is more closely related to a similar ugliness in the times and more responsive to it than the older designers.

For his collection this afternoon that ends the Paris shows this season, Yves has picked the ugliest, harshest period in fashion history to recapture. Other designers have been toying with the '40s but leave it to Saint-Laurent to bring the whole period back alive.

Not that it wasn't the world's most amusing afternoon, or that Yves's silver fox chubbies and early Ceil Chapman sweetheart necklines won't be wonderful camp for the girls who never wore them. Fun is fun in a boutique, but not at couture prices.

Some of the Saint-Laurent clothes might be almost pretty if it weren't for the accessories. Vivier's shoes are positively repellent, and I can only hope that he did them under pressure. They have platform soles, at least four-inch heavy heels and ankle straps. Forced into a new, forward slanted posture, the girls have a hard time getting around in them. Saint-Laurent has even managed to find some harsher, chunkier models to underscore the heavy-handed look.

His skirts are consistently the shortest in Paris. The coats cover the knees by about two inches and so do many of the dresses. About half of them, though, are an inch or two above and all of them are pleated. He skips hot pants completely. He's smart enough to know the boutiques have been full of them for at least two months.

Saint-Laurent's favorite look is a kind of cartoon blazer completely outlined in white braid. The shoulders are extended and the pointed revers are wide enough to touch them. The rest of the costume is a felt hat jammed down over curly hair, an above-the-knee dress, white or colored nylons and the ankle-strap shoes.

Pin-striped pants suits, Saint-Laurent's old favorites, have bare-back halters or just bras under their man-tailored jackets. Fox scarves with bushy tails are draped across the shoulders.

Saint-Laurent has a real thing about foxes. He makes a mint-green fox topper that stops at the knees above orange panty stockings and the platform shoes with a flower tucked into the ankle strap.

Fox coats, all very broad-shouldered, and one real white fox chubby cover some of the tartiest effects. The coats come off to show jump suits laced loosely across the front with narrow rhinestone ribbons or dresses tucked within an inch of their lives from around the bosom to below the fanny, which is cupped in and swingy when the models walk.

Some of Yves's long evening dresses are elegantly and beautifully pin-pleated all over. The colors are terra cotta and clay and the print, said to be taken from an old Greek vase, is slightly pornographic and not to be reported in a family newspaper.

It's not that Saint-Laurent can't design perfectly beautiful dresses when he feels like it, and he felt like it occasionally in the collection. The simple dark blue chiffon and the delicate bamboo prints on silk organdy couldn't have been lovelier.

Oh well, it was a lot of fun and, as a matter of fact, I'd like to see the whole thing all over again.

If you ask me, though, to sum up the whole European couture trend in one adjective I'd say it is suicidal. Designers everywhere seem anxious to do away with made-to-order and get on with the bigger business of ready-to-wear.

This typical daytime ensemble of Saint-Laurent has a pleated skirt at mid-thigh, small puffed sleeves, a sleeveless jacket with shoulder wings and ankle-strap shoes.

Chance.

The switch in lengths over here this season is, in itself, suicidal to any kind of consistent leadership in fashion by the Paris couture. In some houses the hems have jumped up ten inches in six months, just at the moment the public was getting ready to accept the drop.

Give them all lengths and let the women decide, is the way the couturiers feel. But for the moment it's chaos.

Skirts will be stabilized at an inch or two below the knees for a while, just the length Chanel always showed them. It will mean alterations for many women, who will be more skeptical than ever about listening to what Paris says.

In Italy last week the Carosa collection was suicidal, full of gags by a young designer who was obviously fed up with the whole thing. Saint-Laurent's collection is the suicidal gesture of all time.

At a party given by Count and Countess d'Ornano the other night, I couldn't help admiring the ladies in their couture clothes. Princess Edouard de Lobkowicz wore an elegant black velvet with a ruffled neckline and slit skirt. Harriet de Rosière's bright red crepe shirtwaist dress with white collar and cuffs came from Nina Ricci. The hostess's paisley chiffon pullover and Zouave pants were designed by Jean-Louis Scherer, whose house she and her husband have just bought. All three designers are famous for having not enough news to print.

Possibly couture should go back under, dress the ladies and not pretend to set trends, as it did before Christian Dior became the first couture tycoon.

Let the designers with ready-to-wear minds get on with ready-to-wear where gags are less expensive and constant change is the thing.

Alexandre Samson

CHRONICLE OF A SCANDAL

Monday, January 25, marked the beginning of fashion week for the 1971 Spring–Summer haute couture collections in Paris. Journalists were expecting the usual routine of comparing new looks with earlier collections, and they were single-mindedly focused on just one thing—the hemline. "Mini," "Midi," and "Maxi" were recurrent terms. Shorts were ubiquitous in these haute couture collections— sometimes to the profound dismay of fashion chroniclers: Their popularity seemed to argue in favor of an abbreviated skirt length. Journalists acknowledged their consternation as these collections had gradually become increasingly heterogeneous. An exception to the rule, Pierre Cardin garnered widespread praise for styles that flattered most women.

A 1940s influence was making itself felt throughout these shows, particularly in Marc Bohan's designs for Dior. "All you need to do is immerse yourself in a collection of fashion magazines dating from the Occupation. Almost all the styles of the 1971 season—at least those we viewed this first day—are right there."[1]

Scheduled for Friday, January 29, Yves Saint Laurent's collection was the last to be presented after twenty-two other designer shows. Journalistic expectations were running high. Saint Laurent would surely bring the season to a rousing conclusion, as he did so reliably every season, "unless a bomb explodes at the last minute,"[2] as Simone Baron rather oddly commented in *France-Soir*.

So it was with considerable suspense that journalists, buyers, and clients gathered at Yves Saint Laurent's salon on rue Spontini. "From the very first models displayed, the atmosphere was electric. He went full steam ahead,"[3] observed Baron. Consternation soon

1. "Cousu main," *Le Figaro*, January 26, 1971 (unsigned article).
2. Simone Baron, "Collections," *France-Soir*, January 28, 1971.
3. Simone Baron, "Saint Laurent, priez pour elles," *France-Soir*, January 30– February 1, 1971.

Eugenia Sheppard, "Saint-Laurent: Truly Hideous," *International Herald Tribune*, January 30, 1971

41

reigned: After eighty runway walks, it had become clear that a 1940s aesthetic dominated the collection.

Some of the journalists in attendance overtly demonstrated their disapproval. M.-A. Dabadie, of *Le Figaro*, openly read his newspaper; Nathalie Mont-Servan, of *Le Monde*, turned her attention to her write-up on Carven's show. A scandalized Christiane Collange, reporting for the broadcast network Europe 1, confided to Pierre-Yves Guillen of *Combat*: "You just couldn't resist a hiss." Some attendees simply exited the salon before the season's final show concluded, like offended audience members walking out of a theatrical performance.

Throughout the month of February, the press was almost unanimous in condemning Yves Saint Laurent's collection with a fervor that was rare in fashion writing. *France-Soir*, the highest-circulation daily in France, commenced its attack the very evening of the collection's presentation: "Certain individuals are now amusing themselves provoking uncalled-for distress by digging up the past. Memory sometimes supersedes imagination."[4]

The next morning, Saturday, January 30, the major dailies all carried coverage of the collections, heaping scorn on Saint Laurent. In *Le Figaro*, M.-A. Dabadie wrote an article headlined "Saint Laurent: Une triste occupation [a regrettable occupation]," wondering aloud whether the entire show had been a "gag." He concluded: "It's a mistake. A mistake that we fervently hope will be corrected beginning next season."[5]

The international press joined the scandalized chorus. In Britain, Alison Adburgham, writing in the *Guardian*, commented, "[Saint] Laurent spared us nothing. His collection was a tour de force of bad taste," and titled her article "Saving the Worst for Last."[6] Writing for the American news agency United Press International, in an article titled "Designer Yves Saint-Laurent Draws Fire in Fashion World," Aline Mosby described unanimous condemnation.[7] The most memorable diatribe was launched by one of Saint Laurent's greatest admirers, the famous fashion writer Eugenia Sheppard. She wrote a column that appeared in some thirty American newspapers, initially publishing her article in the *International Herald Tribune* with the headline "Saint-Laurent: Truly Hideous." She wrote: "What a relief, at last, to write that a fashion collection is frankly, definitely and completely hideous." She concluded, "I'd say it's suicidal."[8]

On Monday, February 1, Nathalie Mont-Servan, writing for *Le Monde*, titled her article "Saint Laurent: Le Renard enchaîné [the shackled fox]," a pun on the name of the satirical weekly paper *Le Canard enchaîné* (the Shackled Duck) and a reference to the presence in the show of fox fur coats. She lamented that the couturier had "lost his sense of proportion, and even his good taste. If he's imitated by the ready-to-wear collections, which have been living off of his inspiration for years now, women will be disgusted by fashions that make a mockery of them. He's playing a very dangerous game."[9] This opinion was shared by Pierre-Yves Guillen in *Combat*, who wrote the most negative French article on the collection: "It's repulsive. It's reprehensible," closing with the parting shot, "I no longer recognize Saint Laurent."[10]

English-speaking journalists expressed amazement at the almost unanimous hostility expressed by the French press: "The attack on

4. Michel Villeneuve, "À la mode de quand?," *France-Soir*, January 29, 1971.
5. M.-A. Dabadie, "Saint Laurent: Une triste occupation," *Le Figaro*, January 30–31, 1971.
6. Alison Adburgham, "Saving the Worst for Last," *Guardian*, January 30, 1971.
7. Aline Mosby, "Designer Yves Saint-Laurent Draws Fire in Fashion World," printed in the *Lorain Journal*, January 30, 1971.
8. Eugenia Sheppard, "Saint-Laurent: Truly Hideous," *International Herald Tribune*, January 30, 1971.
9. Nathalie Mont-Servan, "Saint Laurent: Le Renard enchaîné," *Le Monde*, February 1, 1971.
10. Pierre-Yves Guillen, "Saint-Laurent: L'Apprenti sorcier," *Combat*, February 1, 1971.

Saint Laurent was all the more unusual because French fashion writers generally just tell what they see and avoid extensive criticism of designers, considered a virtual part of the French patrimony."[11]

Rereading these articles, it is obvious that the vast majority of journalists were highly critical of Yves Saint Laurent's references to the bleak years of the German Occupation. Six months earlier some had alluded to styles influenced by "the winds of the 1940s." These influences were evident in the 1970 Fall–Winter collection, which was deemed by some observers to be "utterly bizarre."[12] Critics immediately made the connection when they viewed the next season's offerings: "When in his last collection he inserted four models in Carmen Miranda getups, some of us hoped he was joking. Alas, not so. They were a trailer, now we have the lot."[13]

Most journalists heaped scorn on the perceived ugliness of 1940s styles, but they excoriated the couturier's lack of inspiration even more. He was then thirty-five, and some observers found his youth "the excuse for not understanding."[14] Others went so far as to seek out explanations in the designer's childhood. They were convinced that the wardrobe of his mother, Lucienne Mathieu-Saint-Laurent, was an influence. Others suggested that the couturier had been shocked as a child when faced with the streetwalkers of the rue Saint-Denis.[15] The journalists who offered these speculations were evidently unaware that Yves Saint Laurent had been raised in Oran, Algeria, and would not have been exposed to this sort of scene.

These various articles make it clear that the violent reaction was prompted by Saint Laurent's deliberate effort to shock with a collection that was "presented in such an aggressive manner."[16] Simone Baron conceded that the couturier had warned her in advance: "Saint Laurent . . . told me before the presentation: 'Convention bores me; I need to make a clean break.'"[17] His models were compared to prostitutes, flaunting provocative poses and outrageous makeup. Artificial flowers—mostly poppies—were prominently displayed. "The colors are indefensibly garish. And the accessories are in equally bad taste," wrote Marie Guyon in *La Croix*.[18] Eugenia Sheppard remarked: "Vivier's shoes are positively repellent, and I can only hope that he did them under pressure."[19]

The collection's final styles were inspired by the draping of Greco-Roman garments. These included the wedding gown concluding the show, which softened the blow for some commentators. However, the outfits adorned with prints inspired by Greek vases were judged "slightly pornographic and not to be reported in a family newspaper."[20] For self-respecting journalists, this was the ultimate provocation.

In its analysis the press deemed the collection "derivative"[21] of Parisian haute couture. The garments were little better than flea market finds, simply quoting 1940s styles without reinterpreting them. Their simplicity was too close to ready-to-wear, diminishing the quality and exclusivity of haute couture. "Fun is fun in a boutique but not at couture prices,"[22] Eugenia Sheppard commented. The prestige of Parisian design seemed to be at stake; some commentators saw it as a wake-up call for American designers: Perhaps it was their moment to take the lead.[23]

Journalists also realized that, for the first time, Yves Saint Laurent was not trying to appeal to his traditional clientele. These styles were

11. Associated Press, "French Writers Criticize Yves for Fashions Recalling Nazi Era," printed in the *Saint Paul Dispatch*, February 1, 1971.
12. Marcelle Jean, "Long sera l'hiver," *La Marseillaise*, August 2, 1970.
13. Adburgham, "Saving the Worst for Last."
14. Dabadie, "Saint Laurent: Une triste occupation."
15. "Yves Saint Laurent: à la guerre comme à la guerre," *Paris-Jour*, January 30, 1971 (unsigned article).
16. Mont-Servan, "Saint Laurent: Le Renard enchaîné."
17. Baron, "Saint Laurent, priez pour elles."
18. Marie Guyon, "Saint Laurent, triste influence 1940," *La Croix*, February 2, 1971.
19. Sheppard, "Saint-Laurent: Truly Hideous."
20. Ibid.
21. "Où va la haute couture? À la dérive . . ." *Ouest-France*, February 3, 1971 (unsigned article).
22. Sheppard, "Saint-Laurent: Truly Hideous."
23. Yvette de La Fontaine (Women's News Service), "Time for U.S. to Take the Lead? Paris Fashions Called Suicidal," *Pittsburgh Press*, February 15, 1971.

aimed at younger women who had never experienced the glory days of prewar haute couture or the privations of the Occupation. Eugenia Sheppard was seventy, and, like the majority of her colleagues, she addressed a readership of women who felt that this collection was not meant for them. Yves Saint Laurent was highlighting the mutual incomprehension that had arisen between two generations. It was a divide that had been revealed by the demonstrations and political turmoil of May 1968. "It was sad for women who were twenty years old when the war began, and it will be a surprise for young women who are about to experience . . . the constraints of extremely tight clothing that restricts the body."[24] In this collection, the couturier was asserting that fashion had to address a new audience of younger women. And the press understood this shift in orientation. "My young neighbor finds all this 'très sexy!'"[25] wrote Brigitte Amalvy.

A few reactions were less negative. Some journalists preferred to focus their attention on deeper analysis. Bernadine Morris's article in the *New York Times* had harsh words for the collection's detractors. In her opinion, the collection "was probably the youngest, liveliest and most ebullient of his career."[26] Amalvy demonstrated a more forbearing attitude than her colleagues: "He disappointed, but he astonished me. Wasn't it Cocteau who said to the poet: 'Astonish us'? . . . And isn't this also a way to be part of our moment, after all?"[27] When filming the collection, the French public broadcasting agency ORTF admonished, "This collection reflects what's happening today. We have to change our state of mind before we change our clothes."[28]

It was generally understood that fashion magazines would very rarely express negative views of a couturier or a collection. They were deliberately accommodating and customarily omitted coverage of styles likely to offend their readerships. However, the 1971 Spring–Summer show created such outrage in the daily press that journalists were compelled to take a stand and fashion editors reacted. *Marie-France* alluded to "an unforgivable lapse of taste,"[29] and *La Dépêche de la mode* referred to "a lack of imagination."[30] Some expressed more tempered views. Jeanne Stéphane, editor in chief of *L'Officiel de la couture et de la mode de Paris*, put a model from the Yves Saint Laurent collection on her cover, while expressing certain reservations. Although she approved of collections inspired by "reminiscences," such as Marc Bohan's designs for Dior, she spoke out against "retrospectives that are brazen, deliberate, and thrown about as a willful kind of provocation,"[31] alluding to Yves Saint Laurent.

Diana Vreeland, the iconic editor in chief of American *Vogue*, was intrigued but conscious of American opinion. She did not engage in the debate, advising her readers: "These collections from the great couture houses of Paris—the experimental laboratories of fashion—are showing us the shifts in the fashion winds. . . . Let's go with the wind . . . ride with it . . . keep a weather eye on it."[32]

Vogue Paris was the only publication to offer unqualified support to Yves Saint Laurent, featuring photographs by Helmut Newton. His work played along with the press's accusations: The models were posed in the couturier's salons, which bore a curious similarity to the alcoves of a brothel. Francine Crescent, editor in chief, hammered the message home: "Adieu, folklore and disguise, adieu,

24. Jeanne Stéphane, "Plus qu'une évolution, une transformation," *L'Officiel de la couture et de la mode de Paris*, March 1971, p. 1.
25. Brigitte Amalvy, "Saint Laurent 'revient de guerre,'" *La Nation*, February 1, 1971.
26. Bernadine Morris, "Now Why Are They Throwing Brickbats at Saint Laurent?," *New York Times*, February 2, 1971.
27. Amalvy, "Saint Laurent 'revient de guerre.'"
28. ORTF, 8:00 P.M. news broadcast, February 5, 1971, INA archives.
29. J. D., [untitled], *Marie-France*, March 1971, p. 32.
30. Jacqueline Bigand, "La Haute couture," *La Dépêche de la mode*, February–March 1971, p. 32.
31. Stéphane, "Plus qu'une évolution, une transformation."
32. Diana Vreeland, "The Vogue's Eye View on Paris," *Vogue* (US), March 15, 1971, p. 35.

neurasthenic fabrics! No, Yves Saint Laurent is not 'hideous' as some would have it! No, Paris has not murdered fashion! The couturiers have simply delivered a wake-up call that makes everything that's been done before look obsolete."[33]

Even more surprising was Hélène Lazareff's reaction in *Elle*. Known for her lively curiosity and openness to novelty, the magazine's sexagenarian founder pronounced her resolute opposition to the collection: "Are we reversing course back to the past? . . . We are uneasy about these backward glances."[34] She reiterated her negative view in *Jardin des modes*: "Why did Yves Saint Laurent get things so wrong in '71? Why this retrospective that's of interest to no one but himself?"[35] Still, *Elle* embarked on a novel venture at the initiative of the journalist Claude Berthod: She initiated the "Frenchwomen and the collections" poll. One hundred women from Paris and its environs were invited to analyze the 1971 Spring–Summer haute couture shows. She interpreted the findings, which were a direct reaction to the Yves Saint Laurent collection, "in the light of immediate responses, which are sometimes unfair, sometimes violent, and often contradictory. Couturiers are used to being hailed and criticized by the usual audiences: buyers, fashion writers, individual clients. Now they're confronted with public opinion for once."[36] For Claude Berthod, the verdict was clear: "Our jury of readers, despite some acerbic commentary . . . seems to have grasped the profound originality of Yves Saint Laurent more clearly than fashion writers and professional buyers. He is able to do something new even with something old."[37]

Responding to the brutality of the press reaction against him, Yves Saint Laurent granted an exclusive interview to Aline Mosby of United Press International on February 18. It was immediately published in forty international newspapers. The couturier went head-to-head with his critics, accusing them of being incapable of adapting to a "fresh intellectual initiative." "I can't hide my disappointment, because I didn't expect that in a profession that is open to all I would encounter so many narrow-minded individuals. What's more, with such reactionary views," he admitted. He also reiterated his desire to pursue haute couture while appealing to the younger generation. To those who accused him of having blundered, he retorted: "Generally speaking, I think I'll continue in the spirit of my collection because I am in the right."[38]

Time has validated Yves Saint Laurent's views. In February 1971 the *New York Times* published an article on the influence of 1940s films on fashion, titled "The Forties—Not That Bad?"[39] In April the ready-to-wear collections were presented. Journalists in Paris easily discerned the couturier's influence in the collections of Kenzo, Ter et Bantine, and Dorothée Bis.[40] That same month in Florence, Saint Laurent's name was on everyone's lips. And in New York, Eugenia Sheppard was compelled despite herself to acknowledge the designer's influence on the new silhouettes of suits and furs. "There was some good, after all, in Yves Saint Laurent clothes which, otherwise, won the blue ribbon for the ugliest in Paris this season. It took a long time expert like Sydney Gittler to spot them, but YSL's white reefer coat and his tailored suit with the huge yellow chrysanthemum on the lapel turn out to be the trend-setting, trail blazing fashions in the show."[41] Marion Christy of the *Boston Globe*

33. Francine Crescent, "Le Point de vue de Vogue sur les collections," *Vogue Paris*, March 1971, p. 127.
34. Hélène Gordon Lazareff, "Collections 71," *Elle*, March 1, 1971.
35. Hélène Gordon Lazareff, "Du po po au magicien," *Jardin des modes*, March 1971.
36. Claude Berthod, "Les Françaises et les collections," *Elle*, March 1, 1971 (poll conducted on February 4, 1971), pp. 126–29.
37. Ibid.
38. Interview by Aline Mosby, "Yves Saint Laurent Blasts Critics," *Reading Eagle*, February 18, 1971.
39. Angela Taylor, "The Forties—Not That Bad?" *New York Times*, February 17, 1971.
40. NYT Service, *Express News*, April 2, 1971.
41. Eugenia Sheppard, "Fashion Takes a Broad Outlook," *San Francisco Chronicle*, April 23, 1971.

remarked at the same time: "When Yves Saint Laurent brought out Chubbies in January, the press clobbered him. Editors alternately boo'd, laughed, then observed Yves had gone mad. A few months later, Yves's non-waning influence is obvious."[42]

The 1971 Fall–Winter collection was presented in late July. The press, which had granted Saint Laurent a few months of respite, acknowledged the designer's triumph. "Yves Saint Laurent presented an outrageous collection on the first day of the fall and winter fashion showing here and everybody's going to copy him. . . . He received a drubbing for his last collection which zeroed in on the 1940's and went on to inspire half the designers in Rome and New York. You can imagine what will happen with this one, which was wildly cheered."[43]

The press's reaction to the 1971 Spring–Summer collection was commensurate with the significant issues raised by Yves Saint Laurent himself. In just one show the designer had made himself the focal point of an era, with all its fashions and perplexities. Challenging the distinction between haute couture and ready-to-wear, questioning the concept of good taste, addressing himself to young women rather than their mothers, and freeing fashion from its long-standing obsession with hemlines, the designer faced down an entire system. For the very first time, a couturier challenged critics to adopt a fresh mentality. They were invited to open their minds to a new concept of fashion, as critics had accepted elemental changes in the art world.

The woman in the street vindicated Saint Laurent and even raised questions about the legitimacy and relevance of the fashion press. Eugenia Sheppard, whose article had most offended Saint Laurent, was not invited to the Fall–Winter show in 1971. She made amends and officially reconciled with the couturier in the summer of 1972, in an article she titled "At Home with Yves."[44]

On that unforgettable day of January 29, 1971, Yves Saint Laurent inaugurated a new decade in fashion, precipitating a radical break with the past. Despite the diatribes of the press, critics were forced to acknowledge the incontrovertible evidence: "Fashion will never be the same again."[45]

42. Marion Christy, "Hey, Chubby," *Boston Globe*, May 7, 1971.

43. Bernadine Morris, "Saint Laurent Cheered in Paris," *Nashville Tennessean*, July 28, 1971.

44. Eugenia Sheppard, "At Home with Yves," *Woonsocket Call*, August 4, 1972.

45. Yvette de La Fontaine (Women's News Service), "'Suicidal' Is Reaction to Paris Styles," *Asbury Park Press*, February 13, 1971.

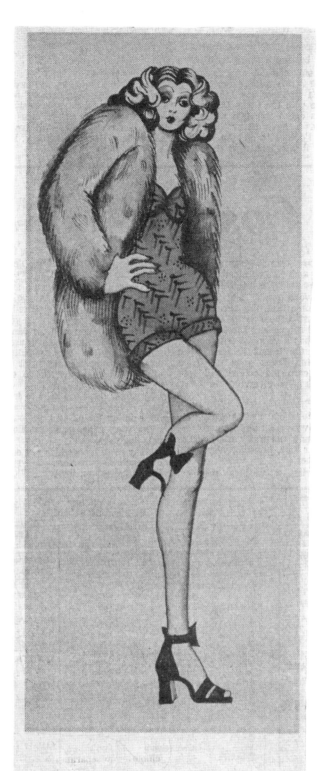

The Chubby Is In

Chubby jackets, mostly of the silver fox variety, have been reinstated (but not revamped) from the pin-ups of the 1940s to high-camp-fashion-today. Yves Saint Laurent brought out the chubbies in January only to be clobbered by the fashion press, but today, a few months later, they are popping up in every big-name collection. Above, chubby by Jacques Kaplan of New York.

Marion Christy, "The Chubby Is In," *San Bernardino Sun*, May 13, 1971

COLLECTION PRINTEMPS-ETE 1971

par Pierre-Yves Guillen

330/6

SAINT-LAURENT :
l'apprenti sorcier

Yves Saint-Laurent, la saison dernière, avait lancé la « bombe 40 » mais en gadget ! Bombe que je n'avais pas manqué de vous décrire dans ces mêmes colonnes.

Cette bombe devait être au napalm : elle s'est en effet répandue et a sévi tout au long de la semaine des collections Printemps-Eté 71 que nous venons de vivre.

Probablement dépassé par les événements, Yves Saint-Laurent s'est vu contraint, je l'espère pour lui, de faire pire que les autres !

Cette mode était déjà épouvantable en son temps, aujourd'hui elle va faire peut-être à quelques minettes niaises du style « Hitler, connais pas » et que seul ce grotesque vraiment fera remarquer.

C'est donc hideux.

C'est donc honteux.

Yves Saint-Laurent aurait dû se contenter de sa farce de l'hiver dernier et surtout rire aux éclats de ce qu'elle avait provoqué.

Il aurait dû créer, je lui fais confiance, tout à fait autre chose.

Ainsi nous aurions continué de clamer : Saint-Laurent c'est divin !

Mais nous ne pouvons que pleurer.

Parce que c'est de très, très mauvais goût : ces turbans, ces semelles compensées, cette longueur au-dessus du genou, ces revers larges, c'est ce que l'on voyait dans les pièces de Sacha Guitry en 42.

Pendant que les mannequins défilent, mon confrère Dabadie du Figaro lit « Le Temps ». Il est nostalgique et inquiet, Dabadie. Cela lui rappelle les pièces jouées par Michèle Alfa et dont il interprétait le rôle au Stalag 43 ! Nathalie Mont-Servan du « Monde » écrit son Carven. Christiane Collanges, courageusement, dit : « On devrait siffler ». Soudain, un modèle imprimé d'étoiles jaunes passe. C'est le comble.

Les mannequins, tondus probablement par les FFI portent des perruques bouclées avec le fer à friser de Corinne Luchaire, et retenues par de ridicules turbans.

Quel scandale lorsqu'on a le talent d'Yves Saint-Laurent ! Ou quel orgueil de croire que tels des moutons déportés nous allons applaudir à ce carnage du bon goût, à ce charnier de l'élégance, à ce crématoire du prestige.

Pour le soir, des hommes imprimés et sexe en main tournent autour des robes comme autour d'un vase grec. Réminiscence de la virilité nazie sans doute !

J'ai brûlé tout cela en 44. Vous aussi je l'espère. Mais il y aura, j'en ai peur, encore au moins une folle par arrondissement ou par village qui portera cela. Vous savez de ces folles que l'on voit parfois: 70 ans et habillées en gamine Oui, c'est cela. Oui, c'est fait pour des folles qui ne veulent pas vieillir. Oui, c'est fait pour des nostalgiques du vert de gris, oui, c'est fait pour des idiotes, oui, cela va peut-être plaire !

Saint-Laurent ? Connais plus.

Designer Yves Saint-Laurent Draws Fire in Fashion World

By ALINE MOSBY

PARIS (UPI) — Members of the international fashion world today condemned the Yves Saint-Laurent 1940's floozy look, but they had to admit the girls may go wild over his spring high fashion collection.

The bespectacled designer proved he was still the "enfant terrible" of haute couture when he scandalized press and buyers Friday with a spring show evoking of soldier-chasing girls of wartime France.

"It was a mistake, an error," the Paris newspaper Le Figaro said. One of the most important buyers at the show, Irene Satz of the Ohrbach chain in the United States, said the collection was "a big disappointment."

Many of the World War II clothes Saint-Laurent showed were those most women wore in the jitterbug era — mannish tailored suits with broad shoulders, black crepes swathed tight around the hips, turbans, shoes with platform soles and four-inch heels and square fox "chubby" coats.

SAINT-LAURENT, who was born in 1936, said recently he thought women never were more chic then between 1938-1945.

Many of the items in the Saint-Laurent show left the audience in a shocked daze.

One mannequin in bright roughed cheeks and lips looked like Lili Marlene waiting under a lamp post near a red light district in a bright green chiffon gown with short puffed sleeves covered with artificial flowers. Another swiveled by in purple crepe, waist plastered with sequins in violent hues.

Artificial flowers were plunked at the waist, on the bosom or in the girls' long brassy blonde or red curly hair. One girl wore a stuffed little bluebird in her Deanna Durbin hairdo. Virtually the only wartime item Yves forgot was an ankle bracelet.

The show stopper was a series of gowns in a fabric printed with pornographic scenes from Greek vase paintings.

Pierre-Yves Guillen, "Saint-Laurent: L'Apprenti sorcier," Combat, February 1, 1971

Aline Mosby, "Designer Yves Saint-Laurent Draws Fire in Fashion World," Lorain Journal, January 30, 1971

LES FEMMES SERONT cet été... en 1945

1 330/7

C'EST fait, c'est dit, et ils nous l'ont montré cette semaine : les grands couturiers sont pour une mode d'été courte et s'ils ont encore quelque influence, les femmes vont donc se mettre à couper leurs ourlets et la plupart des hommes seront contents.

Ainsi, dans la journée, les femmes montreront leurs jambes jusqu'aux genoux. Et le

par Simone BARON

short, direz-vous ? A la veille des collections, il semblait impensable que ces messieurs de la haute couture y attachent une grande importance. Et pourtant, dans ce domaine, ils sont allés beaucoup plus loin que prévu et même ceux qui disaient, huit jours avant les présentations, qu'ils étaient « contre », ont ajouté discrètement un certain nombre de shorts dans leurs collections, de peur sans doute d'être dépassés.

Il règne d'ailleurs actuellement une grande confusion dans la haute couture et nous l'avons bien vu au cours de la semaine. Où s'arrête le style plage et où commence le vêtement de ville ? Bien malin qui pourrait l'affirmer. On dirait vraiment que les couturiers ne travaillent plus que pour les heures de loisirs. A regarder les tenues baroques et indécentes que certains ont osé présenter, on ne sait plus où l'on veut en venir : en s'encanaillant de la sorte, la grande couture perd beaucoup de son prestige. C'est si flagrant qu'un des siens et non des moindres, André Courrèges, a dit avec la plus grande simplicité :

— Après la disparition de Mlle Chanel, on n'a plus le droit de parler de la haute couture. Elle était de l'époque des Rolls, nous sommes de celle des Matra.

Et pour appuyer ses dires,

Dior : le rassurant tailleur en lainage blanc ou marine, épaules élargies, jupe droite et fendue.

Yves Saint-Laurent : la petite robe imprimée qui découvre les genoux, veston rouge à large carrure.

Courrèges a donné le nom de « prototypes » à ses recherches vestimentaires.

Tout cela a créé, autour des collections qui viennent d'être présentées cette semaine, un climat singulier dont il est bien difficile de dégager des intentions et des conseils utiles pour les femmes de la rue. Bornons-nous donc à retracer ici quelques indications essentielles.

LA SILHOUETTE. — On met des paddings dans les épaules des vestes et même dans les robes. La taille est indiquée à sa place par une ceinture, les jupes des tail-

leurs sont droites et celles des robes plissées ou froncées. C'est un peu la mode de 1945.

LE TAILLEUR. — Sachant parfaitement que le vrai tailleur est difficile à réussir, les grands couturiers en ont fait une vedette. Il est en lainage d'homme à long veston croisé et jupe fendue derrière. Sous le tailleur, une blouse chemisier sans manches unie ou imprimée.

LA ROBE. — Les imprimés, tous très beaux, constituent à eux seuls une telle attraction qu'ils donnent à la robe son chic de l'année. Deux formules : la robe chemisier, la robe floue à jupe froncée, souvent fendue sur un short.

LA ROBE. — Les imprimés, tous très beaux, constituent à eux seuls une telle attraction qu'ils donnent à la robe son chic de l'année. Deux formules : la robe chemisier, la robe floue à jupe froncée, souvent fendue sur un short.

LE SOIR. — C'est la liberté totale. Je vous indique que le fourreau imprimé, style cardigan à la cheville, a dominé les collections. Il a son short, naturellement.

LE SHORT. — Dior n'en a pas fait. Courrèges le traite comme il se doit, pour le sport seulement. Cette mini-culotte est, en général strictement assortie au tissu du vêtement.

LE MANTEAU. — Souvent long, c'est plutôt un imperméable en gabardine, shantung, flanelle, qu'un vrai manteau.

LES TISSUS ET LES COULEURS. — La flanelle, les peignés rayés, le tweed, le jersey sont en tête, avec les crêpes de Chine et le georgette. Les tissus imprimés sont soit à dessins « cravate », soit à larges traits géométriques et assez multicolores. Le marine est en tête du sombre, devant les tons doux : amande, rose thé, bleu dur, et tous les tons de sable chaud.

LES DETAILS. — Roses, colliers, pendantifs, ceintures de corde à motifs de métal, pointes-mouchoirs, chapeaux « Miss », gros sacs en ballon de rugby, bas chair, bijoux d'émail et sandales à hauts talons.

Trois collections m'ont laissé une grande impression : Chanel, parce qu'il était émouvant, après sa disparition, de venir regarder ses tailleurs, que vous avez tellement aimés, et dont je souhaite que vous les aimiez encore ; Courrèges, parce qu'il est le seul vraiment de notre époque et sans chichis ; Pierre Cardin, dont les ensembles pratiques et surtout les robes flous sont de la plus grande poésie et nullement rétrospectifs. Quant à Saint-Laurent, on ne peut mettre plus de talent au service d'une rétrospective de la mode 1945. Je pense qu'il s'agit pour lui d'une expérience, non d'une grande collection.

Simone Baron, "Les Femmes seront cet été . . . en 1945," *Le Journal du dimanche*, January 31, 1971

M.-A. Dabadie, "Saint Laurent: Une triste occupation," *Le Figaro*, January 30–31, 1971

Reportage de M.-A. DABADIE, V.-CH. GREYMOUR et H. de TURCKHEIM

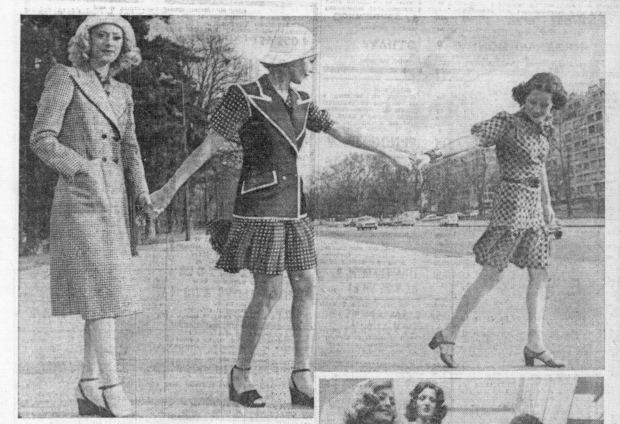

Ces photographies ont été prises, hier, 29 janvier 1971. Une précision qui s'imposait pour tous ceux qui croiraient que nous avons utilisé des archives de... guerre, pour illustrer la collection d'**Yves Saint-Laurent.** Un couturier qui a la nostalgie de cette époque... et l'excuse de ne pas l'avoir connue.

SAINT LAURENT :
une triste occupation

LA LIGNE

● **Tailleurs** : veston masculin croisé à double boutonnage éclairé parfois d'une ganse plus sombre sur jupe plissée. Tailleurs pantalon ou short en gabardine. Tailleur à veston sur robe crêpe imprimé.

● **Ensembles** : veste chasuble à padding arrondi renforçant la ligne des épaules avec des revers très larges en points, sur chemisier plissé.

● **Manteaux** : droits à double boutonnage ou simple avec revers longs et carrure bien soulignée.

● **Robes** : robes chemisier imprimées à ampleur s'évasant grâce à des plis ; robes soulignées à la taille par un corselet ; robes maillots, au buste et aux hanches serrées étroitement dans une sorte de tunique drapée d'où l'ampleur part en plis. Pour le soir, longues robes en mousseline volantée et tuniques aux dessins grecs.

● **Couleurs** : blanc, marine, beige, imprimés marbre mauve et noir, rouge et vert, bleu et marron.

● **Tissus** : gabardine, crêpe Georgette, crêpe de Chine, mousseline de jersey de soie.

« Qui est cette fille qui s'habille de « Puces » pour venir chez Saint Laurent ? », demandaient intrigués les journalistes étrangers devant une jeune personne en turban de velours rouge et plumes beiges, en trois-quarts de renard noir sur une courte robe plissée noire et des chaussures style promeneuse de la rue Saint-Denis dans les années 40.

Renseignements pris, Paloma Picasso, la fille du grand peintre, portait l'un des plus récents modèles de Saint Laurent lui-même.

Non loin de là, Marisa Berenson en béret basque, frisettes et fleurs dans les cheveux, avait dû, elle, puiser dans les vieilles toilettes de sa grand-mère Elsa Schiaparelli qui fut l'une des reines de la mode parisienne sous l'occupation. La tenue de gaucho marron de Bettina, l'ancien mannequin, avait du coup l'air toute « démodée ».

NOTRE OPINION

CETTE collection d'Yves Saint-Laurent, que l'on attendait avec une certaine curiosité, nous a déçu. Est-elle digne du talent de son auteur ? Je ne le pense pas. Je me pose donc la question. Pourquoi a-t-il choisi pour thème de sa création les années qui ont précédé la guerre et celles de l'occupation et qui ne sont pas parmi les plus réussies de l'histoire du costume ? Pourquoi ces épaules trop carrées, ces hanches drapées lourdement, ces violences dans les couleurs et ces chaussures à semelles compensées qui complètent la silhouette et achèvent de l'enlaidir ? Peut-être, qu'entraîné par les modèles avant-coureurs qu'il avait présentés la saison dernière, a-t-il été obligé de poursuivre son idée et affirmer ainsi son projet de rétablir la mode 40 ? Peut-être a-t-il pensé que la tête enturbannée, la taille serrée dans un corselet, la jupe froncée et courte plairaient aux jeunes et qu'elles en raffoleraient (cela pourrait bien arriver ? Peut-être après tout a-t-il voulu s'amuser et nous amuser et s'en servir comme d'un long gag ? De toute façon, Yves Saint-Laurent, qui a souvent fait preuve de goût, ne devrait pas faire cela à la mode. C'est une erreur. Une erreur que nous voudrions bien voir réparer dès la saison prochaine.

M. A. D.

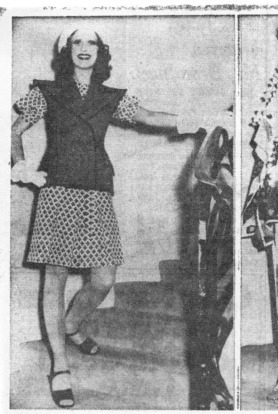

AMONG THE NEW *fashions unveiled by Yves Saint Laurent recently was this tailored suit, left, with a sleeveless jacket of red gabardine with padded shoulders. It is worn over a red and* white crepe de chine dress. Plat[shoes complete the ensemble. Bl and white silk-crepe fashion the Gre print wedding gown by Saint Lau (AP)

Sad reminder of Nazi days— French press attacks Yves

PARIS

Yves Saint-Laurent, once the man who could do no wrong of French fashion, was criticized for his new collection, called a sad reminder of the Nazi occupation.

Saint-Laurent dressed his models Friday in jackets with shoulder pads and high heeled platform shoes.

"SAINT-LAURENT took a particularly trying step backwards," the newspaper Paris Jour wrote, "This fashion doesn't have a good reputation for elegance. We thought at first these were the designer's usual gags, but the evidence was otherwise: these excesses were deliberate, sad and demoralizing."

The attack on Saint-Laurent was all the more unusual because French fashion writers generally just tell what they see and avoid extensive criticism of designers, considered a virtual part of the French patrimony.

The fashion expert of Le Figaro asked Saint-Laurent why he chose as a theme "the years that preceded the war and those of the occupation" which she said produced styles that made women ugly instead of beautiful. "It's a mistake," Le Figaro concluded.

LE MONDE guessed Saint-Laurent may have fallen victim to a string of 1940s movies shown endlessly on French television.

"He has lost all sense of proportion, indeed good taste, and if he's followed by the ready-to-wear industry, which has been following him for years, women will only be disgusted by a fashion which makes fun of them. It's an extremely dangerous game," said Le Monde.

France-Soir, the country's biggest circulating newspaper, was less harsh with Saint-Laurent, but also asked if he were joking.

There was at least a marginal explanation from the designer.

"I'm bored with gimmicks," Saint-Laurent told France-Soir. "There had to be a clean break."

—Associated Press

Saint Laurent's Scandal Is Stimulating to Designer

By ALINE MOSBY

PARIS, (UPI) — Yves Saint Laurent says the critics who called his World War II floozy look for spring the truly hideous fashion of the century are a pack of "petty . . . narrow-minded reactionaries."

To the wispy, bespectacled boy wonder of Paris, his critics just did not understand that his spring fashion collection of Jan. 28 had "a revolutionary spirit" that did not kill off high fashion as they said but "on the contrary, brought it out of a rut."

In an exclusive interview with UPI, the "enfant terrible" of high fashion broke his silence on the scandal he stirred up when his mannequins paraded like 1940 streetwalkers in football shoulders and tight dresses. One critic cried "hideous" and a U.S. news magazine renamed him "Yves St. Debacle."

"I DID not think in a profession as free as fashion that one could meet so many people so narrow-minded and reactionary, petty people paralyzed by taboos," said Saint Laurent.

"But I also am very stimulated by this scandal because I know that which shocks is new. And basically it was not the details that were important in my collection — the (Ginger Rogers) coiffures or platform-soled shoes — but the revolutionary spirit that upset people.

"It breaks traditional so-called good taste, and if one regards it with eyes used to a certain illusion of traditional good taste, it certainly can shock.

"FASHION IS the reflection of our time and if it does not express the atmosphere of its time it means nothing. My aim never was to shock or amuse. I made this collection in a spirit of gaiety and freedom to express what I thought to be our times.

"Haute couture is bogged down in a boring tradition of so-called good taste and refinement, and it has become a museum, a refuge for people who do not dare to look life in the face and who are reassured by tradition."

Saint Laurent admitted his puffed sleeves and striped mannish suits "perhaps did not please a certain press or American buyers. But it pleased youth and that is what counts for me. It pleased people who understand. One must try to make fashion interesting to youth and to people who make our epoch and not stay locked up in a tradition made for some people living in the 19th century. Certain buyers and journalists will be further shocked this spring when they see women wearing what they judged as 'hideous'."

THE DESIGNER added he did not want to compare himself to great artists, but he recalled that when Edouard Manet painted the nude portrait "Olympia" people cried scandal. And when Igor Stravinsky conducted the modern "Rites of Spring" listeners were revolted. It was just the same he said, when the directress of another fashion salon told him after viewing his collection she "felt insulted."

The bearded Saint Laurent insisted his tightly swathed hips and cutout bodices were not trollopy at all, but merely revived "a true female body."

"For years the eye was used to a boyish girl without breasts, waist or hips. I never thought the appearance of a true woman would provoke such a scandal," mused Saint Laurent.

ALTHOUGH critics complained Saint Laurent's World War II chubby fox coats and turbans reflected a ghastly fashion era, the designer defends the '40's styles as "very feminine. Very modern."

Did Saint Laurent and other couturiers stage an inglorious retreat by baring the knees again after putting women into midis and maxis last fall? To Saint Laurent "this hemline question is stupid." He insisted it was the new "spirit of fashion freedom" for any hemline "which is saving high fashion."

So is Paris high fashion dying as critics say?

"It is a laboratory and as such its future is assured. But it would be a mistake to try to keep it in its old golden frame, as a museum destined to dress only a few privileged women," Saint Laurent said.

"CERTANLY haute couture is no more as it was 30 or 50 years ago

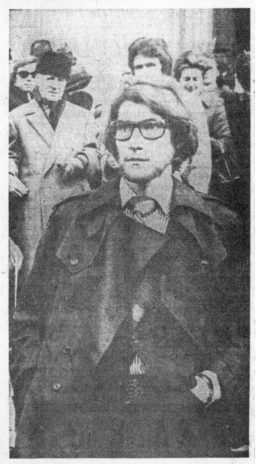

YVES SAINT LAURENT, *designer of the controversial '40s fashions, leaves the funeral for Gabrielle "Coco" Chanel in January. (UPI)*

but is the world the same? Fashion now is international. Ideas can be born everywhere, but I believe Paris will remain the marvelous catalyst. Paris is an old grandmother who still has a trick up her sleeve."

To critics who urged him to forget the '40's look, Saint Laurent announced his future collections will continue in the same spirit "because I know I am right." Furthermore, he added slyly, his new style undoubtedly will show up "in the collections of others."

Aline Mosby, "Sad Reminder of Nazi Days—French Press Attacks Yves," *Birmingham News*, February 1, 1971

Aline Mosby, "Saint Laurent's Scandal Is Stimulating to Designer," *Columbus Dispatch*, February 25, 1971

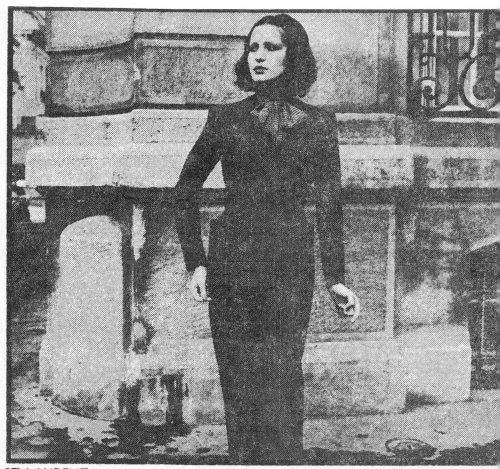

ST LAURENT : trouser suit in pin striped wool suiting ; navy and blue and whi

Long, court, transparent, enveloppé...

L'air de Paris

par Jean-Michel CASTEL

S AINT-LAURENT martyrisé, hué, moqué, s'est bien vengé de ses détracteurs par la réponse de la rue à sa proposition de revenir à la mode des années de guerre. On avait dit que cela ne marcherait pas, que c'était trop laid, que cette époque rappelait de trop mauvais souvenirs. Et voilà pourtant que les chaussures à semelles épaisses, les blazers descendant au ras des jambes, les chemisiers froufroutants, réapparaissent aux détours des avenues, portés par de frêles jeunes filles qui têtaient encore leur mère à l'époque des cartes d'alimentation.

Ce n'est pas la première fois qu'Yves Saint-Laurent calomnié par les professionnels de la mode, renverse la situation par le jugement de la rue. On lui avait déjà promis les pires déboires lorsqu'il avait présenté sa première collection maxi et c'est bien le public qui lui a donné raison en adoptant le long au-delà de ce qu'on pouvait espérer.

La couleuvre de la mode 44 était plus difficile à faire avaler. Mais Paris réagit en faveur de Saint-Laurent lentement, mais sûrement. Il n'est que les coiffures qui ont du mal à s'imposer. Les cheveux tirés vers le haut et découvrant les tempes et les oreilles ne fascinent pas la nouvelle génération.

En fait, comme pour toutes les modes, le couturier a donné une impulsion. Il reste à chaque femme d'adapter cette tendance à ses goûts et à sa façon de vivre, rejetant ce qui lui paraît trop anachronique ou aud

SUITE . PAGE 14

passage que les initiales font « U.S.A. ». Il s'agit, en effet, d'une série de sketches qui veulent dénoncer l'Amérique.

Le moins qu'on puisse dire, c'est que le sujet est un peu usé. On peut penser ce qu'on veut des Etats-Unis, mais cette insistance qu'ont certains intellectuels français à attaquer systématiquement les Américains et leurs travers, devient irritante.

Il y a assez de choses à dire sur ce qui ne va pas chez nous, pour qu'on n'ait pas ce besoin infantile de s'en prendre à un pays étranger dont on connaît par cœur les problè-

54

Saving the worst for last

ST LAURENT spared us nothing. His collection was a tour de force of bad taste. Good taste may be considered ghastly, but nothing could exceed the horror of this exercise in kitsch. When in his last collection he inserted four "Carmen Miranda" models in 1940 get-ups, some of us hoped he was joking. Alas, not so. They were a trailer; now we have the lot. I say again he spared us nothing. It was a travesty of the nineteen forties designed by a man who must see that sad period through malicious lenses. He has picked out every fashion feature of the time, and then distorted it . . . or, where there is not distortion, he has wilfully featured the aspects that were most unhappy. And underlined that. His model girls were made up with rouged cheeks, dark lips, heavy eye shadow; their hair was a mass of curls—blonde, or brazen red. They were young girls with makeup that made them look old, raddled, defiant. If Toulouse Lautrec had lived in the Paris of the Occupation, these are the girls he would have painted.

However, it is my duty to report the details, so herewith a summary in so far as one can summarise a collection that contained so many contradictions. First the consistencies: all through shoulders were exaggerated. They were built up, built out, extended with stiffened epaulettes; they were raised with padding, puffed up with gathering, underlined with broad lapels which reached out to the full width of the exaggerated shoulders. Jackets were doublebreasted, waisted but not belted, reaching far down over the hips. Often and often these jackets, which appeared to be made of men's suiting cloth, were inappropriately worn over printed crêpe de Chine dresses with skirts that were pleated all round from a low hipline. Sometimes the jackets were sleeveless, although tailored and lapelled in exactly the same way. The printed dresses underneath had little puff sleeves, V-necked; they usually covered the knee by two or three inches but occasionally were longer. Sometimes they stopped short of the knee. And sometimes they reached only a few inches below the jacket—in which case, they often turned out to be culottes. Shoes were heavy platform-soled strappy sandals, often with immensely high, straight heels—around about four inches.

Sometimes the jackets went with long trousers, occasionally with Bermuda-length shorts. For evening they were called "smokings," sometimes in velvet, sometimes in brilliant satin, sometimes embroidered in even more brilliantly flashy colours or sequins. The "smokings" went with shorts, and when unfastened they were worn next to the skin, no bra. Sometimes there was a little chiffon blouse which, nonchalantly draped, seemed to underline the nakedness. Sometimes there was just a little jersey maillot. There were also little dresses with great bunches of scarlet poppies in the bosom. Often there were bunches of poppies in the hair.

Of course, if one were not so stunned by the mixture of fabrics and artificial flowers, monkey fur and green ostrich, this and that—and always, it seemed, worse to come—it would be possible to pick out some wholly admirable clothes. Clothes that we may well see copied by an enthusiastic ready-to-wear trade; almost certainly we shall see the satin blazer short suits. There were also clothes that were so beautifully, unmistakably couture as to defy the copyist. And fortunately the collection finished with a beautiful group of Grecian evening dresses of crêpe de Chine in earthy colours printed with beautiful designs. But to my way of thinking, these were not enough to take away the taste of bad taste.

J. DAVID —

ompensé... rien ne nous sera rgné !...

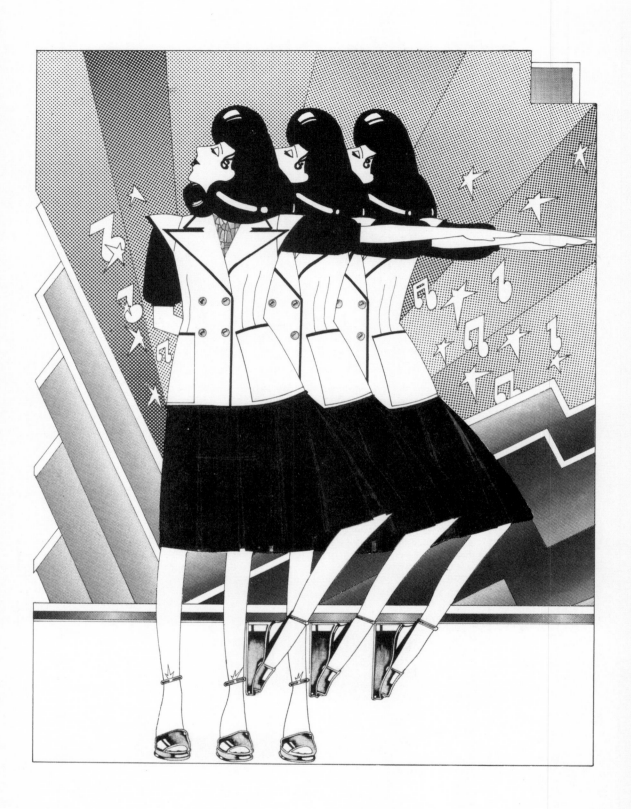

Illustration by Chris
Mac-Evan, published in
La Dépêche de la mode,
February 1971

Dominique Veillon
Research Supervisor, CNRS

FASHION IN THE 1940S

On the eve of World War II, Parisian haute couture was the undisputed arbiter of feminine fashion. Striking and luxurious, these designs were reserved for the enjoyment of a wealthy few. Haute couture was dominated by a handful of prominent names: Gabrielle "Coco" Chanel, Jeanne Lanvin, Jean Patou, Marcel Rochas, Robert Piguet, Lucien Lelong, and Maggy Rouff were among the most prestigious. They were joined by foreign-born designers who came to live in Paris, where they contributed to the rejuvenation of couture. They included Nina Ricci and Cristóbal Balenciaga, as well as Elsa Schiaparelli, who was widely recognized and admired for her extravagant tastes.

Fashion confronts harsh reality

Changing undercurrents in the domain of fashion were first felt during the uneasy months of the Phony War. Several famous houses closed, including those of Chanel and Madeleine Vionnet. Presentation of the 1939–40 winter collections was delayed so that they could be "updated" to reflect the current mood. Designers embraced restrained lines, and a utilitarian aesthetic dominated these collections. Women adopted shorter outfits with stiff shoulder pads, in marked contrast to the fluid lines of the 1930s. Military styles influenced tailoring, and neutral colors borrowed from uniforms (the Royal Air Force's blue-gray and the army's khaki) predominated. Even the names of the outfits reflected the era's mind-set. Jeanne Lanvin's trimmed, belted suit was called "Spahi."[1] Robert Piguet enjoyed considerable success with his "Service Secret," a suit with multiple pockets. The gown formerly

1. A soldier in a light cavalry regiment recruited predominantly from North Africa.

known as "Un Soir près de toi" [A night in your arms] was renamed "Permission." For fashion-conscious women who were forced to take refuge in air-raid shelters, Elsa Schiaparelli, who never lacked ideas, concocted a very special outfit. It consisted of a wool jumpsuit inspired by an aviator's uniform, to which she added a belt that accommodated a flashlight and a little bag to contain that indispensable accessory, the gas mask. The military cut of these garments owed much to current circumstances. Other influences also made themselves felt—the use of Scottish woolens in honor of the Allies, for example. Milliners found that a Scottish wool beret was a fresh look that invited additional stylistic innovations.[2] These included the glengarry, a cap worn by Scottish soldiers, and the fez, a tall hat of red fabric worn by Zouaves and Senegalese riflemen. Aviator helmets were also an inspiration. Demonstrating patriotic fervor, the triumvirate of red, white, and blue—a tribute to the French tricolor—appeared in many designs.[3] To accessorize these looks, Hermès offered the "Petits Soldats" scarf with its ranks of little Zouave soldiers. Trimmings flaunted the red, white, and blue, while jewelry designs featured soldiers from all the armed forces.

Defeat takes its toll on fashion

The defeat and subsequent German Occupation in the summer of 1940 altered circumstances radically. Immediately following the armistice, new political and economic structures upended private life, imposing radical measures that had a major impact on fashion. One of the Occupation's primary consequences was the country's rapid descent from abundance to scarcity. Within just a few months France was deprived of its foreign imports (including wool, silk, and cotton). The demarcation line that separated the Occupied Zone from Vichy France caused supply difficulties. Paris no longer received textiles from northern France or the Vosges. Furthermore, there was a severe lack of skilled labor on account of the vast number of workers who were being held in Germany as prisoners of war.[4] Due to the process of Aryanization, Jewish artisans adept in the production of accessories were excluded from any workforce participation.[5] Finally, under the terms of the armistice, the Germans were entitled to deliveries of leather and wool, and they did not hesitate to enforce these demands. Living conditions deteriorated radically. Fashion was not exempt from the occupier's heavy hand or the constraints of the Vichy regime. The authorities implemented pettifogging legislation, inflicting ceaseless frustrations on couturiers, shoemakers, and milliners. They were forced to constantly adapt to new circumstances, testing the limits of their imaginations.

The first collection presented under the Occupation was hailed by a critic who admired its innovations. "It is entirely conceived for the new Parisian way of life: Comfort, walking, and severe cold are all provided for, but elegance remains,"[6] claimed an article in *L'Œuvre*. Pragmatically adapted to current conditions, the designs consisted primarily of tailored suits, practical afternoon dresses, and comfortable coats. Throughout the war years, designers responded to the exigencies of their clientele's new way of life. Bicycles were the sole means of transport

2. See "L'Écossais est à la mode," *Plaisir de France*, October 1939. Note that the Scottish theme was very popular throughout the war years.
3. The tricolor was a constant presence during the years of the Occupation. It was theoretically banned in the fall of 1941, but that did not prevent its use in scarves, buttons, etc.
4. There were close to one million prisoners.
5. On October 18, 1940, Jewish tradesmen were placed under the authority of a provisional administrator as a preliminary phase of Aryanization. More than 80 percent of the businesses determined to be Jewish-owned and affected by the Aryanization process were very small entities, mostly in Paris. Two-thirds of these were engaged in textile and leather work.
6. *L'Œuvre*, November 4, 1940.

available to many fashionable women.[7] Their usage popularized culottes, which the fashion authorities frowned upon for city wear.[8] That posed no problem: Thanks to an ingenious system of zippers or snaps, the offending garment could be transformed into a conventional skirt as soon as the cyclist dismounted. The short-skirted, broad-shouldered suit was widely adopted for its functional merits, but that practicality did not deter designers from making boldly architectural cuts a focal point of their designs. Some of their innovations still astound, including the leisure garments that replaced negligees and other airy attire in favor of very comfortable outfits with evocative names. Among Nina Ricci's offerings was the "Veillée," consisting of black jersey pants worn with a snug pink velvet jacket—as good a method as any for fighting the cold in unheated apartments. Madame Leroy, who headed the furriers Max, vanquished the chill in her home with ingenious solutions that were a response to nonfunctioning furnaces. Her designs included "Salamandre," a long at-home garment lined with mink, and "Mirus," a short fitted jacket in pale green or mauve that warmed the wearer with guanaco fur. The struggle against pervasive cold recurred as a leitmotif in many presentations each winter, compelling couturiers to seek out new solutions. Bruyère was hailed for her winter offerings in 1941: red dresses made from jersey and angora that she called "Robes thermiques." Nina Ricci demonstrated exceptional practicality and inventiveness. For women obliged to wend their way along icy streets, she ingeniously designed jersey gaiters to go with any outfit. Offered in fine wool jersey, "they surprise with their cut and comfort," ads claimed, and they could be matched with the beige, gray, or brown tones of dresses and coats.

Fashion design also had to reckon with fundamental constraints. In the face of shortages and lack of basic materials, strict regulations limited the production and sale of textile and leather products. Beginning in the spring of 1941 for shoes and July 1941 for textiles, the French population was subjected to a regime of tickets and ration cards. Haute couture was not spared these deprivations.[9] Without traditional fabrics to make up their fashions, designers resorted to new textiles that could be mistaken for woolens, jerseys, satins, and crêpes of all kinds,[10] although they were really ersatz substances such as rayon. Dresses became shorter; skirts were narrowed by deft cuts and darts; carefully draped fabrics flattered the hips; skillful gathering provided some fullness in the front or on the sides, allowing for pockets and goring. Complemented by platform shoes and bold accessories, this was the look of the fashionable woman in the 1940s.

Shoemakers and milliners defy scarcity

Wooden soles[11] appeared in the spring of 1941 to address the unavailability of leather. Heyraud, one of the first firms to use them, emphasized the novel designs of its new shoes that featured light soles mounted on a thin wooden base. Among the styles displayed was the "Gitane" sandal, fashioned from lacquered wood, with antinoise and antiskid features. A number of chic shoemakers were successful in introducing platform soles made of cork. Others, including Perugia, used a compound resembling

7. A prize for bicycle elegance was awarded in July 1941 in the Pavillon d'Armenonville.
8. Wearing pants was not permitted.
9. Some couturiers allowed clients to bring their own fabric ration cards.
10. "Today's fashions are a guessing game. Women wear gorgeous jackets, soft to the eye and touch, that seem to be made from angora, but aren't. You might think they're fur, but that's not the case either. . . . They're substitutes." *Le Figaro*, October 9, 1941.
11. A French group utilized a German patent: the Zierold sole, known under the French name Smelflex, was made of plywood sawed in a zigzag pattern for greater flexibility.

leather "that eliminates the clatter made by wooden soles, which is not always pleasant to the ear."[12] Hellestern, the fashionable shoemaker on the Place Vendôme, offered its clientele a very popular style—gaitered boots in kid and felt, with wooden soles. That summer, Perugia was the first to introduce open sandals made from raffia and flip-flops with platform soles to accompany warm-weather outfits.

Initially milliners were fairly restrained. The hats shown in the fall of 1940 had a utilitarian look. Toques and turbans hugged the head and provided much-needed protection from the cold. These styles gained rapid acceptance and soon replaced the rakishly perched little caps that had been so popular before the war. Hoods were soon included among the offerings, and they took many forms. Jean Patou's hood designs were the biggest hits, fashioned from cashmere in glowing colors. In these hard times, headgear was the last refuge for flights of fancy, and women were eager buyers. Milliners made use of every kind of unrationed material: tulle, veils, feathers, and flowers served as the basis for extraordinary creations. Between 1941 and 1944, hats progressed from one extreme to another. They started out tiny, decorated with flowers and fruits to suggest the "return to nature" so devoutly desired by the Vichy leader Marshal Pétain; they soon progressed to menacing heights and featured extravagant trimmings: velvet, lace—anything would do. Faced with German restrictions curtailing the range of available fabrics, milliners responded to the challenge. The first to rise to the occasion was Madame Agnès, who boldly took the lead and employed materials far removed from their customary applications. In the absence of straw, silk, and felt, she collaborated with Jacques Dunand, a lacquer artisan who gave her wood shavings that she fashioned into very attractive styles. She also created delightful hats from cotton wool and used raw wool webbing in her designs. Madame Albouy threw herself into making striking hats from newsprint, and Rose Valois offered her clients enchanting creations in pale blue, pink, and yellow trimmed with little black veils. Imagine her clients' surprise when they learned that she had fashioned these confections from blotting paper!

Accessories and ingenuity

Artisans working in the realm of accessories were obliged to submit to the new regulations, and they took the opportunity to demonstrate their ingenuity. Leatherworkers initiated a fashion for narrow belts and freely repurposed materials, heedless of their intended usage. Hermès replaced leather with metal and offered a twisted chain to be worn with a dress or sweater. Elsa Schiaparelli used "dog chains to fasten first suits and then dresses."[13] In a mischievous allusion to scarcity, a black suede belt bears the word "rutabaga"—a vegetable that was generally loathed at the time. And a model designed for a slender waist is inscribed "Encore un cran" (I still have guts). Handbags faced similar restrictions. Beginning in 1941, leather was no longer allowed in their fabrication, and cloth knapsacks became all the rage. Shopping bags made from polished "leather," felt, passementerie, and even snakeskin were in vogue. Prominent couture houses used lizard

12. *Images de France*, March 30, 1941.
13. Elsa Schiaparelli, *Shocking: Souvenirs d'Elsa Schiaparelli* (Paris: Denoël, 1954), pp. 134–35; published in English as *Shocking Life: The Autobiography of Elsa Schiaparelli* (London: J. M. Dent & Sons, 1954).

and crocodile, both very fashionable, to respond to strong demand from well-off customers who could pay high prices. Tapestry was commonly used by all producers beginning in 1942–43, launching a period of substitution and repurposing. Duvelleroy cut bags from cashmere shawls, and Jeanne Lanvin, who always had a trick up her sleeve, found a new use for suspenders: She converted them into shoulder straps to liven up a handbag.

Scarves featured patriotic or rustic subjects inspired by Marshal Pétain's Vichy ideology. Sometimes humor—and even nostalgia—are in evidence. The square scarf "À la gloire de la cuisine française" (To the glory of French cuisine) was worn defiantly in a country that was ravaged by hunger, and Jeanne Lanvin's scarf bearing the words "Liberté, Liberté chérie" was flaunted in the midst of the Occupation.

Contemporary events also affected jewelers. In the spring of 1941, many of the great jewelry firms drew upon the theme of the return to nature in designing their brooches; some featured dainty peasant women with emerald watering cans. Bicycles sporting sapphire wheels and silver sugar boxes evoked their own images of scarcity. Reine Bailly introduced a pocket-size sugar container, a little box inscribed "Une chaumière, un cœur . . . et un sucre" (A cozy cottage, a warm heart . . . and a lump of sugar). Cartier produced a golden cage imprisoning a captive bird that was fashioned from multicolored precious stones, symbolizing the French defeat. But tiny charms evoked the tricolor and formed the letter V; sometimes "Vive la France" was actually spelled out.

With the end of this global conflict, an era came to a close. Gone were the fashions of the war years where eccentricity, sometimes combined with questionable taste, went hand in hand with indefatigable creativity. When the Liberation came, women longed for something new. They were weary of belted jackets, padded shoulders, and platform heels. The uniform of the Occupation years was now unanimously rejected, for many reasons. Some women were reminded of an unsavory past associated with Nazi collaboration and black market activities. Others yearned to put behind them a period that was remembered as a bleak pageant of suffering and death. When Christian Dior presented his eagerly awaited collection in February 1947, a new era dawned, and a radically different interpretation of femininity triumphed. Sweeping gowns, full skirts, and narrow waistlines fulfilled the longings of most women as they welcomed a new era.

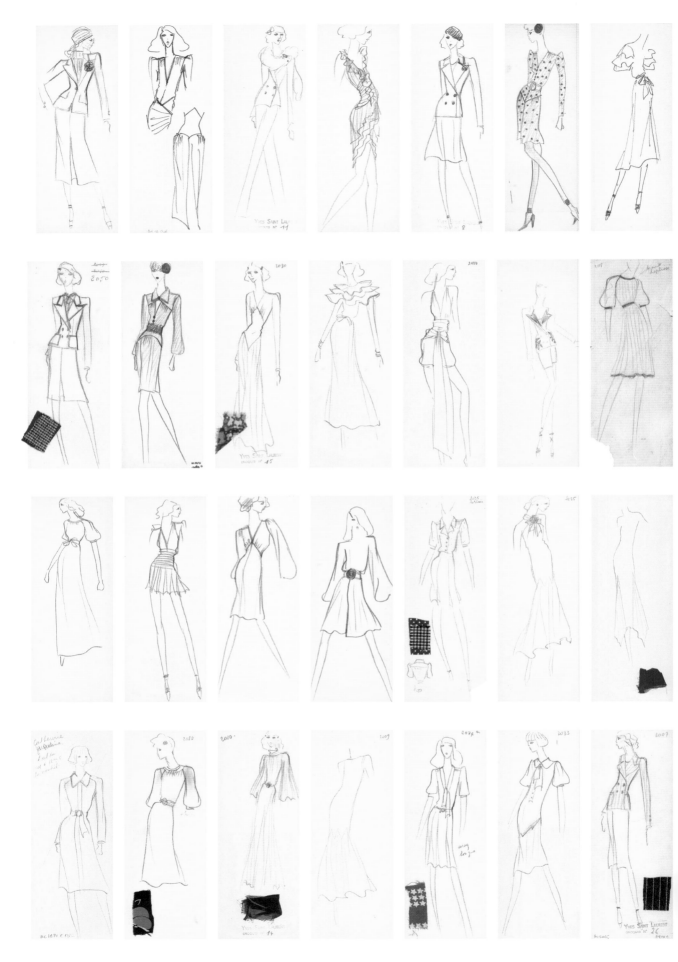

Fifty-six rejected sketches, of which seventeen are
with pinned fabric samples

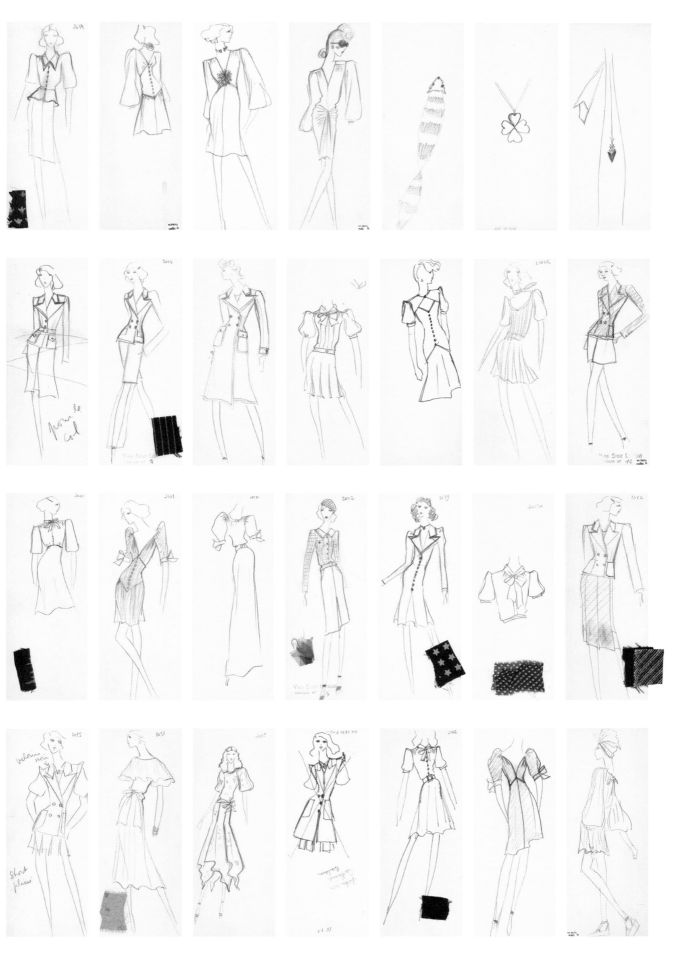

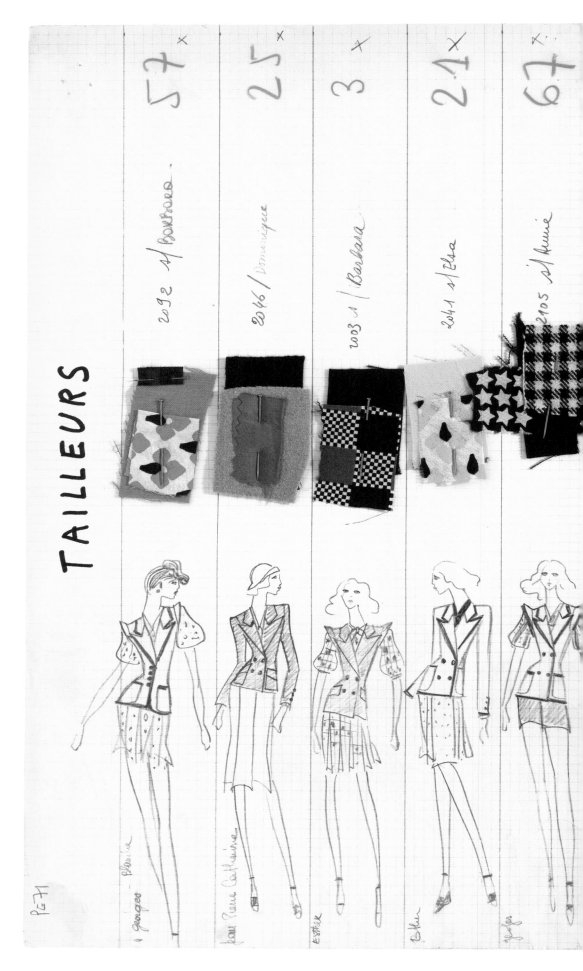

TAILLEURS

57 ×
2092 s/ Barbara
Georges - Blanche

25 ×
2046 / Dominique
pour Pierre Catherine

3 ×
1003 s / Barbara
Esther

21 ×
2041 s/ Elsa
Bleu

67 ×
2105 s/ Anne

PE 71

44 x
72 x
26 x
30 x
49 x
42 x

2074 / Jacqueline

2112 1 / Elsa

2347 / Barbara

2054 1 / Barbara

2089 1 / Jacqueline

2070 0 / Marie-Thérèse

Jean-Pierre

Jean-Pierre Blan

Ellen

Georges / Esther

65

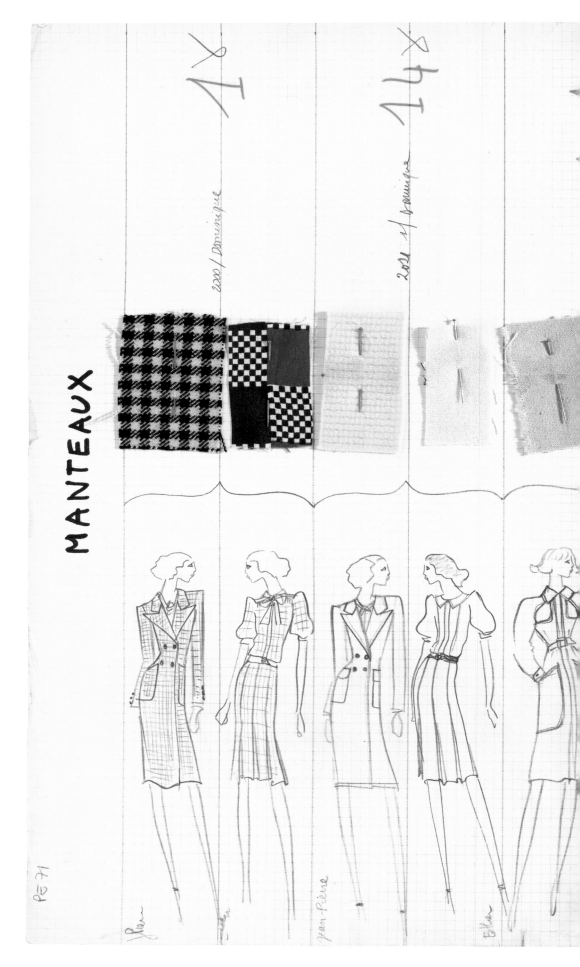

MANTEAUX

2200 / Dominique

2021 1 Dominique

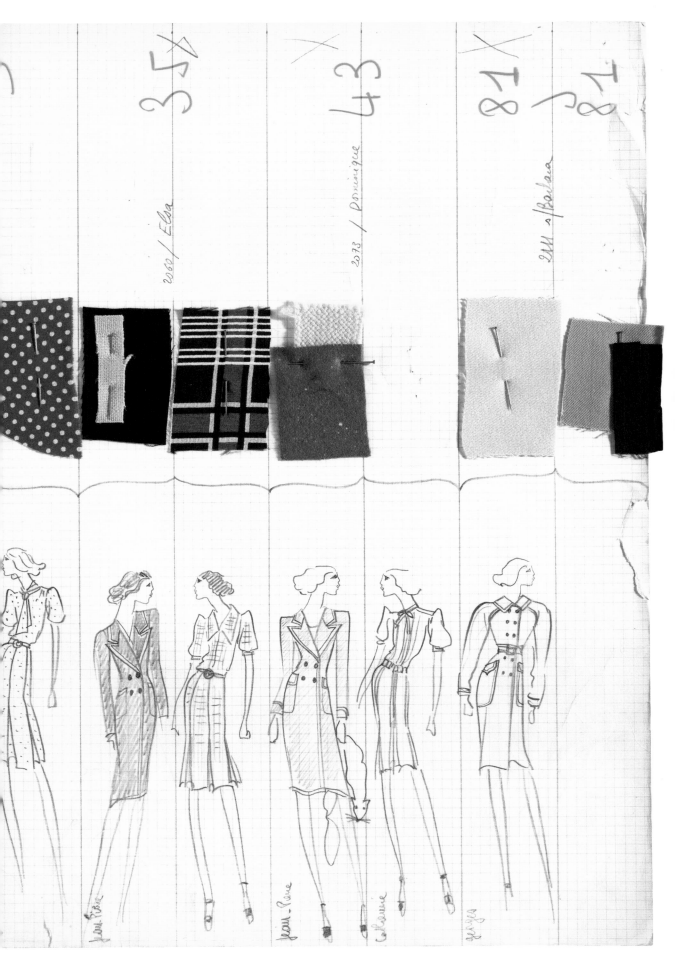

35 57

2060 / Elsa

43

2573 / Dominique

81

81

2111 / Barbara

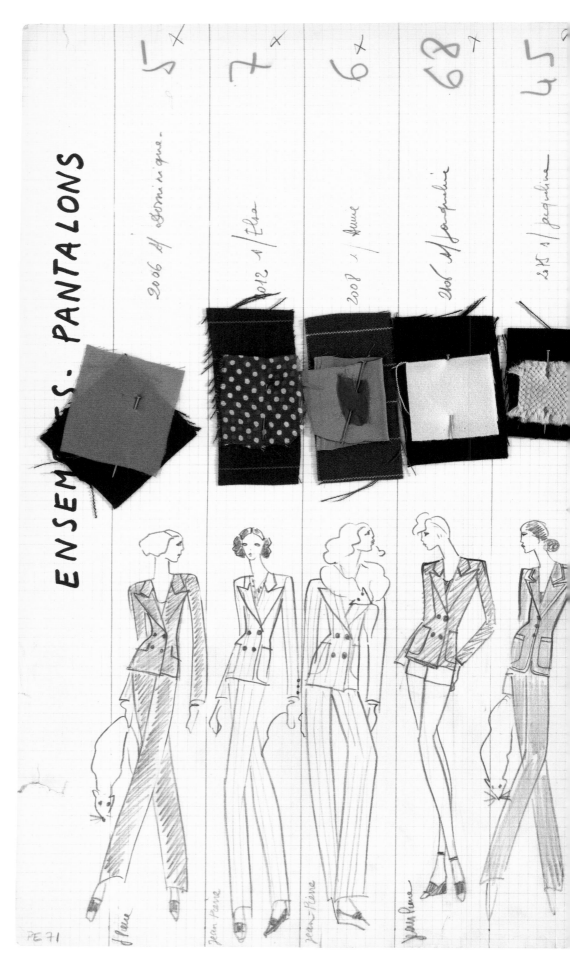

ENSEM S. PANTALONS

5 x
7 x
6 +
68 +
45 ?

2006 A/ Dominique.

2012 A/ Flo

2008 A/ Anne

2006 A/ Jacqueline

2 XS A/ Jacqueline

Pierre
Jean-Pierre
Jean-Pierre
Jean Pierre

PE 71

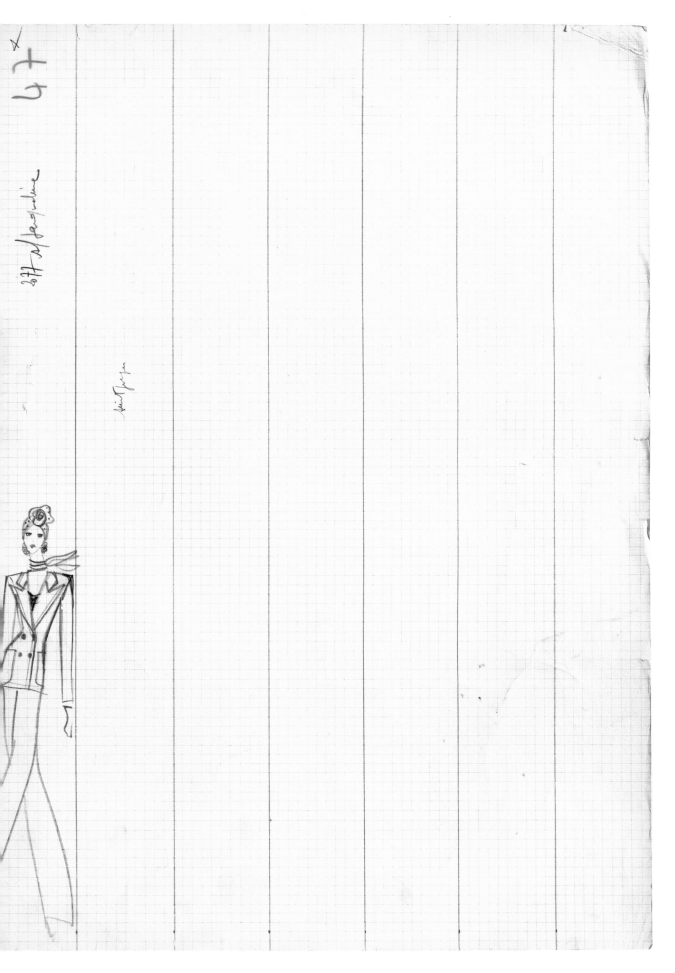

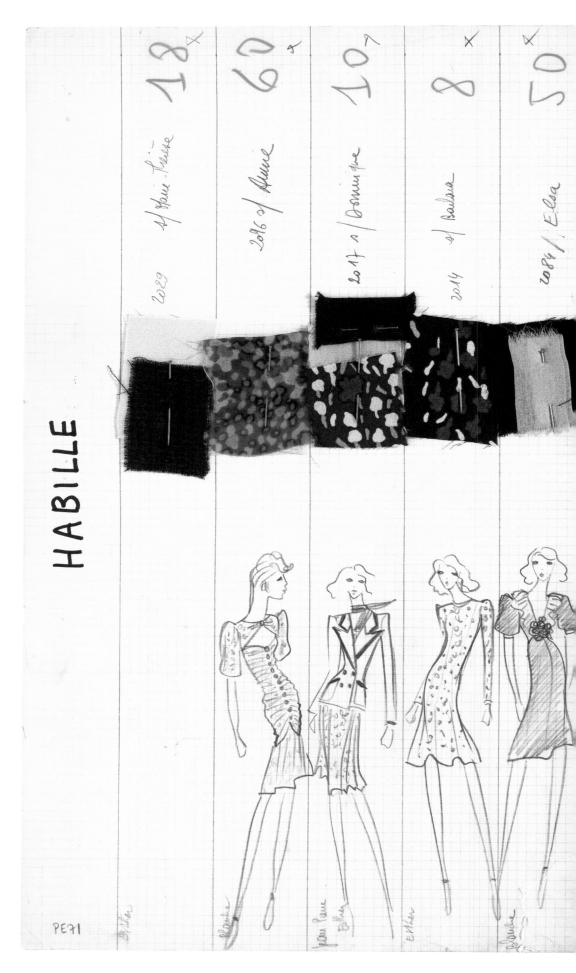

HABILLE

18 x

6 x

107 x

8 x

50 x

2029 2/ Marie-Pierre

2096 2/ Anne

2017 2/ Dominique

2014 2/ Barbara

2084 1/ Elsa

PE71

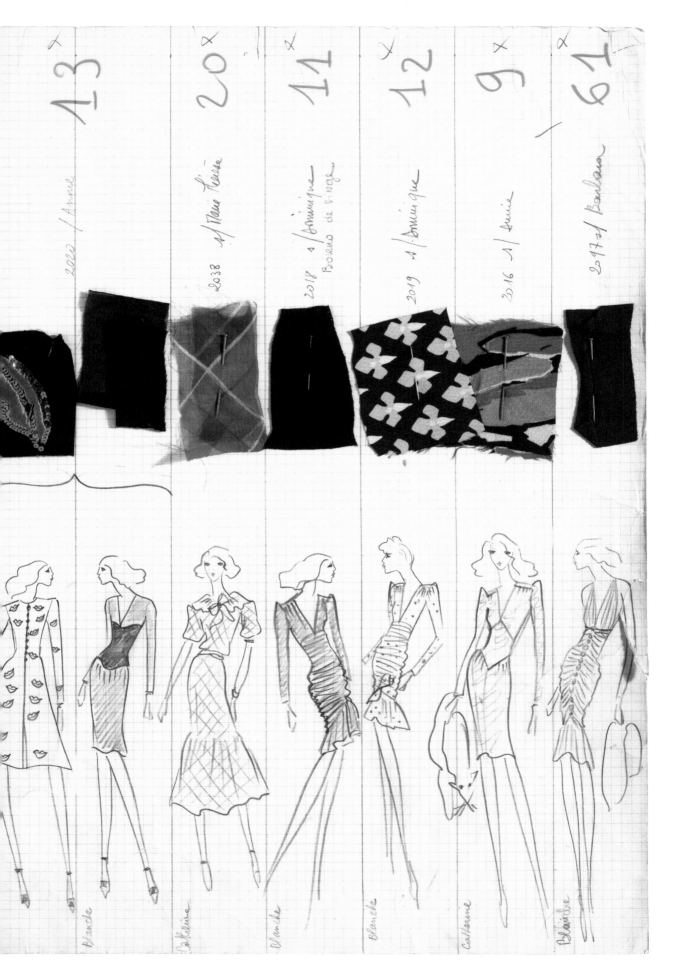

13^x 20^x 11^x 12^x 9^x 61^x

2022 / Anne

2038 s/Marie Pierre

2018 s/Amérique
Boléro de S.Noël

2019 s/Dominique

2016 s/Annie

2017/ Barbara

Blanche Catherine Blanche Blanche Catherine Blanche

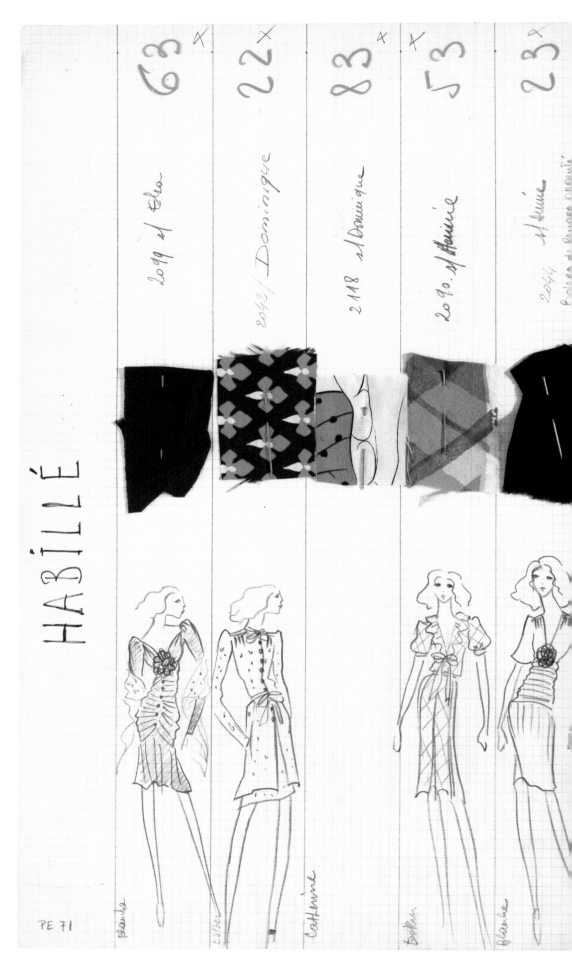

HABILLÉ

63 ×
22 ×
83 ×
53
23 ×

2099 s/ Elsa
2042 / Dominique
2118 s/ Dominique
2090 s/ Maxime
2044 s/ Maxime
Robes de Dames chantés

Blanche
Esther
Catherine
Esther
Blanche

PE 71

Collection board "FORMAL WEAR"

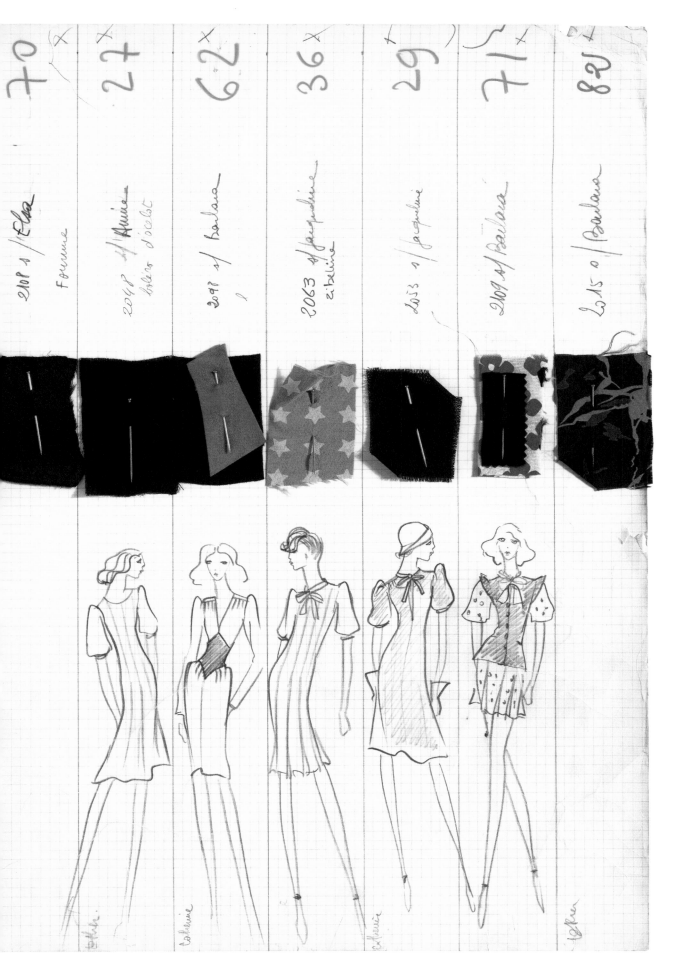

70 ×

27 ×

62 ×

36 ×

29 ×

71 ×

82 ×

2108 s/ Elsa
Femme

2048 s/ Annie
boléro d'oober

2098 s/ barbara

2063 s/ Jacqueline
zibeline

2053 s/ Jacqueline

2109 s/ barbara

2115 s/ barbara

73

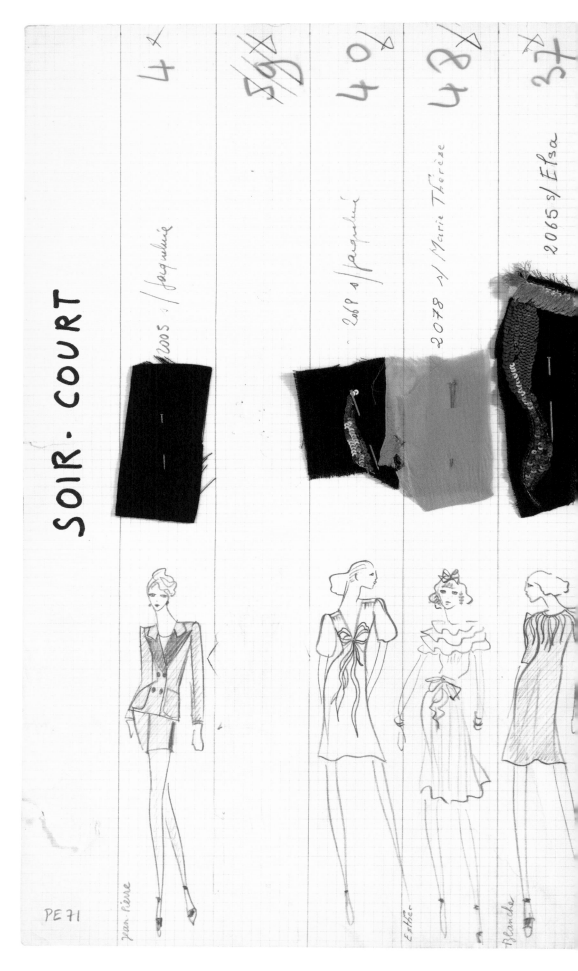

SOIR - COURT

4

59

40

48

37

2005 s/ Jacqueline

206 P s/ Jacqueline

2078 s/ Marie Thérèse

2065 s/ Elsa

PE 71

Jean Pierre

Esther

Blanche

Collection board "SHORT EVENING WEAR"

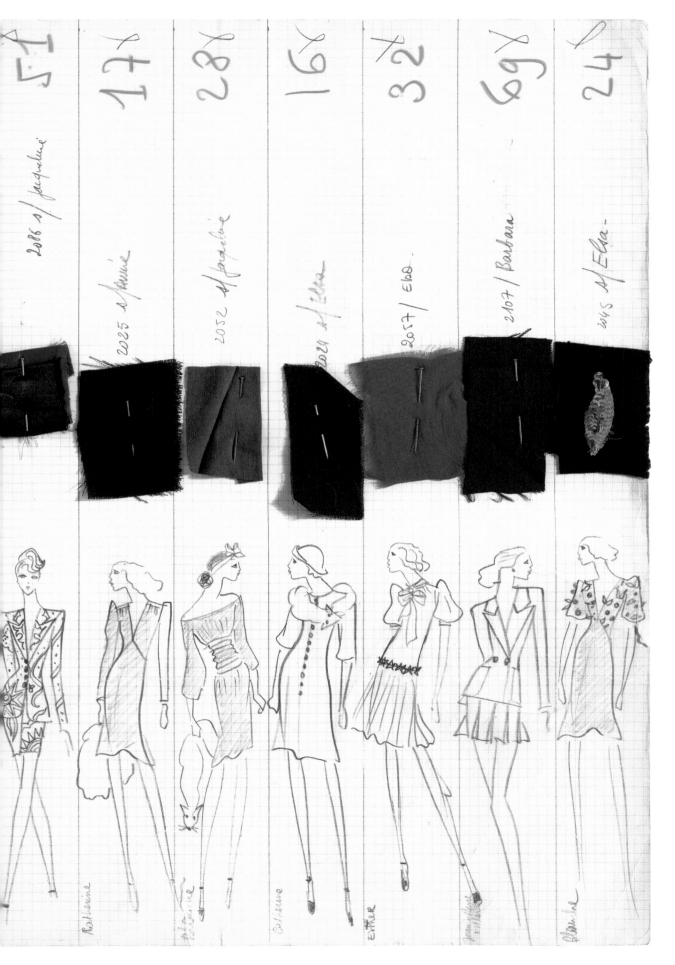

51 171 281 16 32 69 24

2086 s/ Jacqueline

2025 s/Anne

2052 s/ Jacqueline

2024 s/ Elsa

2057 / Elsa

2107 / Barbara

2045 s/ Elsa

Catherine

Catherine

Catherine

Esther

Blanche

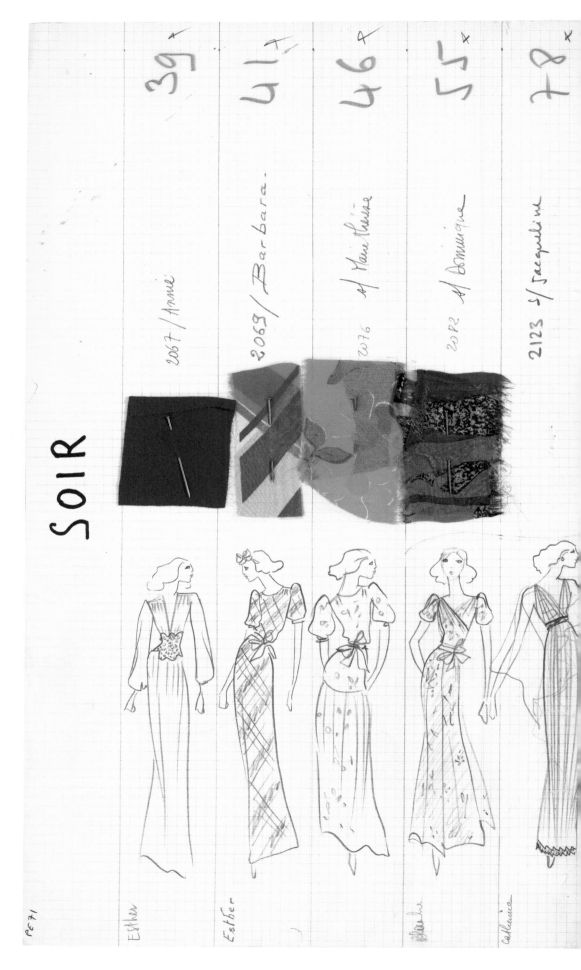

SOIR

39*

41*

46*

55*

78*

2067 / Anne

2069 / Barbara.

2076 s/ Marie Thérèse

2072 s/ Dominique

2123 s/ Jacqueline

PE71

Esther

Esther

Claire

Catherine

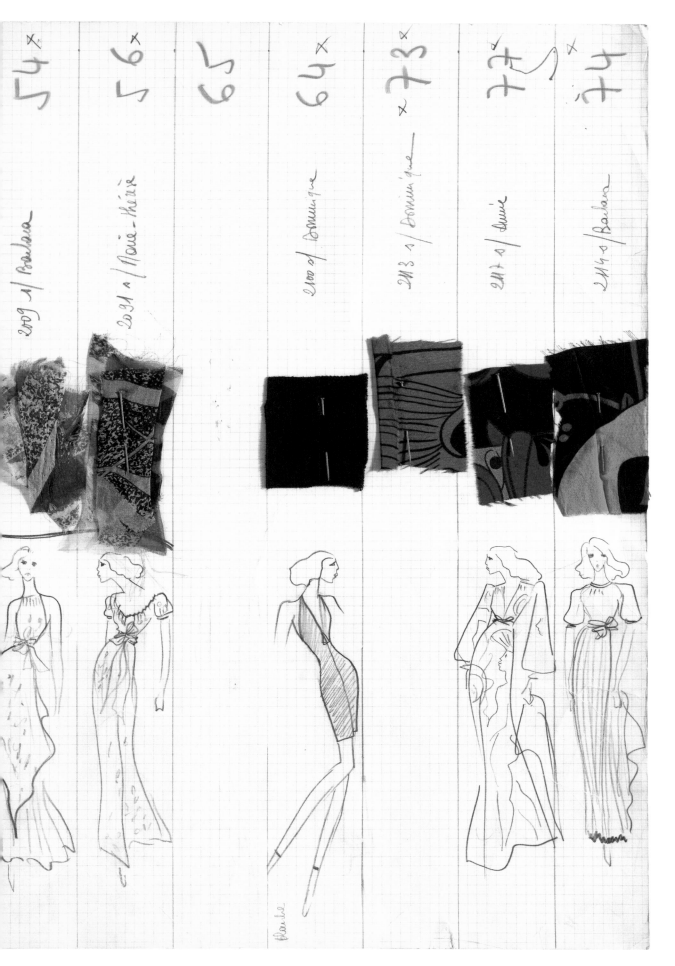

54

56

65

64

73

77

74

2109 s/ Barbara

2091 s/ Marie-Thérèse

2100 s/ Dominique

2113 s/ Dominique

2117 s/ Annie

2114 s/ Barbara

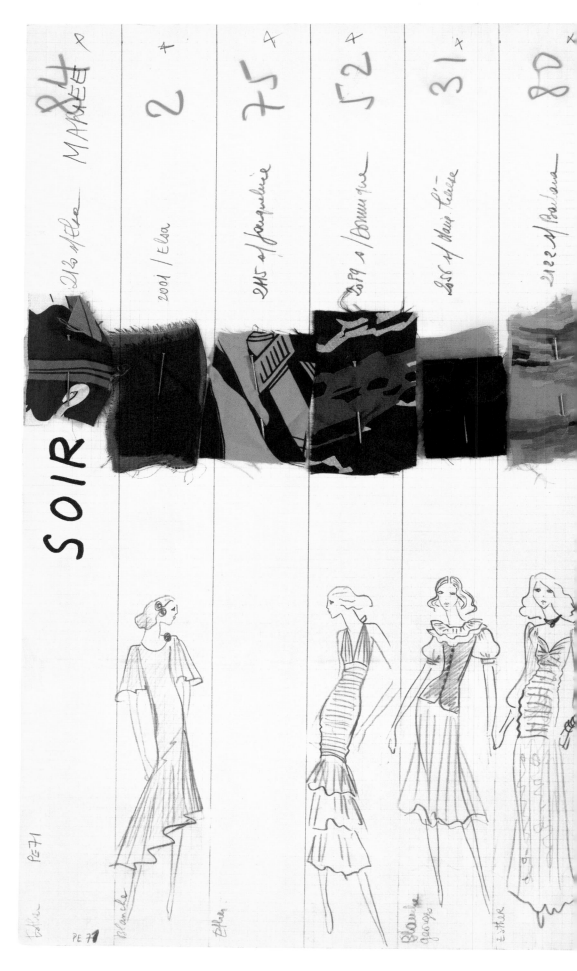

SOIR

84 MAREE x

212 s/Elsa

2 x

2001 / Elsa

75 x

2145 s/Jacqueline

52 x

2089 s/Bernardine

31 x

206 s/Marie Thérèse

80 x

2122 s/Poulaine

PE71

Esther PE71

PE 71

Blanche

Elsa

Blanche
90%/10%

ESTHER

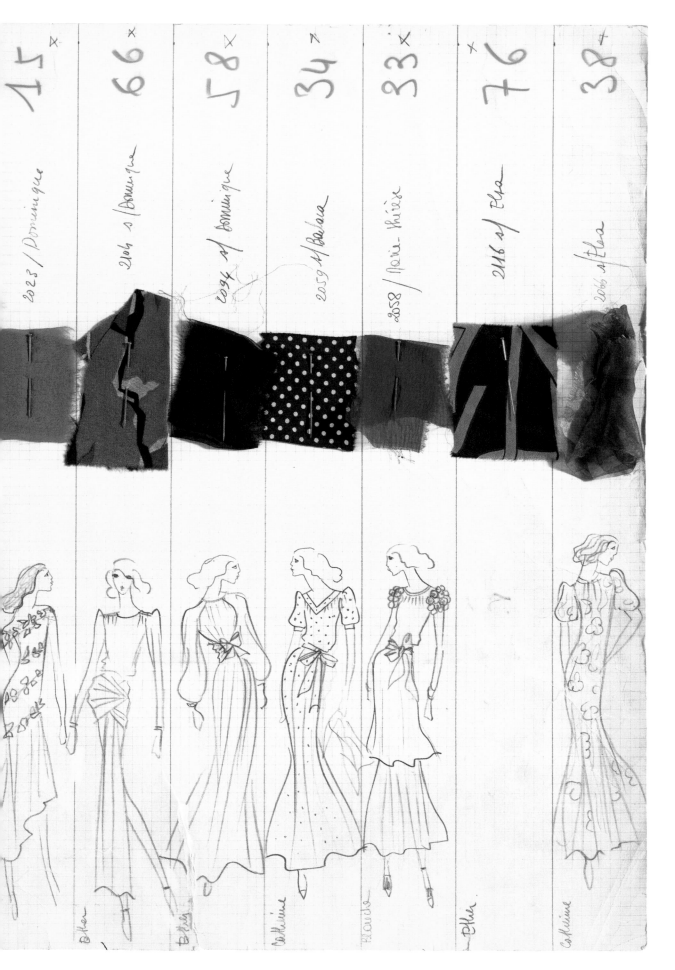

15_x 66_x 58_x 34 33_x 76 38

The Fondation Pierre Bergé–Yves Saint Laurent collection comprises several thousand haute couture outfits together with their accessories, and its graphic arts, photography, and audiovisual collections include tens of thousands of references.

In addition to these archives, there are records from the ateliers, storage facilities, and press services, in which are carefully filed all relevant articles written by French and international journalists.

This extraordinary historical resource allows visitors to trace the creative process for each of the 8,283 haute couture models created by Yves Saint Laurent for his eighty-one collections, providing a comprehensive account of forty years of design.

The *Yves Saint Laurent 1971, la collection du scandale* exhibition and catalog are intended to re-create Yves Saint Laurent's 1971 Spring–Summer collection from the moment the first model set foot on the runway to the eighty-fourth look that concluded the show. The comprehensiveness of the Fondation Pierre Bergé–Yves Saint Laurent archives allows all these styles to be viewed, even if the actual completed garment is not included in its collection.

Each of the show's models is represented by the garment itself, or, in its absence, by one or more documentary records. These may include the original sketch (*croquis original**), the atelier's specification sheet (*fiche d'atelier**), the original print for patterned fabrics (*empreinte originale pour impression sur étoffe**), a fabric swatch, an accessory, a variation on a model customized for an individual client, fashion show photographs (*photographie de défilé**), or photographs from the show's press kit (*photographie de dossier de presse**) or from the International Wool Secretariat.

The terminology used in these documents corresponds to the original usage of the couture house. Terms followed by an asterisk are defined in the Glossary.

Models or furs corresponding to numbers 79, 83, 85, 89, 92, and 93, for which no documentation has been found, have been omitted. Fur coat number 91 is presented with look number 11.

All the photographs are from the Fondation Pierre Bergé–Yves Saint Laurent collection, except for number 5 (Palais Galliera–Musée de la Mode de la Ville de Paris, inv. GAL1977.9.5) and number 26 (Collection Anouschka).

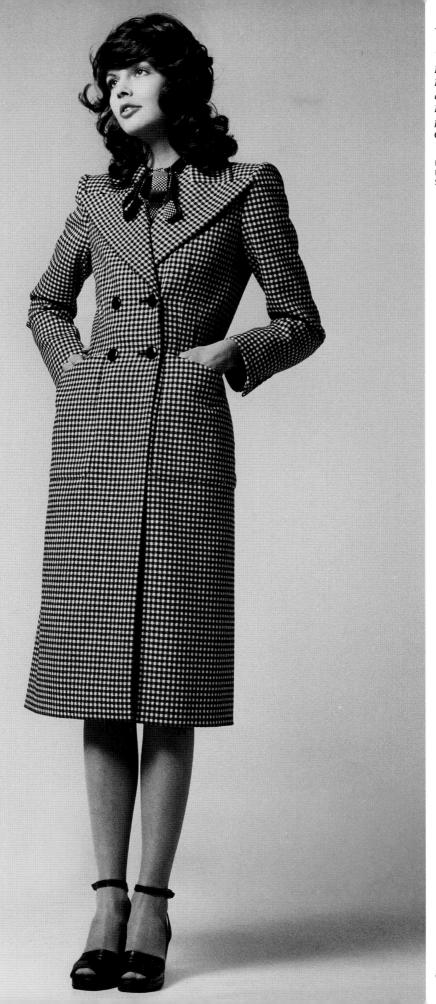

Daytime ensemble. Black and white checked woolen coat. Blue and brown printed crêpe de Chine dress.

Photograph from the International Wool Secretariat

2001

2032
avec une
Berthe
sur Elsa

YVES SAINT LAURENT
CROQUIS N° 24

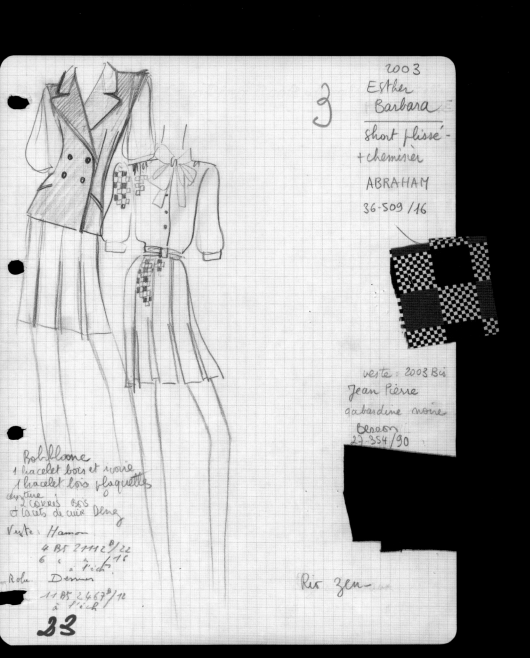

Suit. Sleeveless black serge jacket. Brown and black printed crêpe de Chine dress.

Atelier's specification sheet

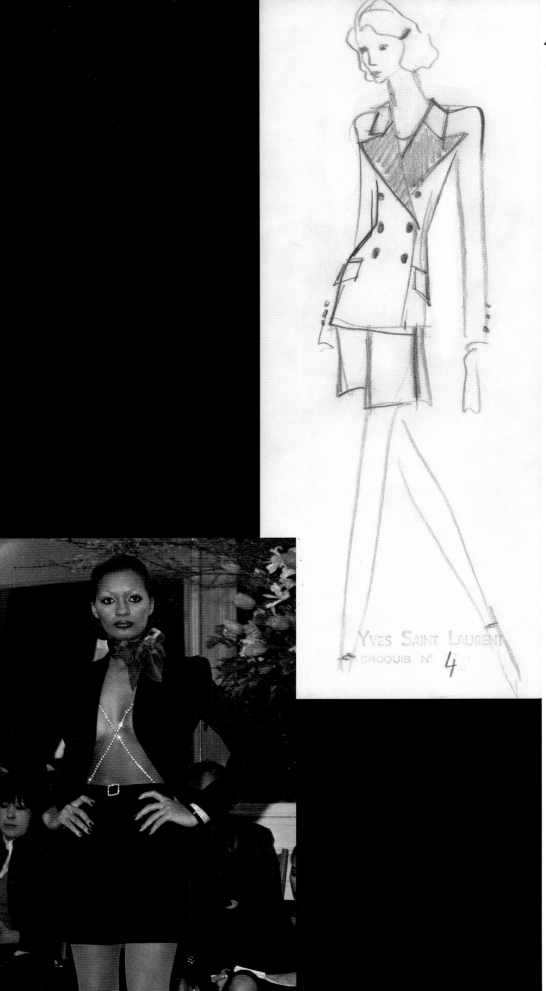

4

Tuxedo in black wool.

Original sketch
Fashion show photograph

YVES SAINT LAURENT
CROQUIS N° 4

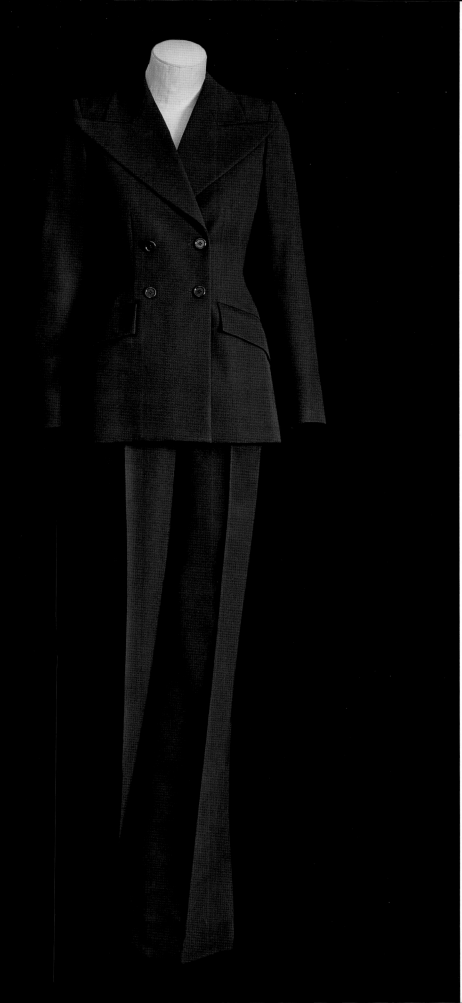

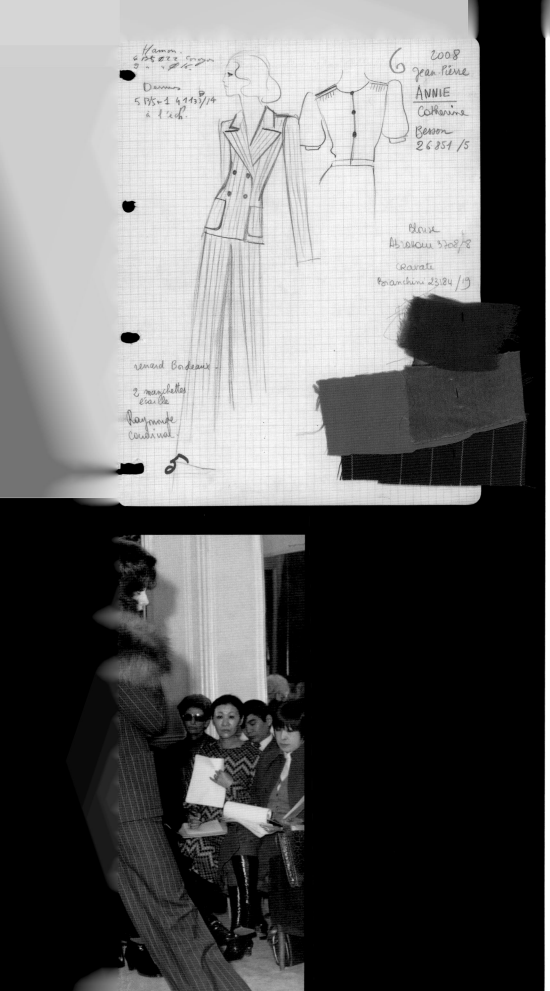

Russet and beige
pinstriped serge
pantsuit. Green
satin blouse.

Atelier's specification sheet
Fashion show photograph

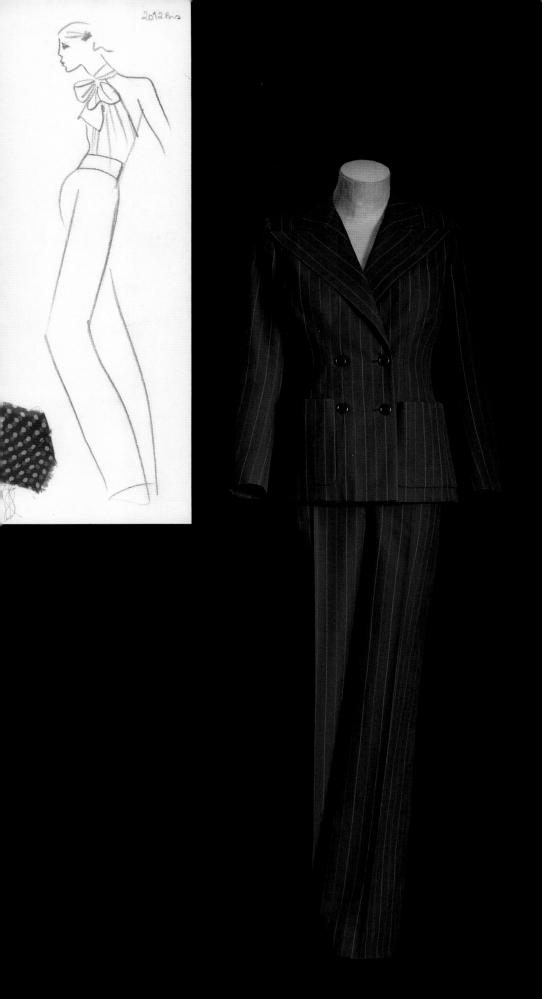

Navy and burgundy
pinstriped serge
pantsuit. Burgundy
chiffon blouse with
white polka dots.

Original sketch

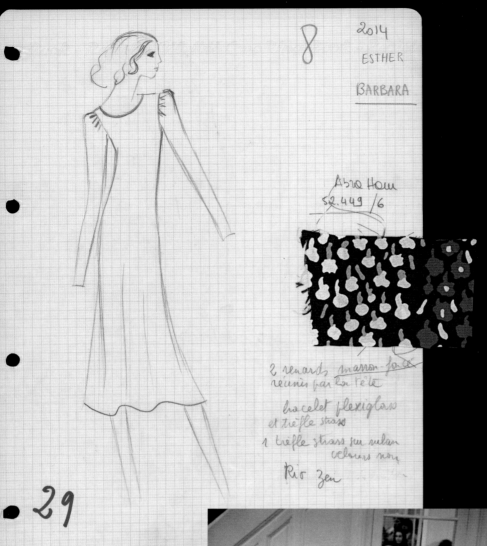

2014
ESTHER
BARBARA

8

Abra Hom
52.449/6

2 renards marron-foncé
réunis par la tête

bracelet plexiglass
et trèfle strass
1 trèfle strass sur ruban
velours noir

Rio Zen

29

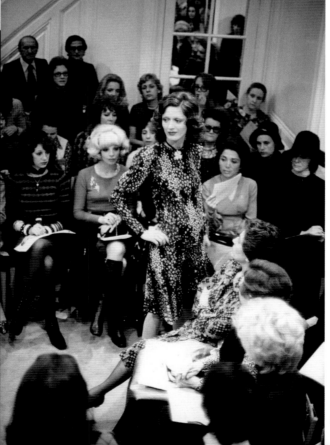

8

*Brown and black
printed crêpe de Chine
formal dress.*

Atelier's specification sheet
Fashion show photograph

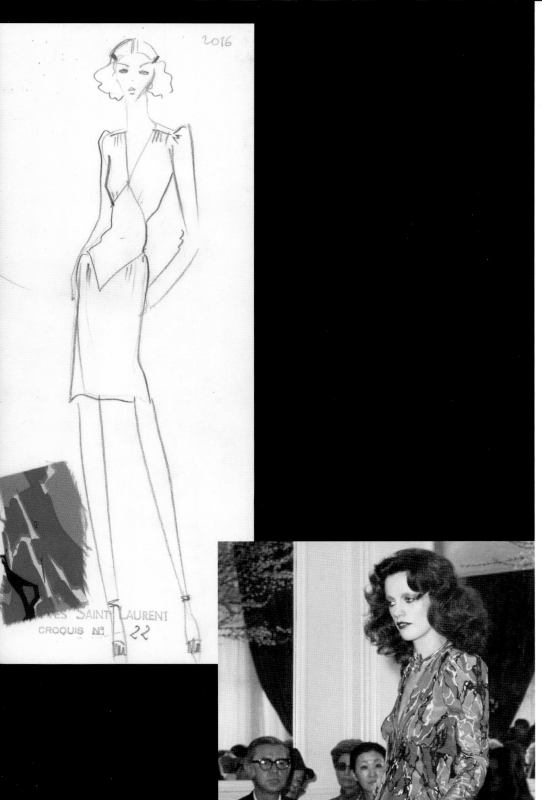

*Marbled russet
printed crêpe de Chine
formal dress.*

Original sketch
Fashion show photograph

2016

YVES SAINT LAURENT
CROQUIS N° 22

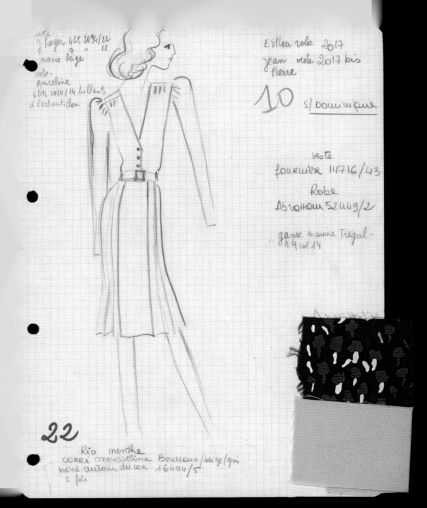

*Formal ensemble.
Beige gabardine jacket
with navy braided
trim. Navy and white
printed crêpe de
Chine dress.*

Atelier's specification sheet
Press file photograph

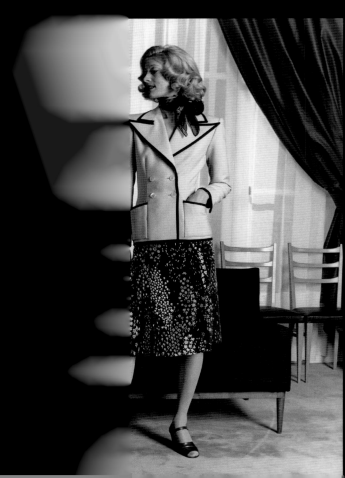

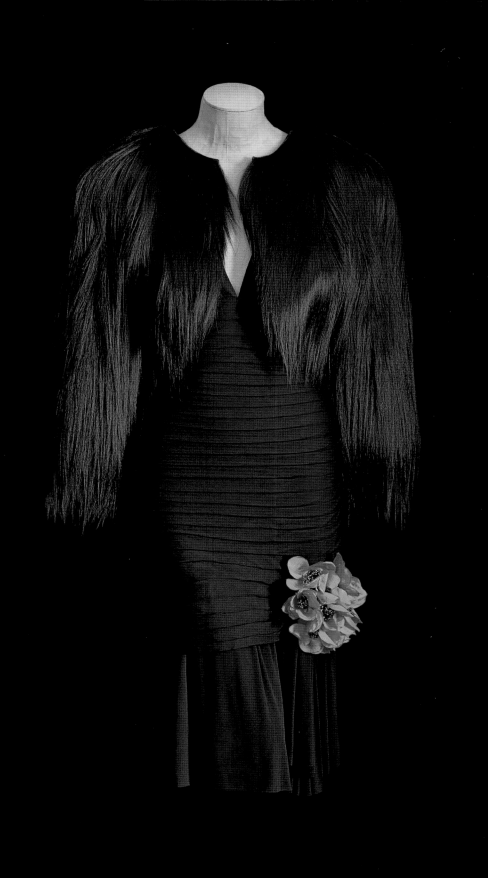

11

Black silk jersey formal dress. Worn during the fashion show with a monkey bolero (outfit 91).

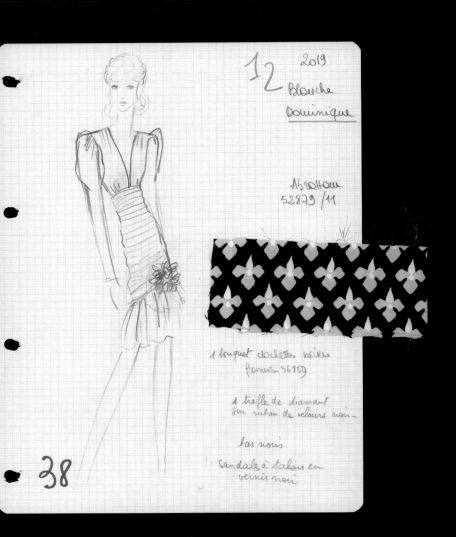

*Yellow and black
printed crêpe de Chine
formal dress.*

Atelier's specification sheet
Press file photograph

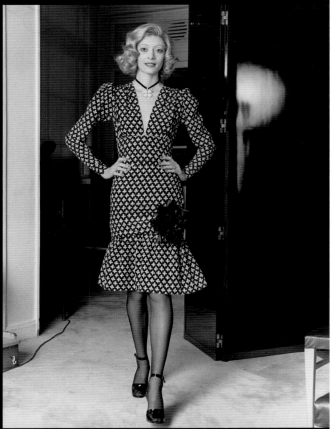

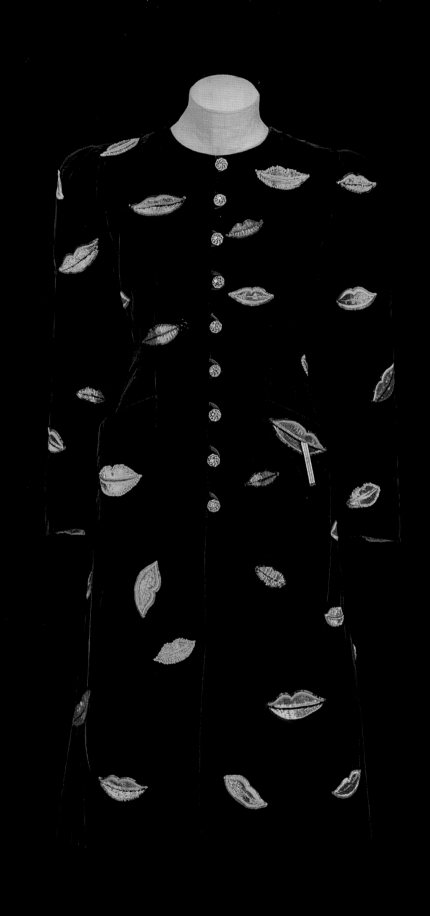

Forn
Emb
velve
and

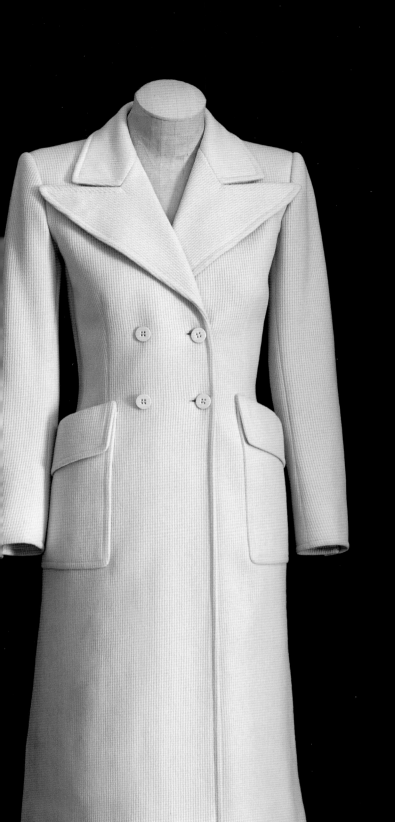

14

Daytime ensemble.
White wool frock coat.
White voile dress.

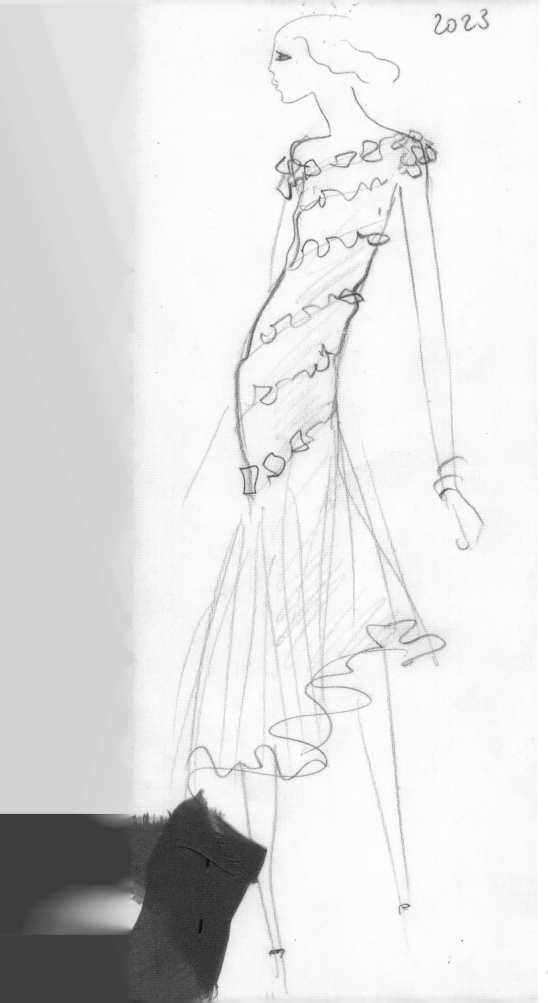

2023

15

Ivy-embroidered green chiffon gown.

Original sketch

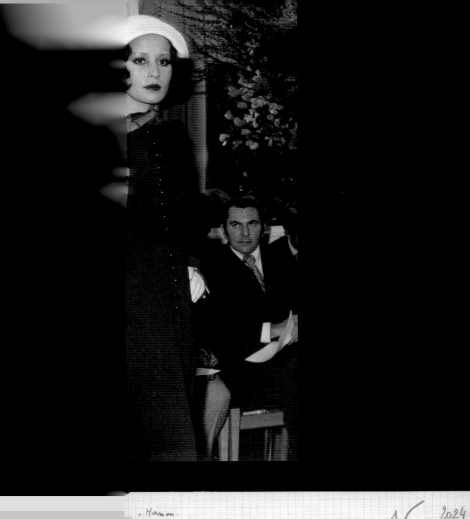

Hamon.
16 B/S 8303"/14
teint à l'échantillon

16 2024.

Catherine

Elsa

robe marine

Gandini
589 bleu 02

19

Bob blanc
gants beige, revers marine
grande écharpe mousseline bordeau
Jaune / Bleu / rouge / blanc
Abraham 15·404/4
nouée à plat un pan de
chaque côté
Sandales vernis noir à talons.

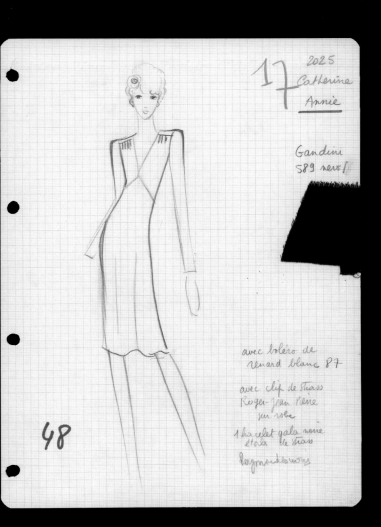

*Black crêpe
formal dress.*
**Worn during the
fashion show with
a white fox bolero
(outfit 87).**

Atelier's specification sheet
Fashion show photograph

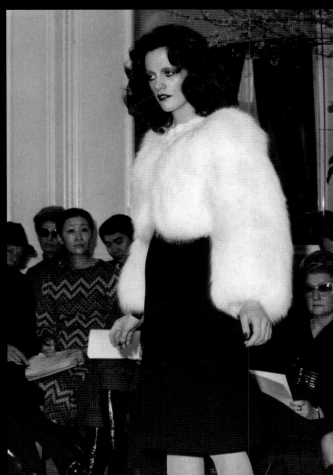

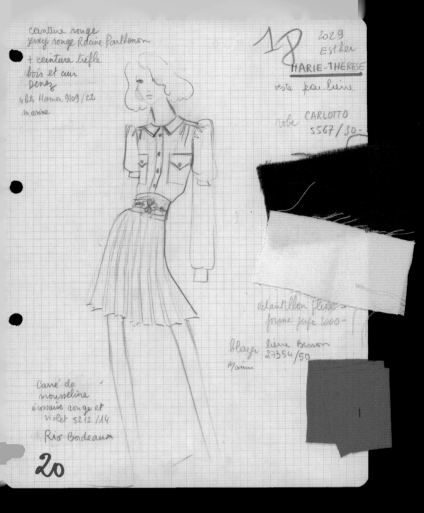

Daytime ensemble. Sleeveless white wool jacket with navy braided trim. Navy voile dress.

Atelier's specification sheet
Photograph from the International Wool Secretariat

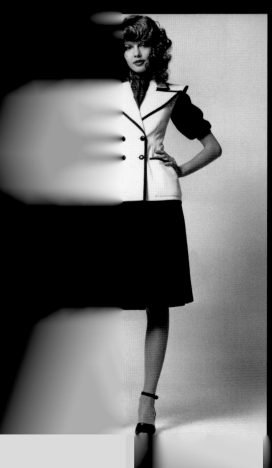

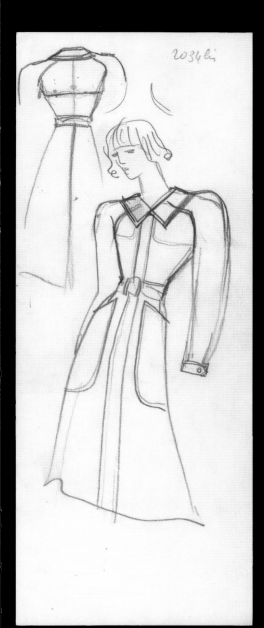

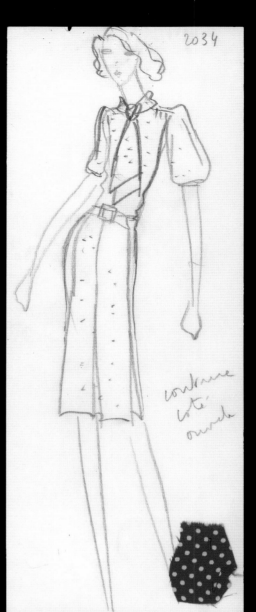

19

*Daytime ensemble.
Beige trench coat. Blue
crêpe de Chine dress
with white polka dots.*

Original sketches

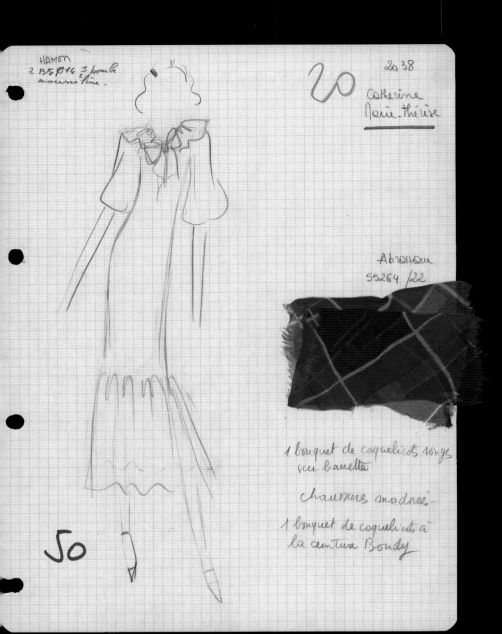

HAMON
2 1315 P14 ½ bomba
mousseline

20 38

20

Catherine
Marie-Thérèse

Abrahau
55264 /22

1 bouquet de coquelicots rouges
sur barette

chaussures mordorées

1 bouquet de coquelicots à
la ceinture Boudy

50

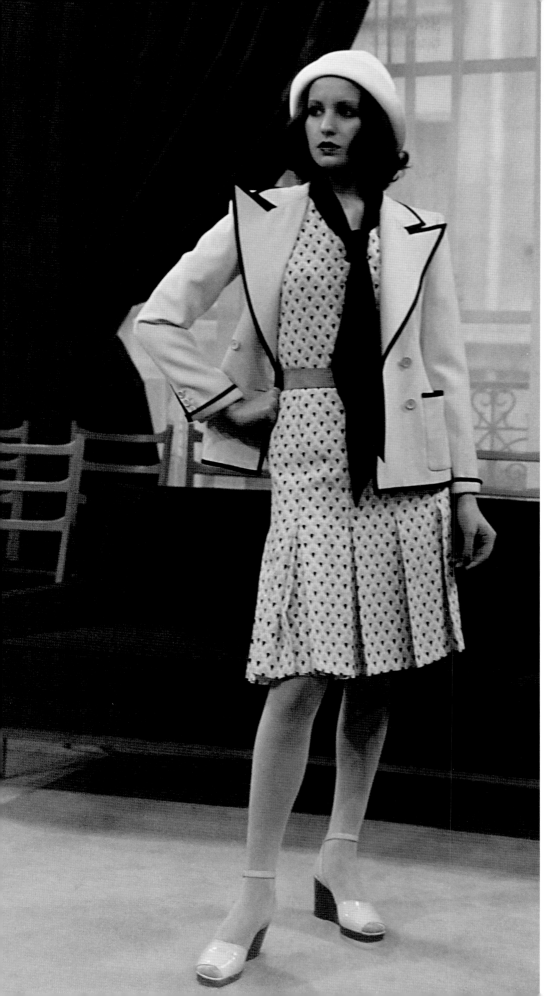

*Suit. Yellow gabardine
jacket with black
braided trim. Yellow
and white printed
crêpe de Chine dress.*

Press file photograph

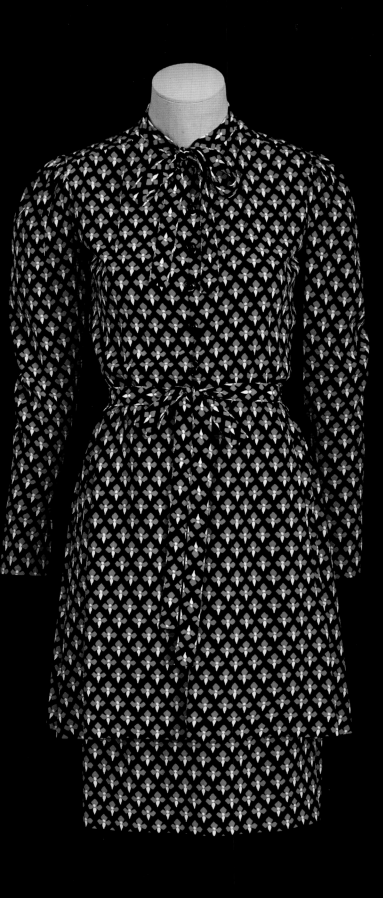

22

*Red and black
printed crêpe de Chine
afternoon dress.*

*Black silk jersey
formal dress.*

Original sketch

Embroidered black crêpe formal dress.

Atelier's specification sheet
Fashion show photograph

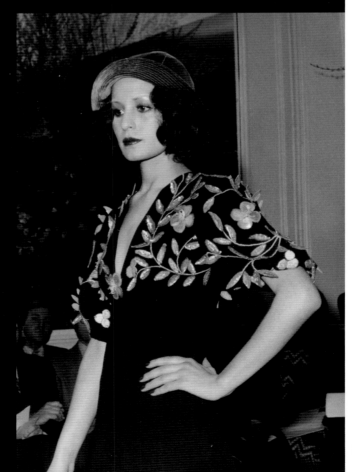

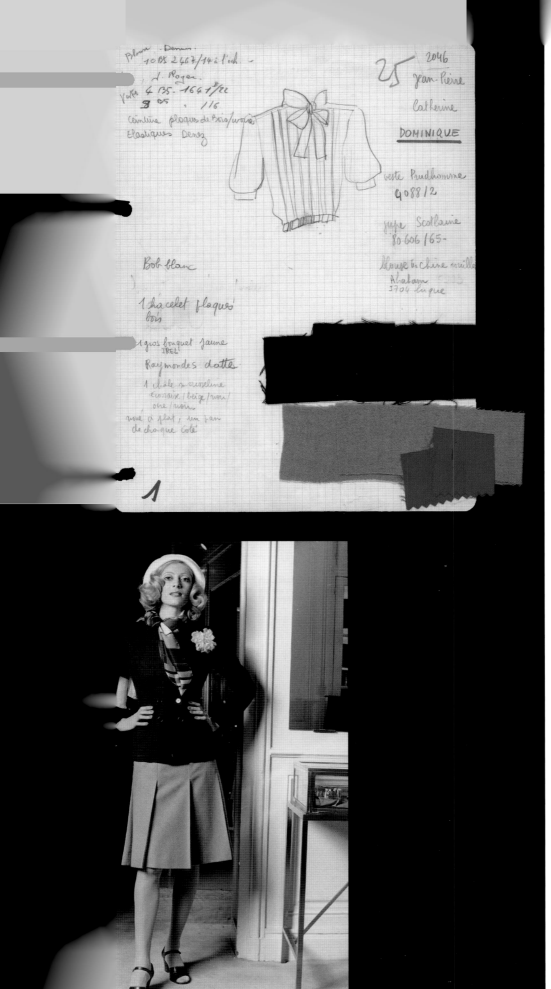

Suit. Black gabardine jacket. Green flannel skirt. Terra-cotta crêpe de Chine blouse.

Atelier's specification sheet
Press file photograph

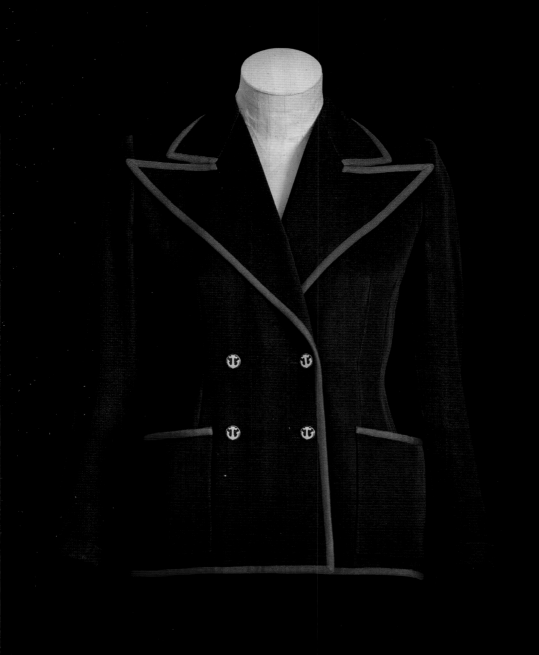

*Suit. Navy gabardine
jacket with burgundy
braided trim. Natural
flannel skirt. Navy silk
jersey pullover.*

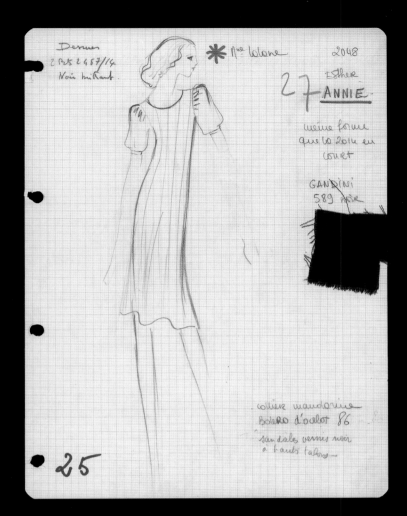

*Black crêpe
formal dress.*
**Worn during the
fashion show with
an ocelot and fox
bolero (outfit 86).**

Atelier's specification sheet
Fashion show photograph

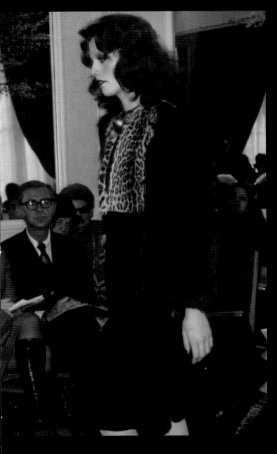

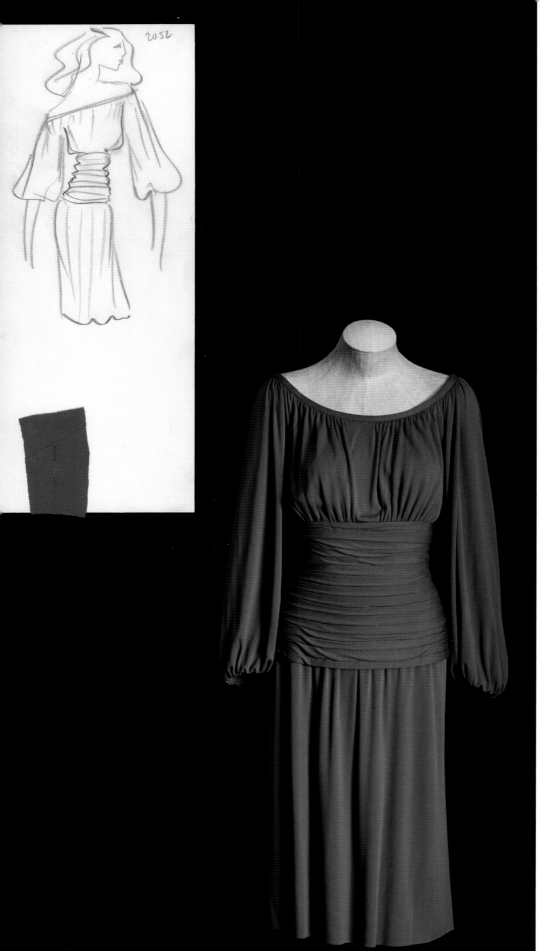

*Terra-cotta silk jersey
formal dress.*

Original sketch

2052

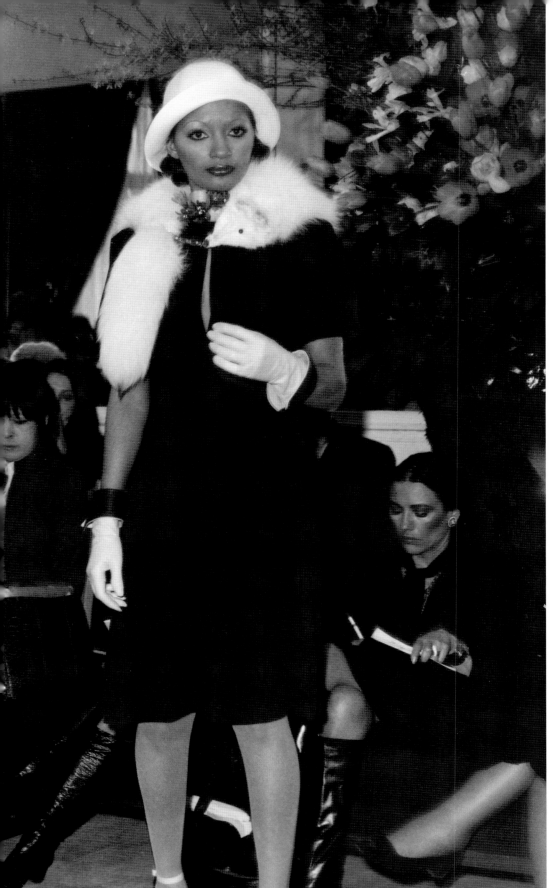

29
Navy crêpe afternoon dress.

Fashion show photograph

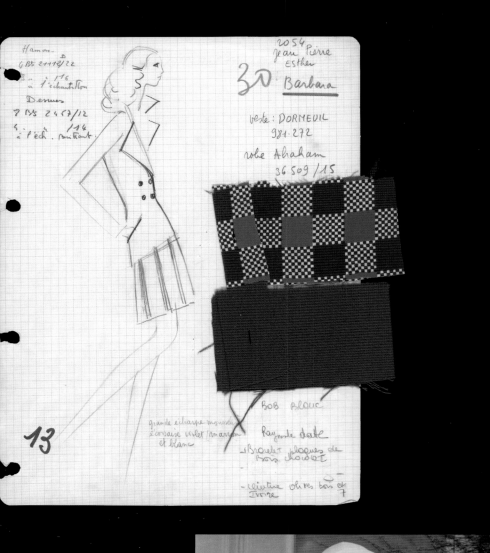

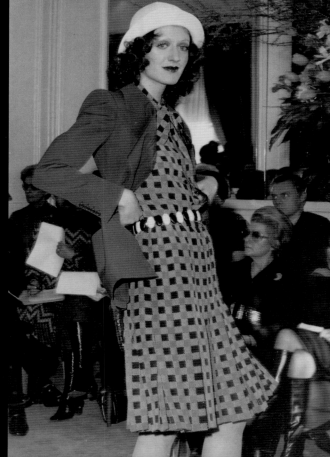

30

Suit. Brown gabardine jacket. Brown and mauve printed crêpe de Chine dress.

Atelier's specification sheet
Fashion show photograph

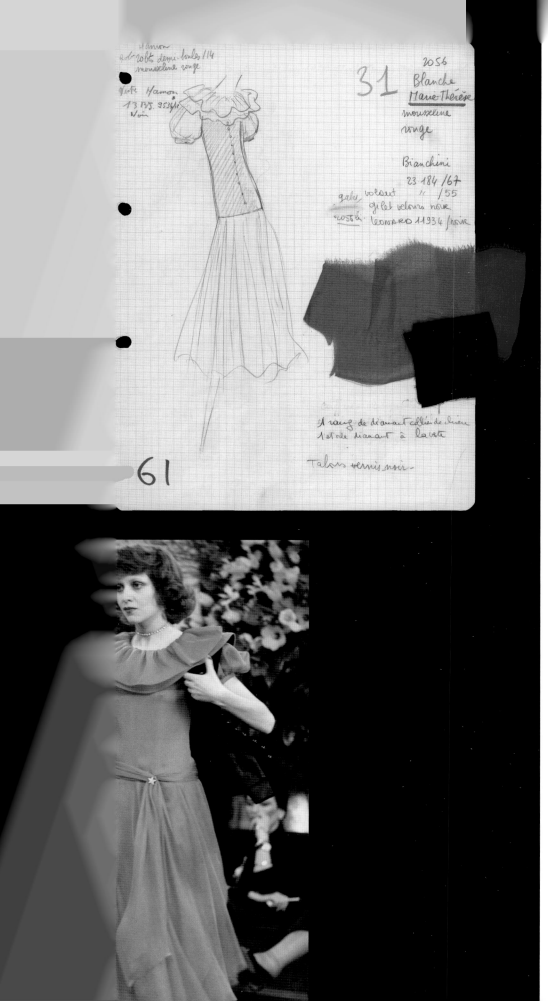

31

*Evening ensemble.
Sleeveless black
velvet jacket. Red
chiffon dress.*

Atelier's specification sheet
Fashion show photograph

111

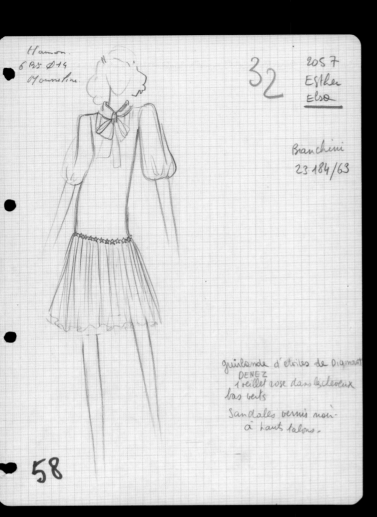

Hamon.
6 Bs Ø14
Mousseline.

32 2057
 Esther
 Elsa

Bianchini
23.184/63

32

guirlande d'étoiles de Diamant
DENEZ
1 oeillet rose dans les cheveux
bas verts
Sandales vernis noir
à hauts talons.

58

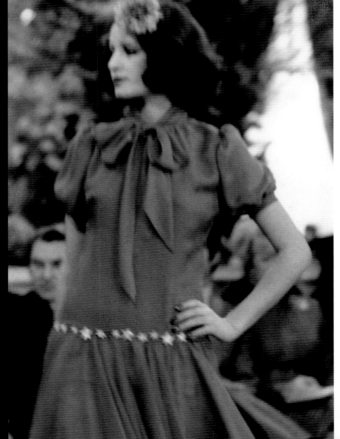

112

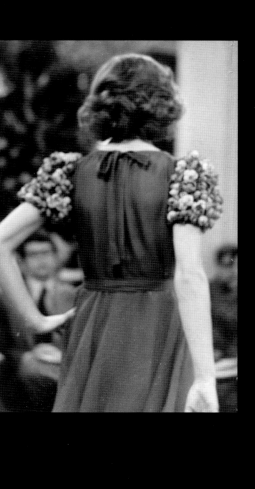

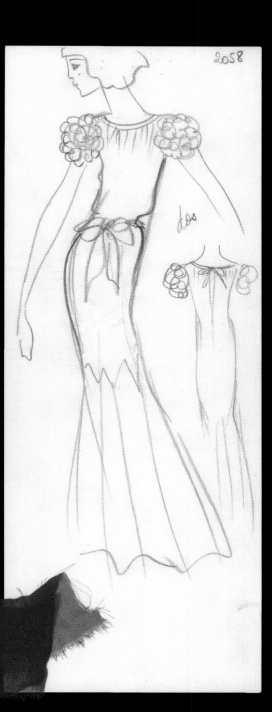

2058

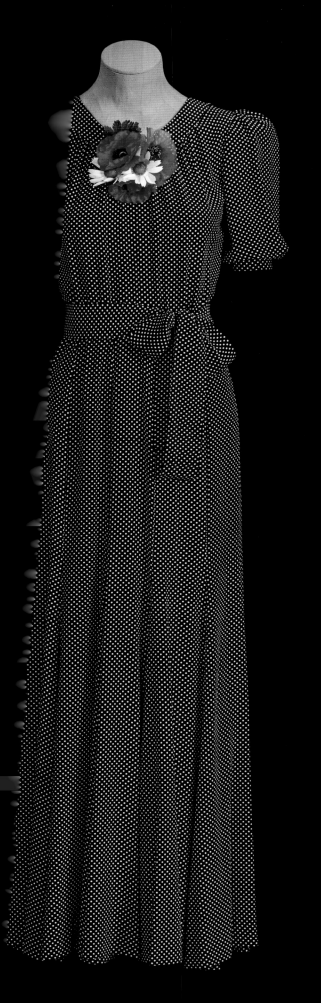

Brown crêpe de Chine gown with white polka dots.

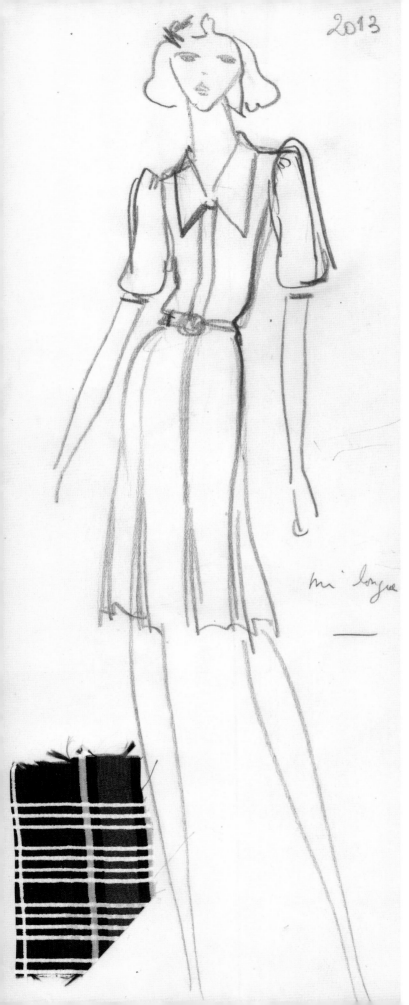

2013

mi longue

*Formal ensemble.
Black wool coat with
beige braided trim.
Brown and black
checked crêpe de
Chine dress.*

Original sketch

115

*Green and beige
printed crêpe de Chine
afternoon dress.*

Original sketch

37

*Black crêpe formal
dress with gold
embroidery.*

Original sketch

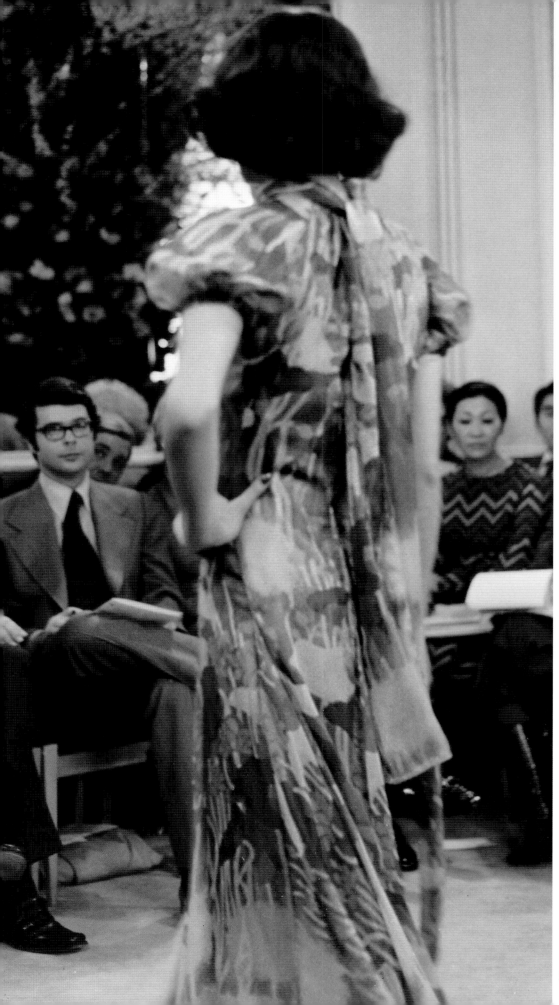

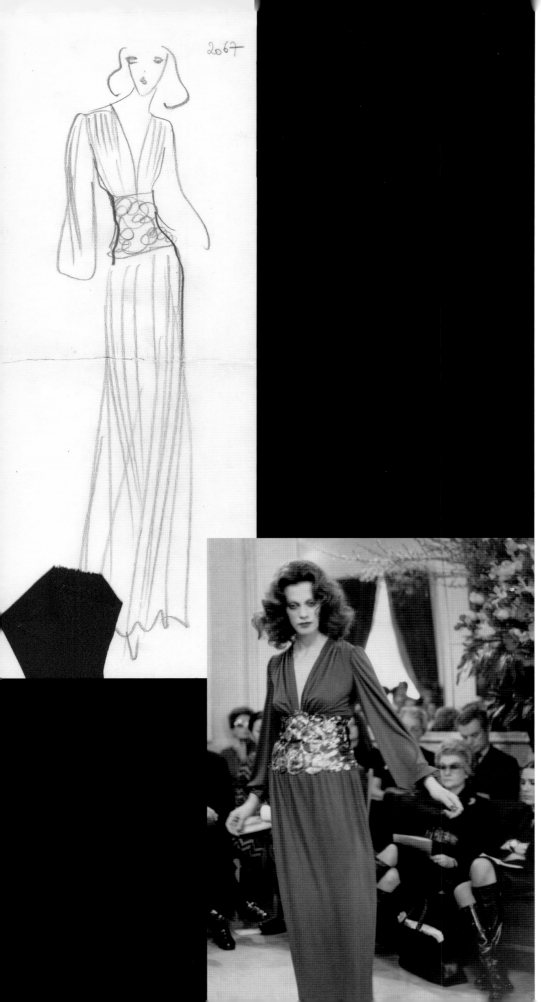

39

Violet silk jersey gown with embroidered bodice.

Original sketch
Fashion show photograph

119

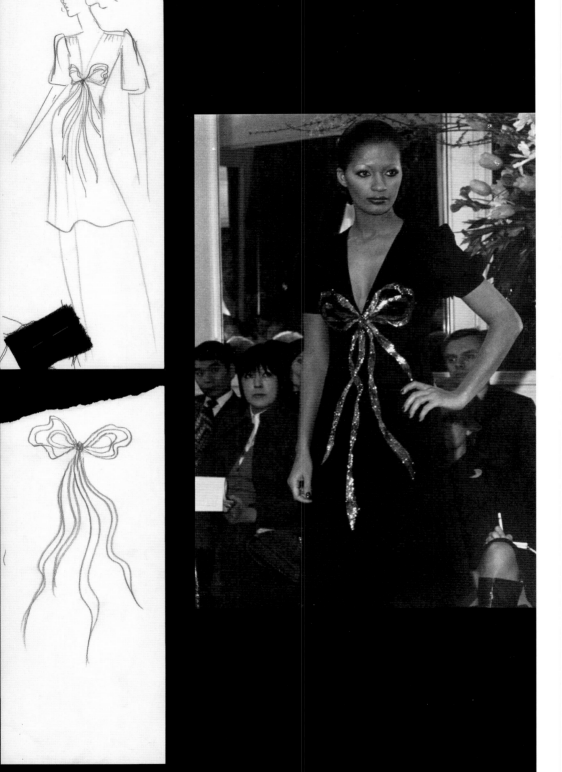

*Black crêpe formal
dress with gold
embroidery.*

Original sketches
Fashion show photograph

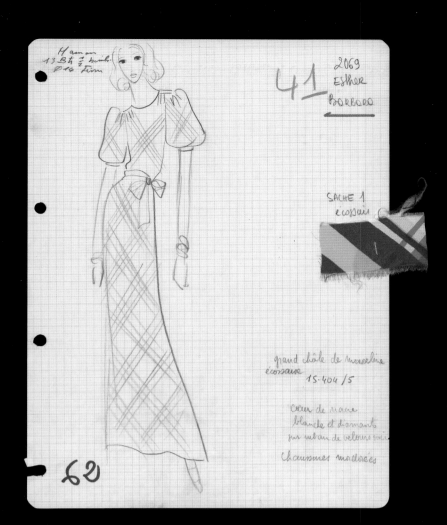

Maman
13 B⅓ ½ bonh.
∅ 10 Firm

41
ESther
Borrero

2069

SACHE 1
écossais

grand châle de mousseline
écossaise
15.404 /5

cœur de nacre
blanche et diamants
sur ruban de velours noir

Chaussures mordorées

62

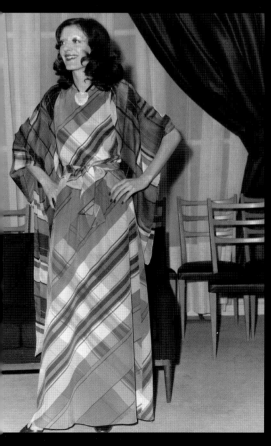

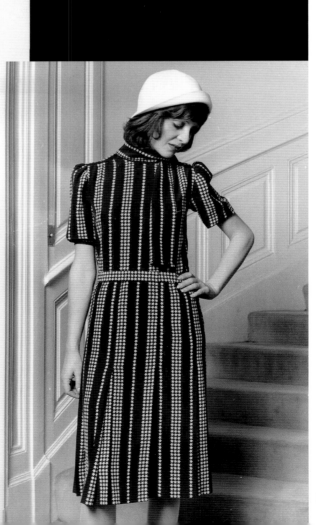

*Suit. Navy serge
jacket with white
braided trim. Navy
and white printed
crêpe de Chine dress.*

Original sketch
Press file photograph

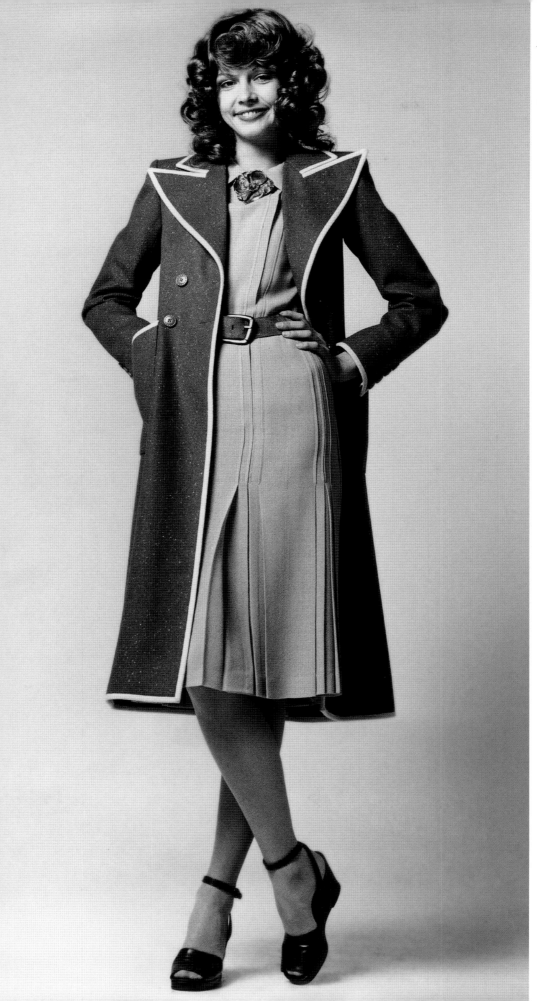

43

Daytime ensemble. Terra-cotta flannel frock coat with beige braided trim. Sand-colored voile dress.

Photograph from the International Wool Secretariat

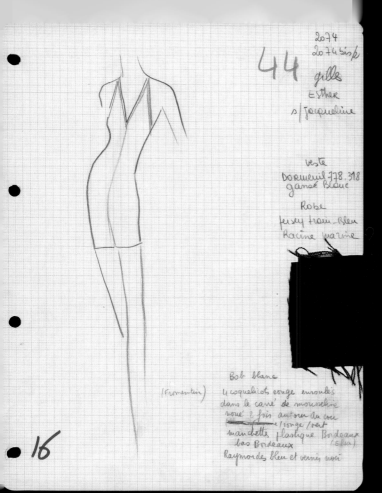

Handwritten notes on the specification sheet:

44
2074
2074 sisp
gille
Esther
s/Jacqueline

veste
Dormeuil 778.318
ganse Blanc

Robe
jersey train Bleu
Racine marine

16

(Fromentin)

Bob blanc
4 coquelicots rouge enroulés
dans le carré de mousseline
noué 2 fois autour du cou
rouge/vert
manchette plastique Bordeaux
(Elsa)
bas Bordeaux
Raymondes bleu et vernis noir

*Daytime ensemble.
Navy jersey Van
Dongen bodysuit. Navy
serge smock with white
braided trim.*

Atelier's specification sheet
Fashion show photograph

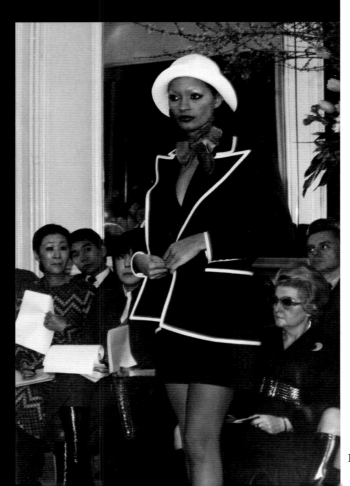

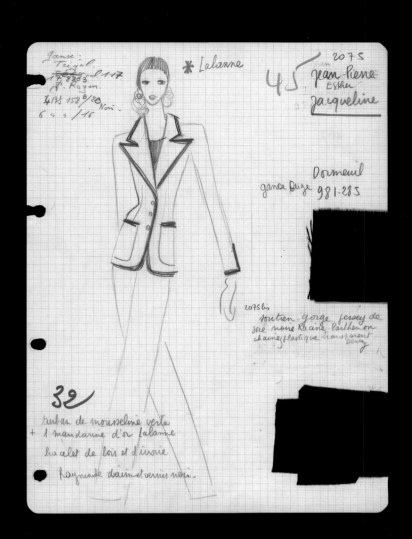

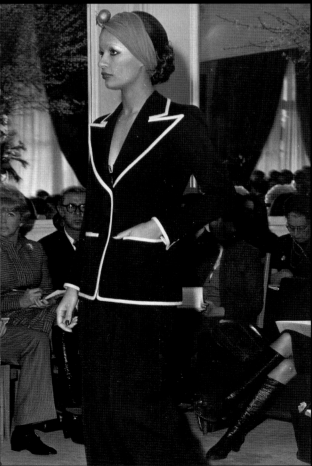

*Black gabardine
pantsuit with beige
braided trim.*

Atelier's specification sheet
Fashion show photograph

2076

*Orange printed
chiffon gown.*

Original sketch

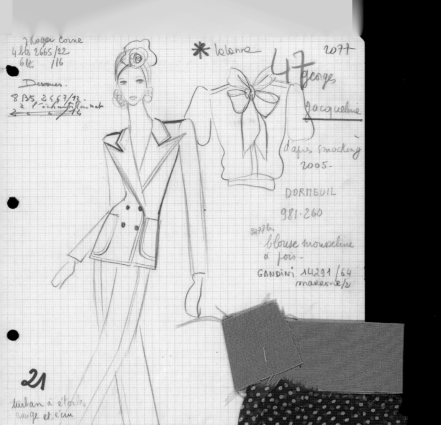

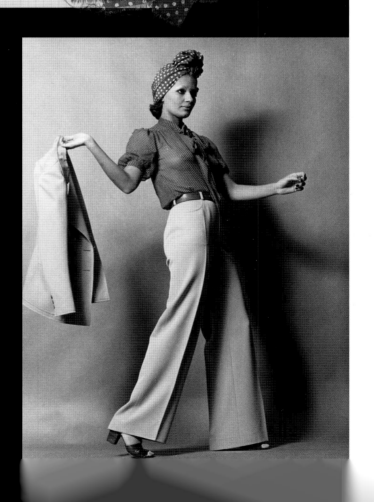

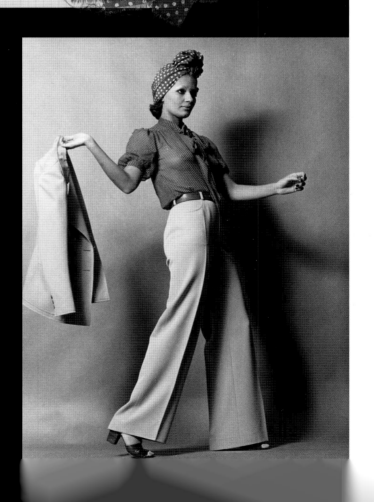

Beige gabardine pantsuit. Brown chiffon blouse with white polka dots.

Atelier's specification sheet
Press file photograph

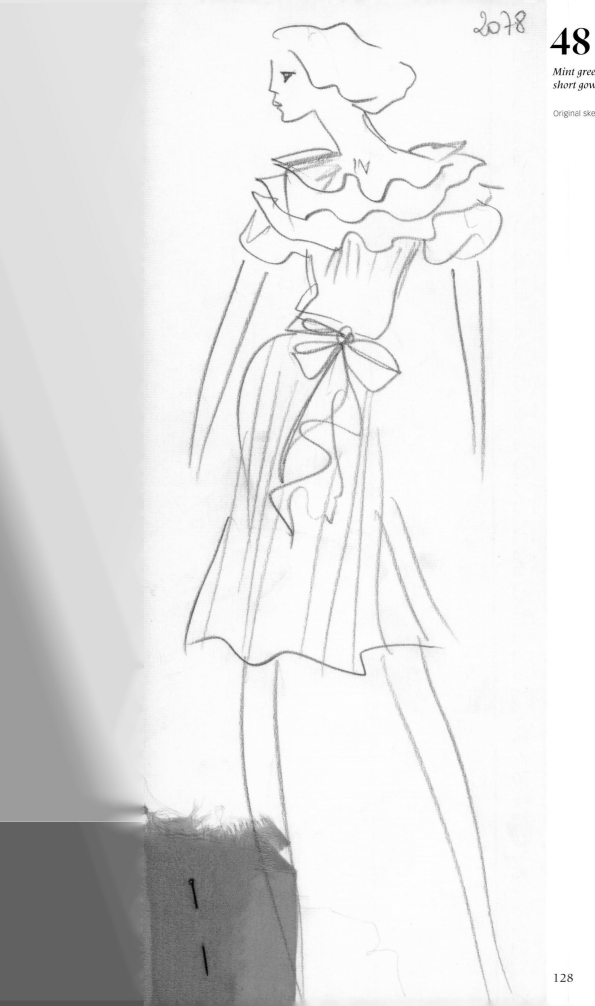

2078

*Mint green chiffon
short gown.*

Original sketch

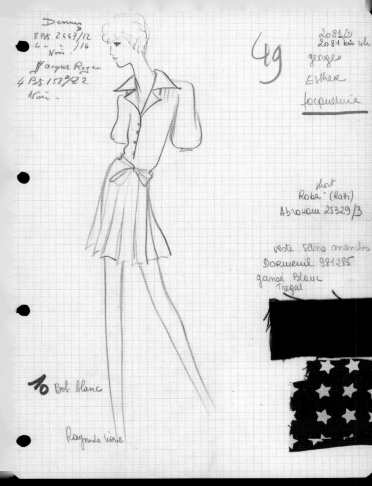

Suit. Sleeveless black
gabardine jacket
with white braided
trim. Black and
white printed crêpe de
Chine dress.

Atelier's specification sheet
Press file photograph

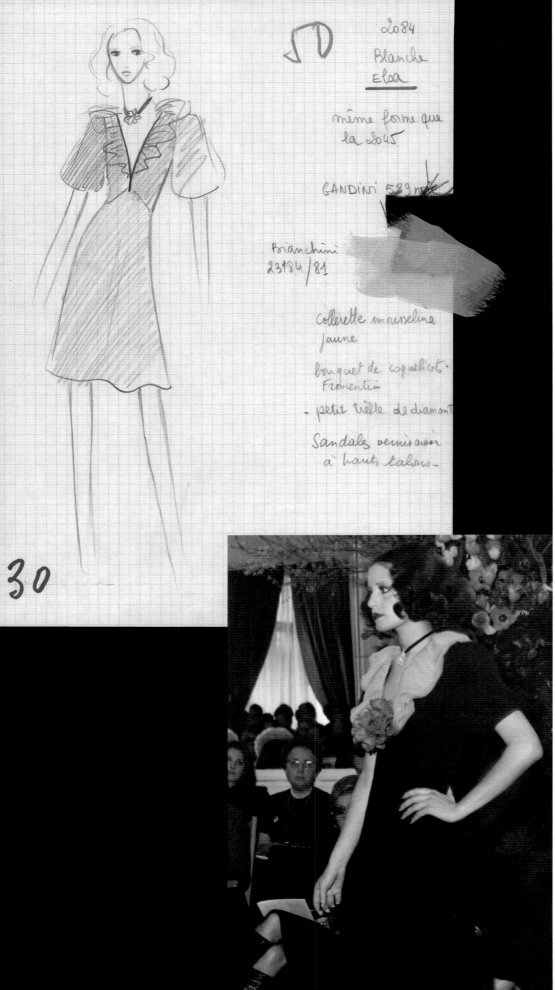

2084
Blanche
Elsa

même forme que
la 2045

GANDINI 589m

Bianchini
23184/81

Collerette mousseline
jaune

bouquet de coquelicots.
Fromentin

- petit trèfle de diamant

Sandales vernis noir
à hauts talons.

30

50

*Black crêpe and yellow
chiffon formal dress.*

Atelier's specification sheet
Fashion show photograph

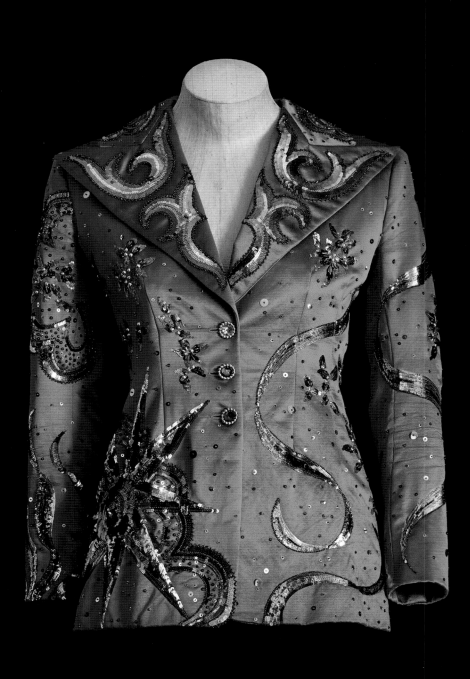

2089

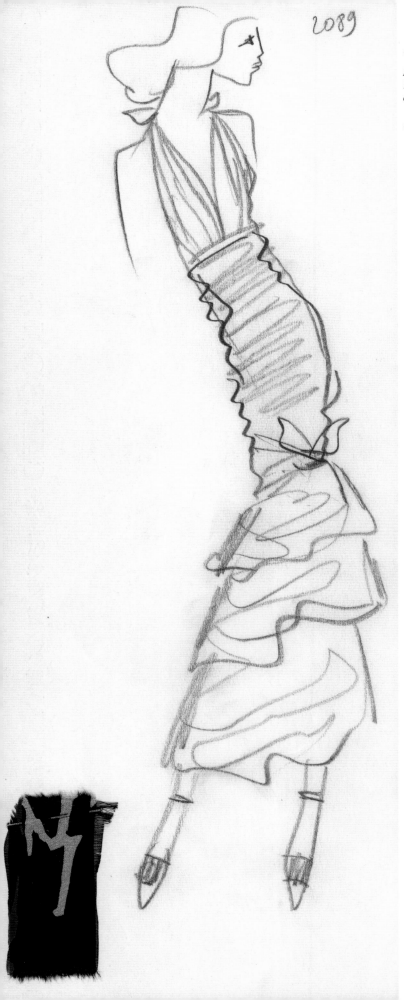

52

*Marbled brown and
black printed crêpe de
Chine gown.*

Original sketch

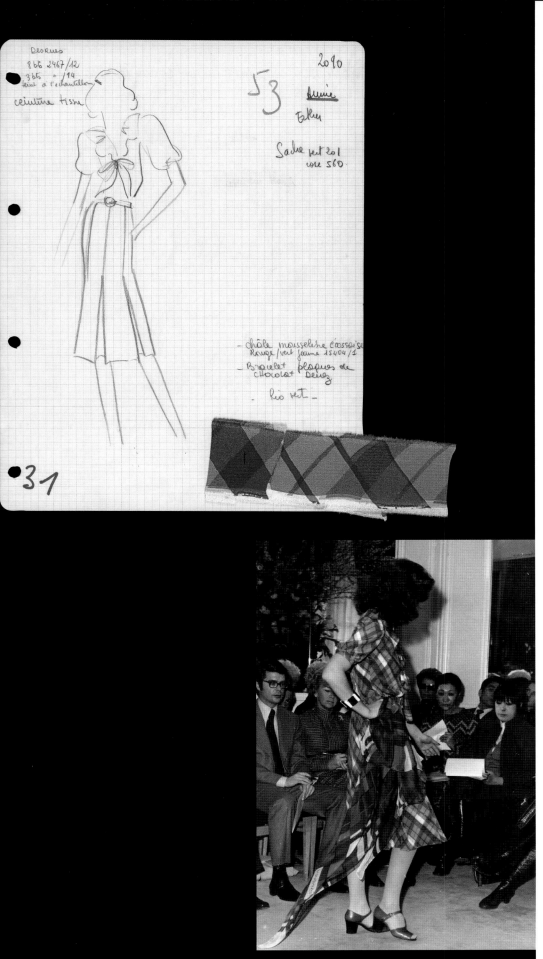

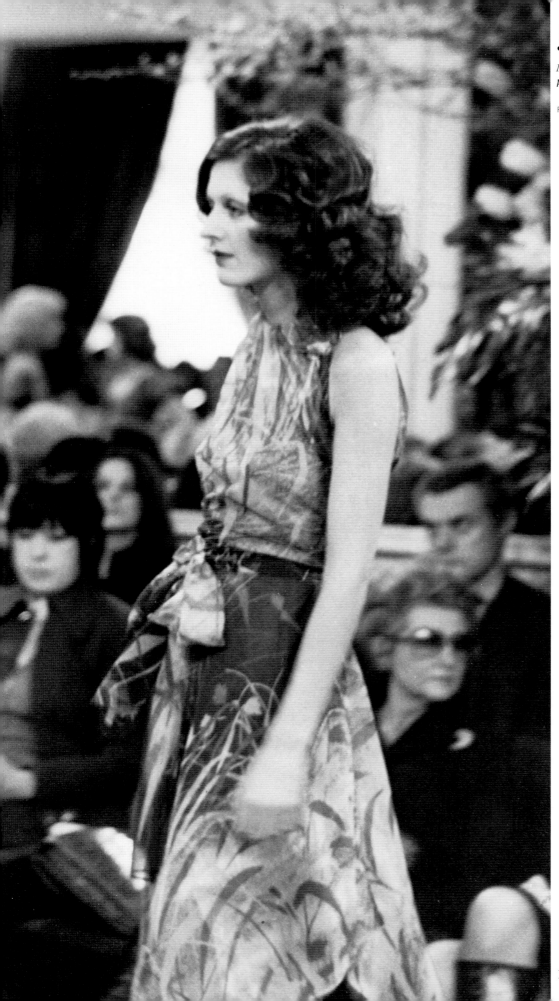

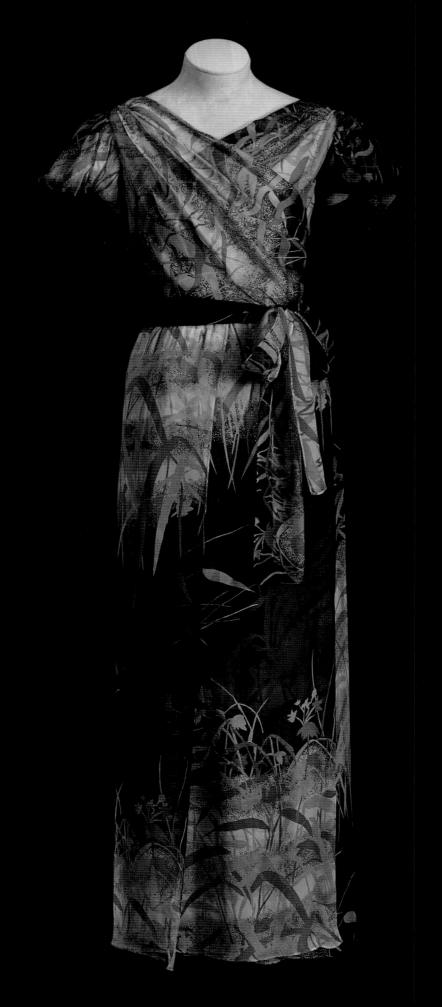

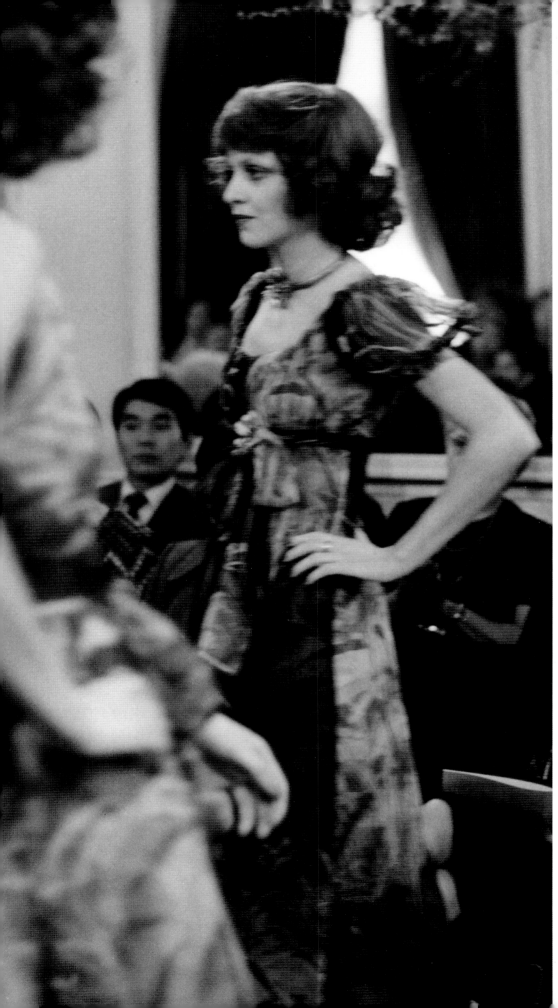

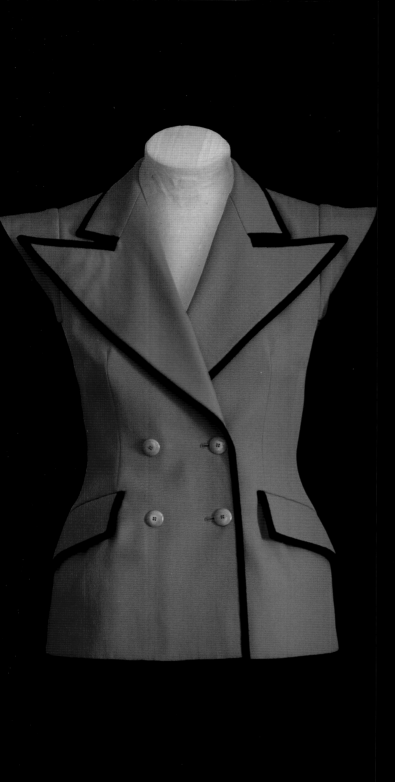

Suit. Sleeveless red
gabardine jacket with
black braided trim.
Red and white printed
crêpe de Chine dress.

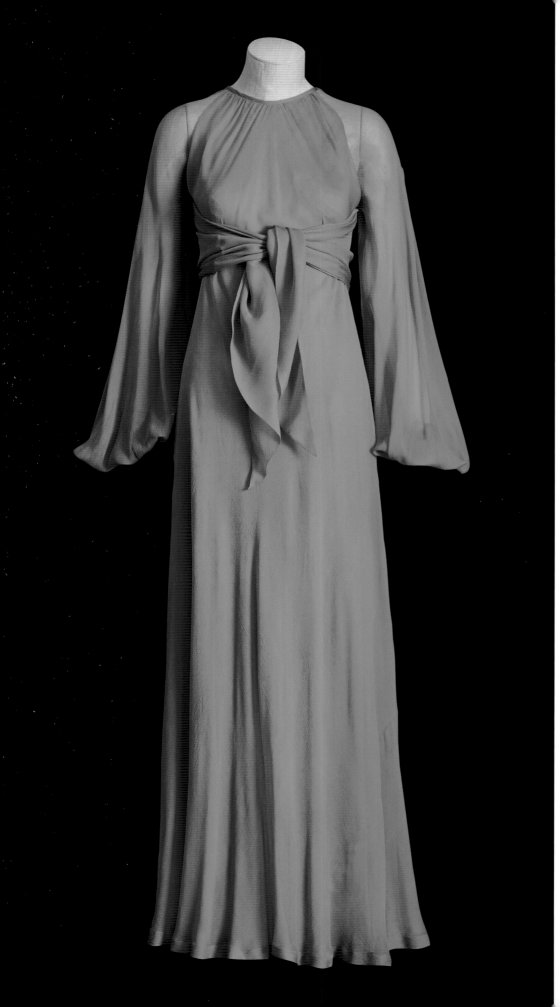

58

Navy chiffon gown.

Variation of design created
in green for a client

**Blue surah
afternoon dress.
Outfit canceled.**

Atelier's specification sheet

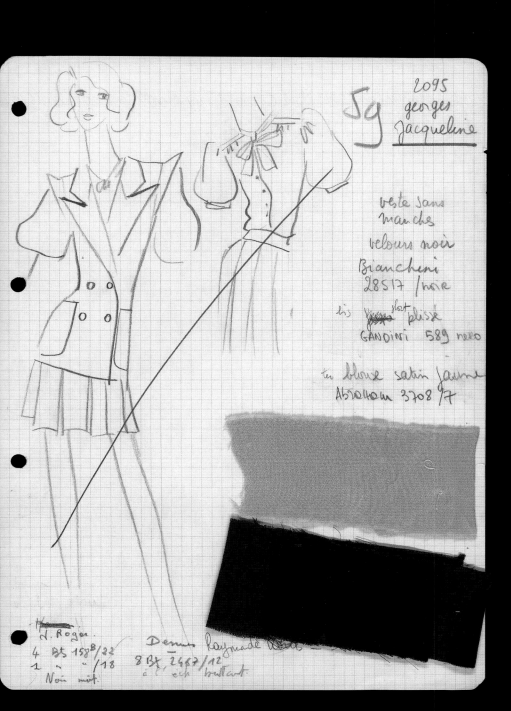

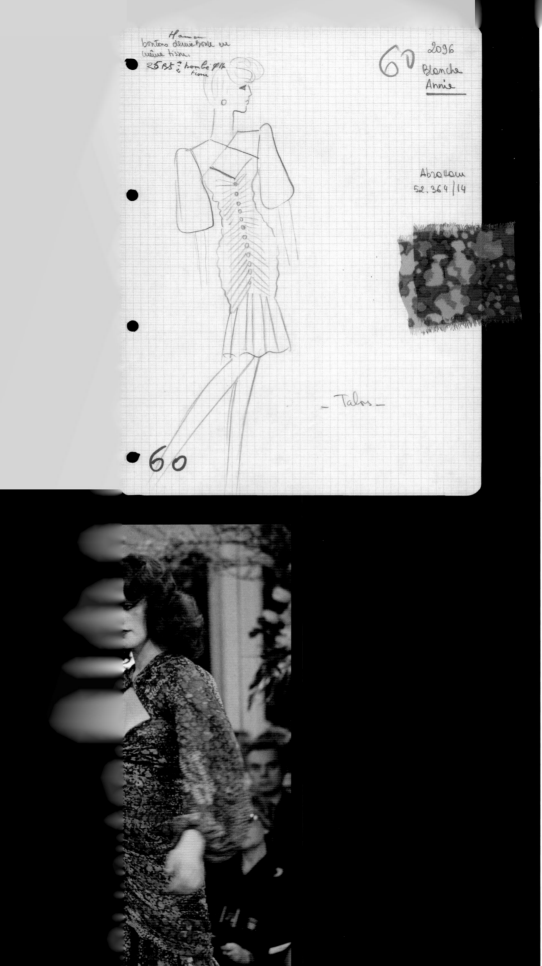

*Printed chiffon
formal dress.*

Atelier's specification sheet
Fashion show photograph

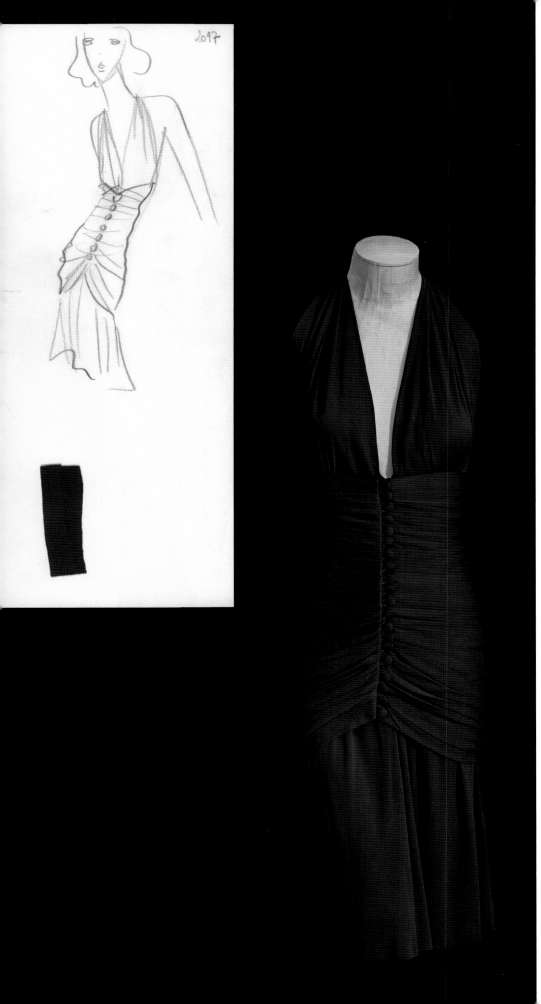

Brown silk jersey formal dress.

Original sketch

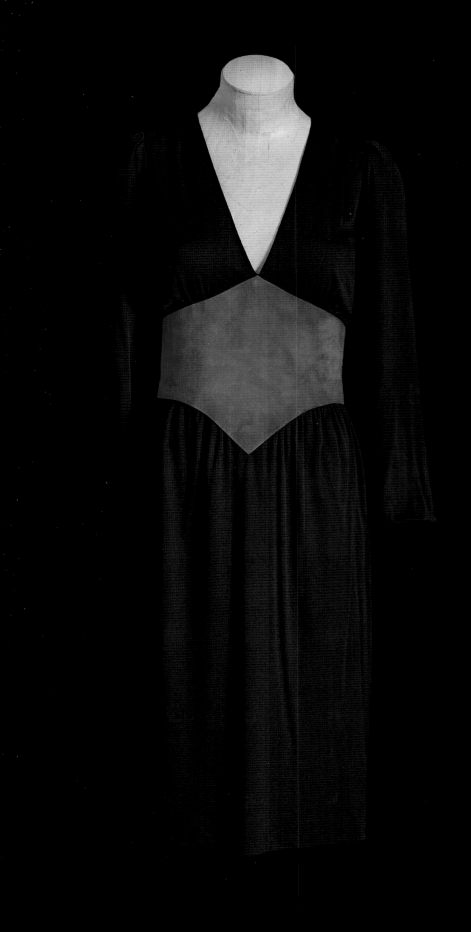

62

Formal ensemble.
Red suede coat.
Black silk jersey dress.
Red suede belt.

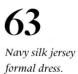

Navy silk jersey
formal dress.

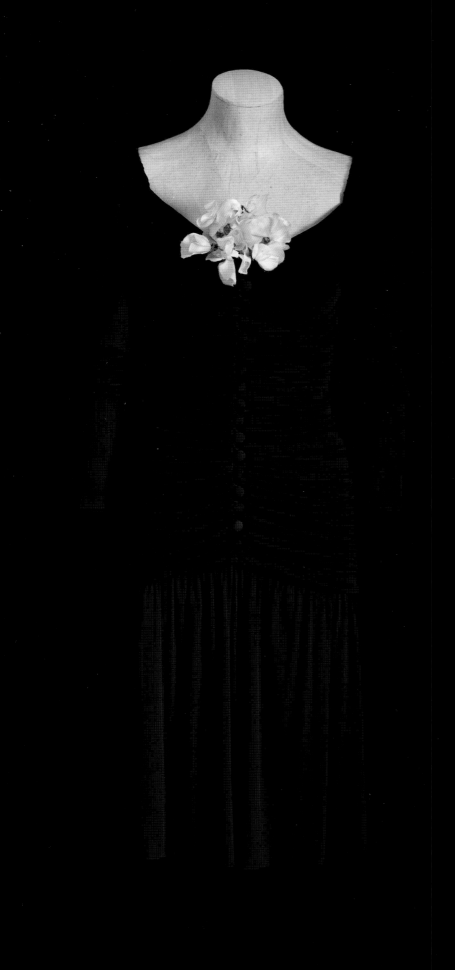

64

Black silk jersey Van Dongen bodysuit. **Worn during the fashion show with a green fox coat (outfit 90).**

Original sketch
Press file photograph

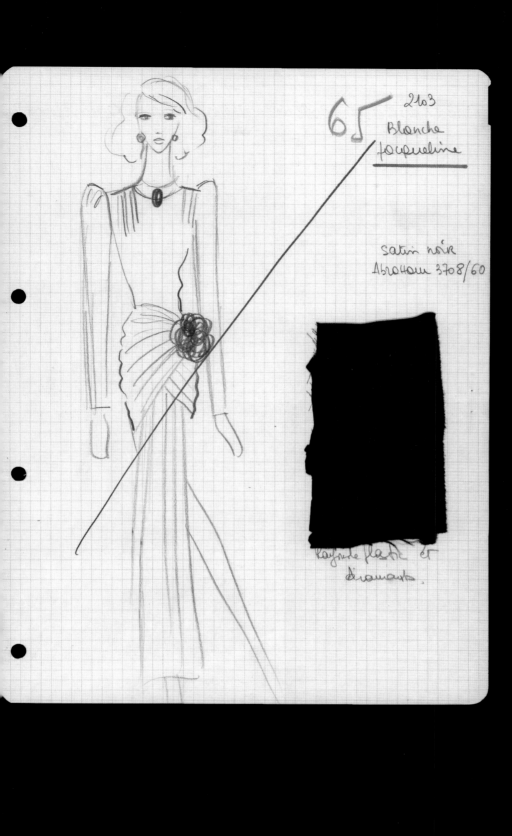

65
2163
Blanche
Jacqueline

satin noir
Abraham 3708/60

Raynde plate et
diamants.

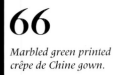

Marbled green printed
crêpe de Chine gown.

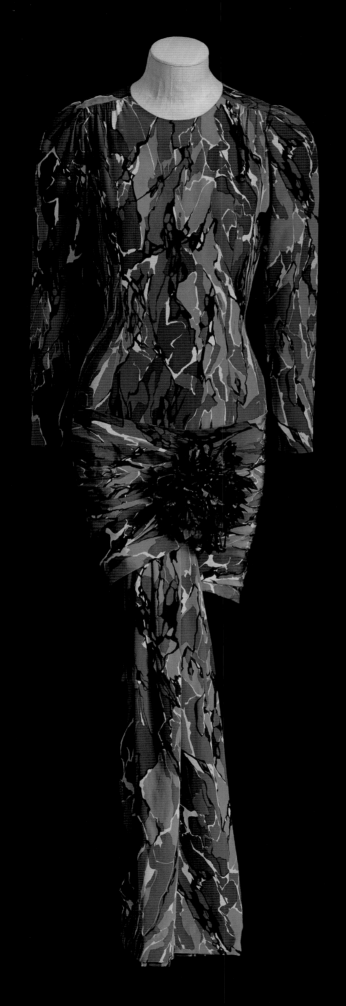

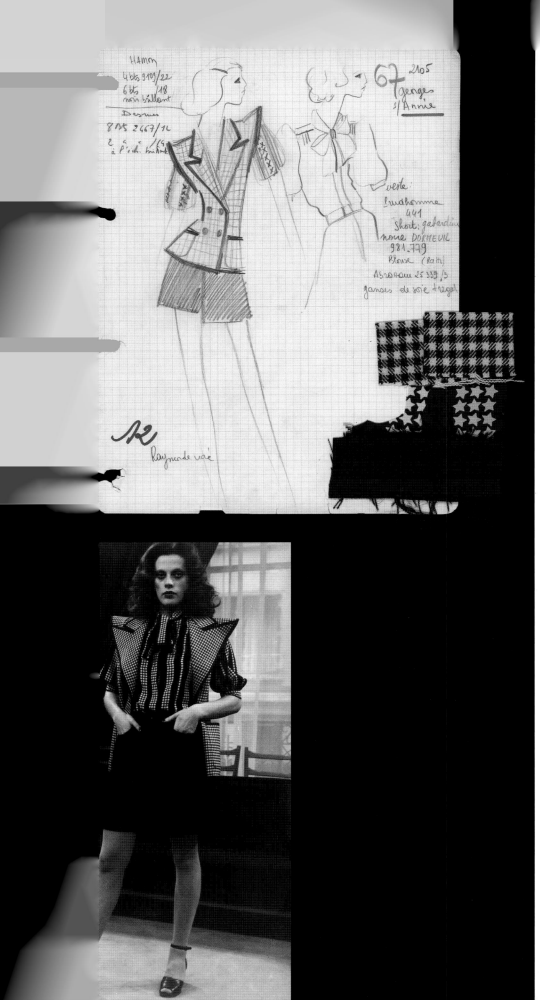

*Daytime ensemble.
Sleeveless black and
white wool jacket.
Black gabardine
shorts. Black and
white printed crêpe
de Chine blouse.*

Atelier's specification sheet
Press file photograph

68

Daytime ensemble.
Navy serge blazer.
White flannel shorts.
Navy silk jersey
halter top.

Original sketch

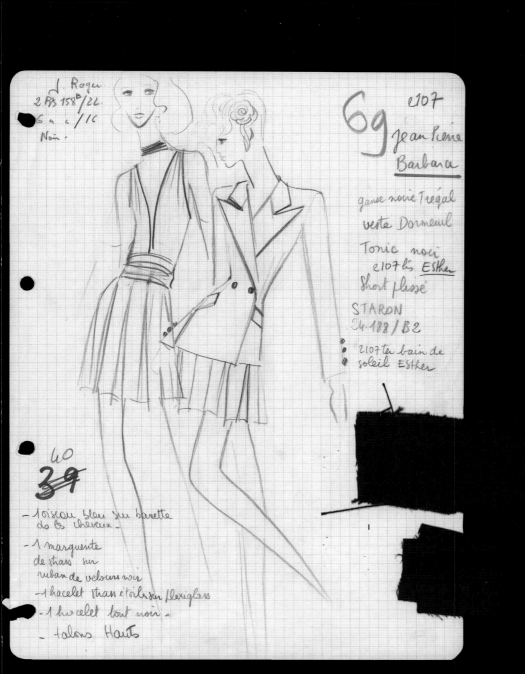


J. Roger
2 FN 158ᵇ/22.
6 a c /16
Noir.

69
Jean Pierre
Barbara

ganse noire Trégal
verte Dormeuil
Tonic noir
2107 bis Esther
Short plissé
STARON
34.188/B2

2107 ter bain de
soleil Esther

2107

40
39

- 1 oiseau bleu sur barette
 ds ls cheveux -
- 1 marguerite
 de strass sur
 ruban de velours noir
- 1 bracelet strass étoiles sur plexiglass
- 1 bracelet tout noir -
- talons Hauts


Formal ensemble.
Black alpaca jacket.
Black pleated silk
crêpe skirt. Black silk
jersey sun dress.

Atelier's specification sheet

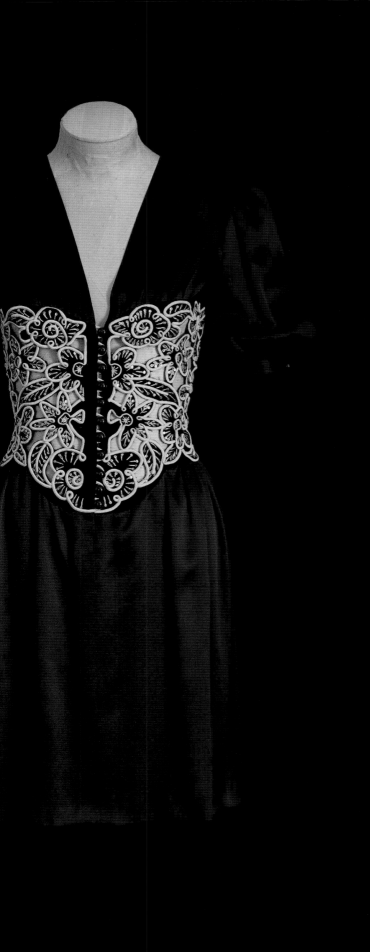

Black satin crêpe
formal dress.
Embroidered bodice.

2109

2109 Bis

71

Formal ensemble.
Sleeveless violet velvet
jacket. Mauve and
black printed crêpe de
Chine dress.

Original sketches

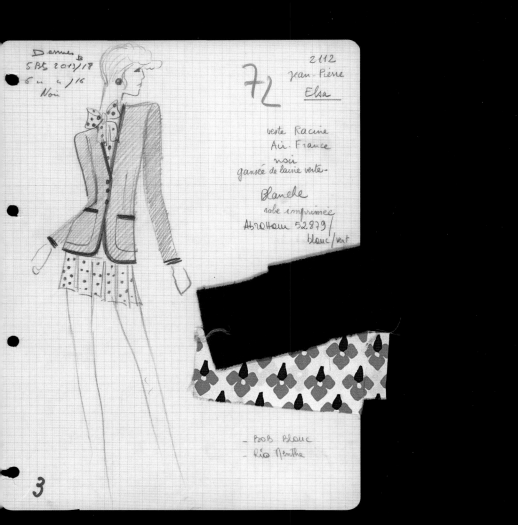

72

*Suit. Black jersey
jacket with green
braided trim. Green
and white printed
crêpe de Chine dress.*

Atelier's specification sheet
Press file photograph

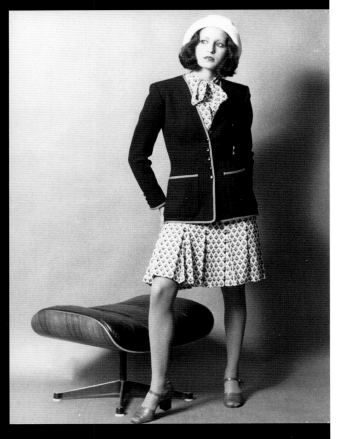

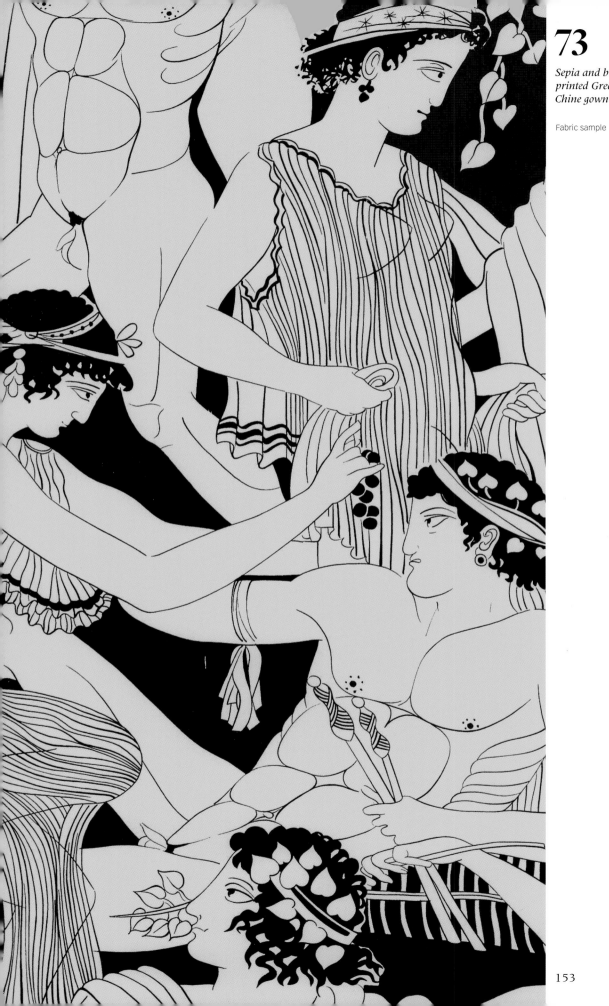

*Sepia and black
printed Greek crêpe de
Chine gown.*

Fabric sample

Terra-cotta and black printed Greek crêpe de Chine gown.

Wrap worn with the gown

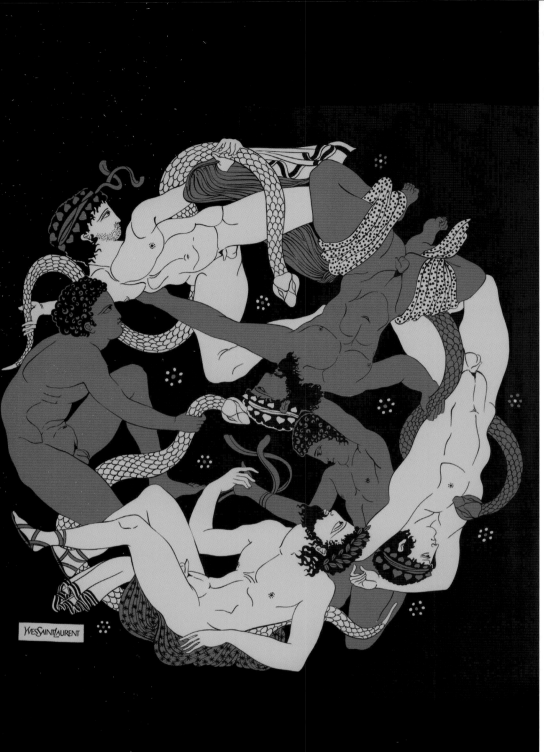

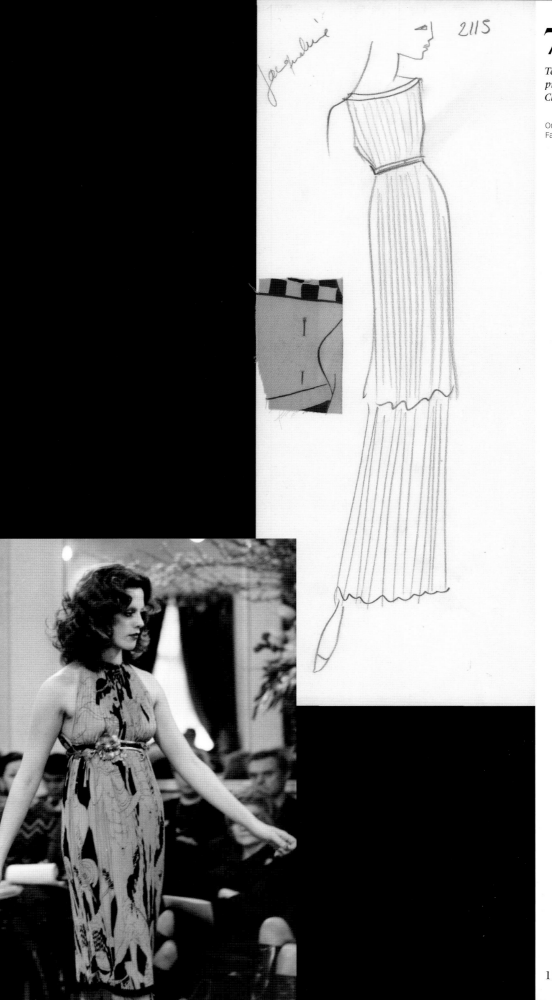

75

Terra-cotta and black printed Greek crêpe de Chine gown.

Original sketch
Fashion show photograph

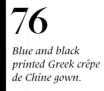

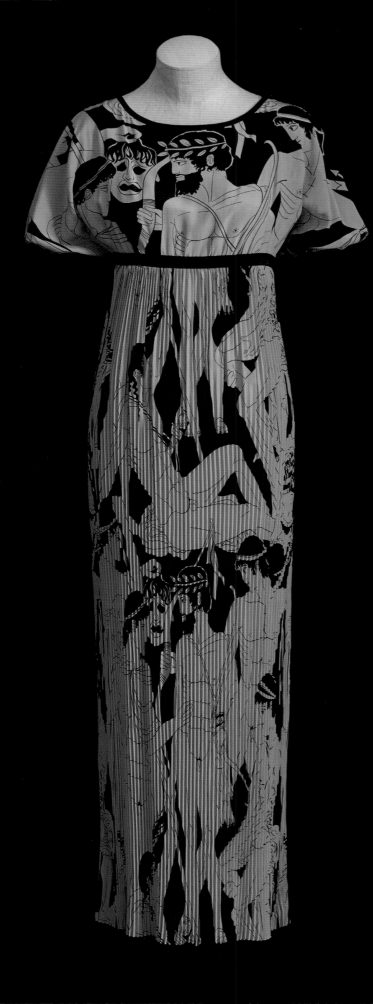

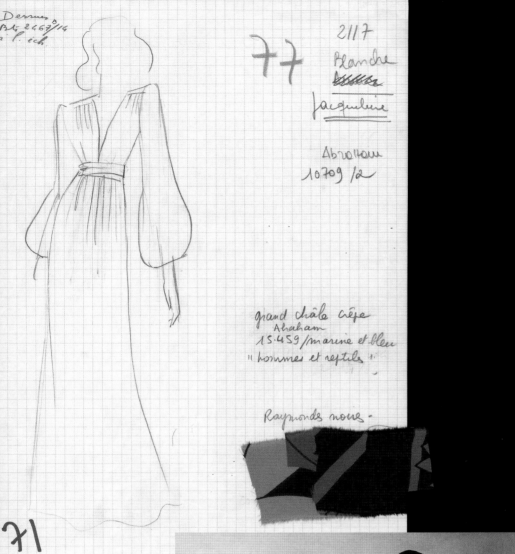

**Bright blue and black
printed Greek crêpe de
Chine gown.**

Atelier's specification sheet
Press file photograph

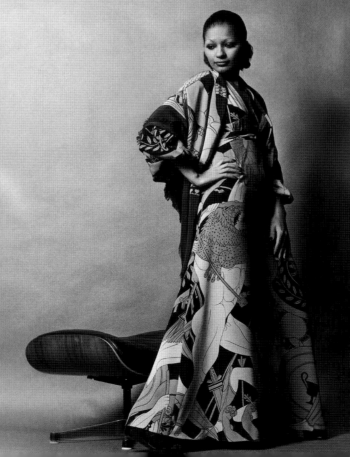

157

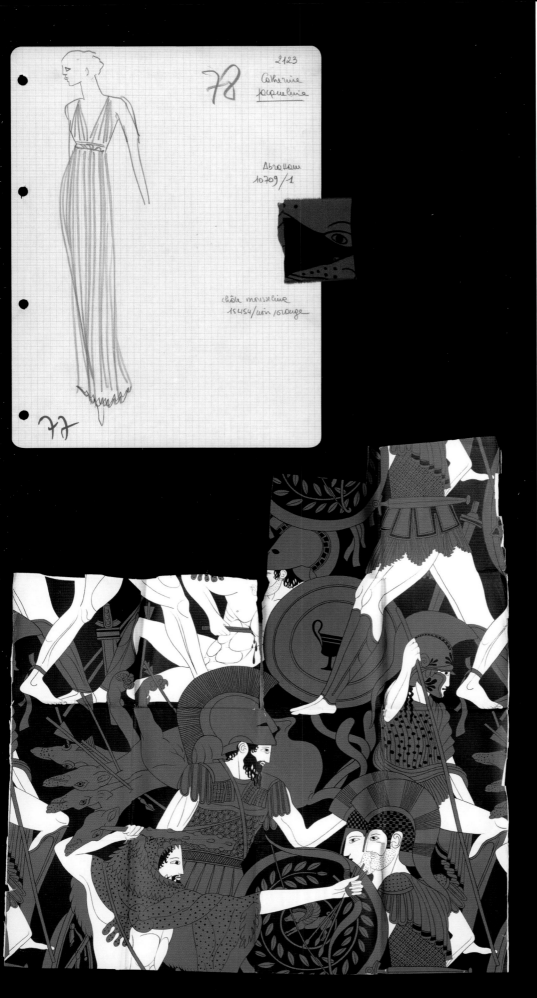

78

Terra-cotta and black printed Greek crêpe de Chine gown.

Atelier's specification sheet
Original print for patterned
fabrics (for use prior to
fabric printing)

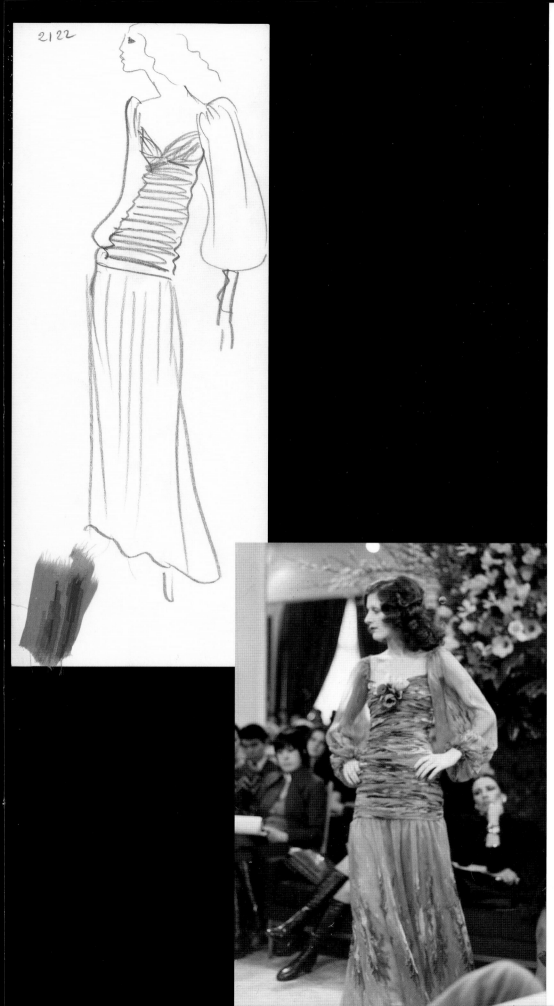

2122

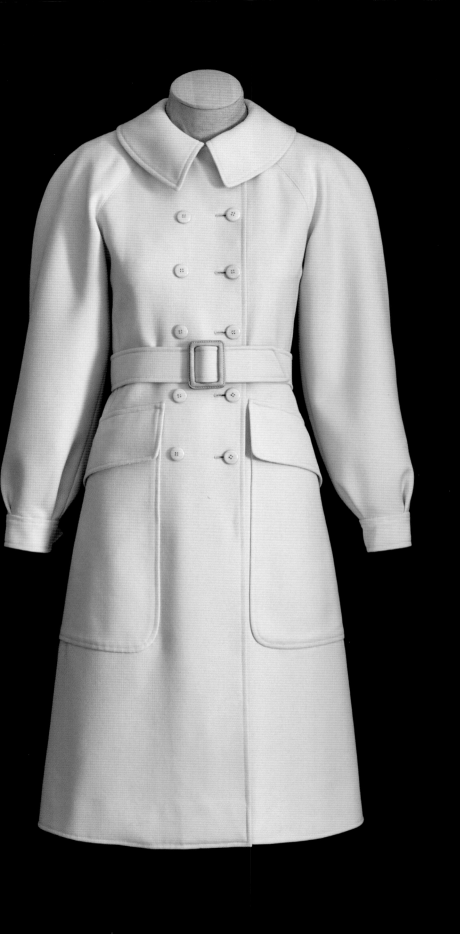

Daytime ensemble.
Cream whipcord frock
coat. Beige gabardine
skirt. Black crêpe de
Chine blouse.

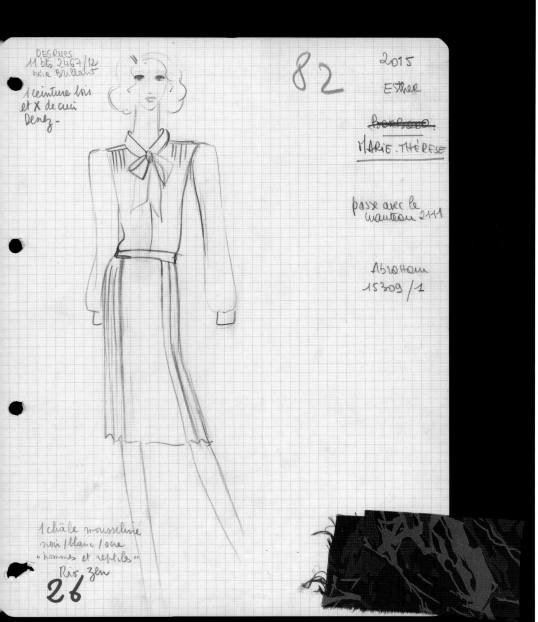

DESPUES
11 bts 2467/12
noie Brillant

1 ceinture bois
et X de cuir
Denez—

82

2015

ESther

~~Bonsoir~~

MARIE-THÉRÈSE

passe avec le
manteau 2111

Abraham
15309/1

1 châle mousseline
noir/blanc/ocre
"hommes et reptiles"
Rio zen

26

82

Marbled brown and green printed crêpe de Chine afternoon dress.

Atelier's specification sheet

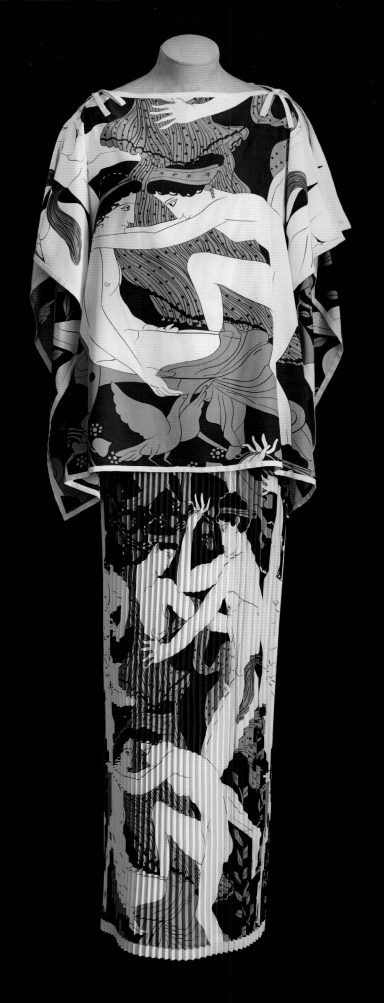

Jewelry
"Star" pin worn with
outfits 26 and 31.
"Comet" pin worn
with outfit 66.

Sketch of accessories
representing three
pins: "Comet," "Star," and
"Cigarette"

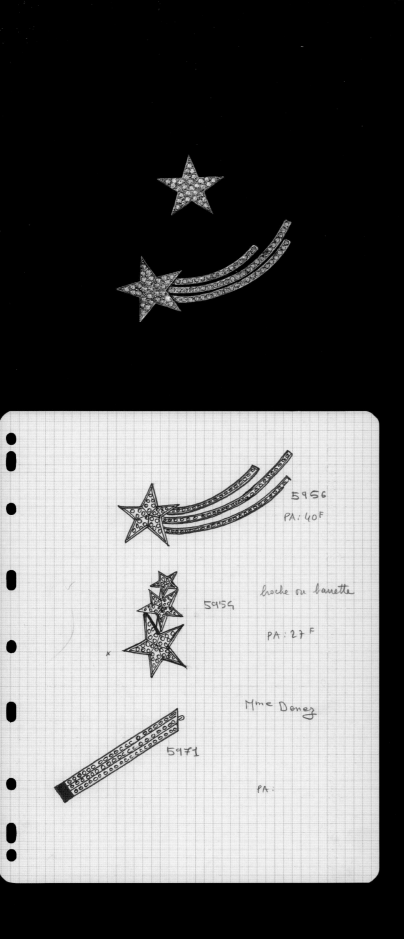

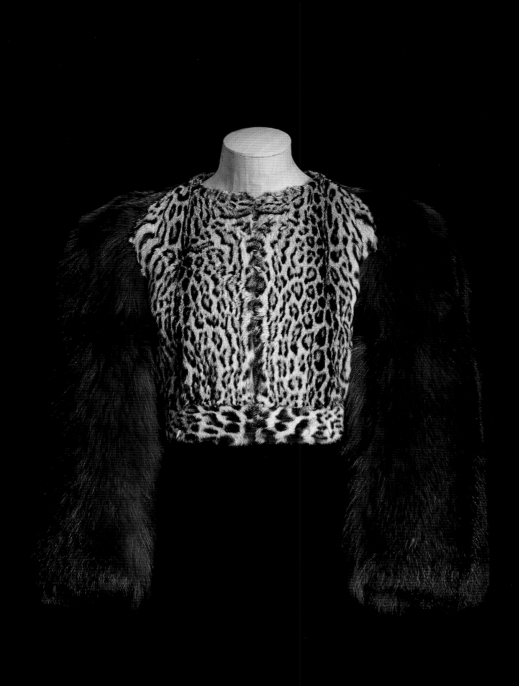

Ocelot and fox
Worn during
fashion show
the black crê
dress (outfit .

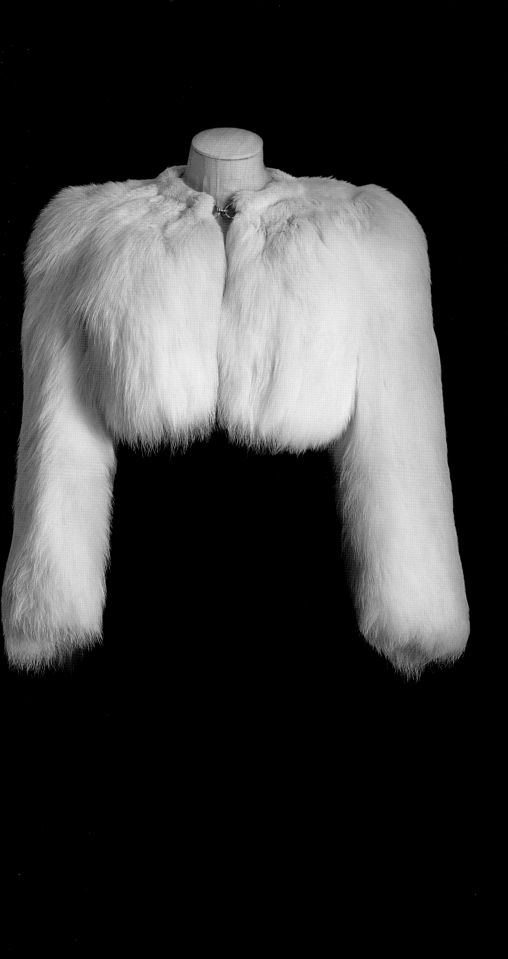

White fox bolero.
Worn during the
fashion show with
the black crêpe formal
dress (outfit 17).

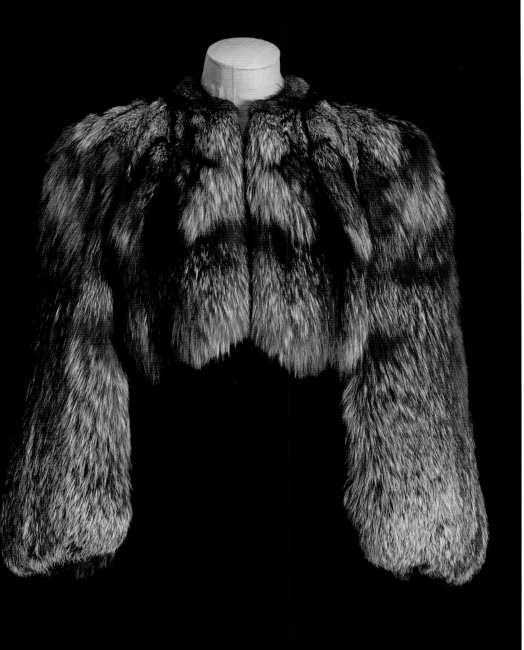

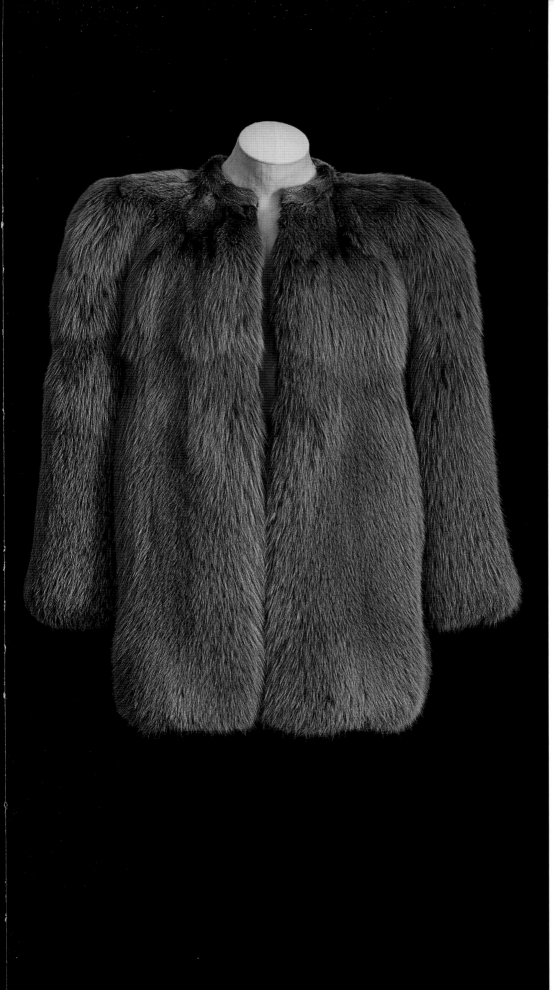

Green fox coat.
**Worn during the
fashion show with
the black silk jersey
Van Dongen bodysuit
(outfit 64).**

Shoe
*"Raymonde" black
suede heels.*
Worn with outfits
28, 45, and 76.

GLOSSARY

Original sketch
Croquis original

Executed by Yves Saint Laurent, and then handed on to the *chef d'atelier*, the original sketch was the departure point for creating a model in the atelier. These sketches were done with a Staedtler 2B graphite pencil or, more spontaneously, with a felt-tip or ballpoint pen, on sheets of special drawing paper measuring 4⅞ x 12½ inches (12.4 x 32 cm). The same paper was used in Christian Dior's studio. Yves Saint Laurent executed most of his sketches on these sheets until the late 1970s. A swatch of the fabric(s) to be used for the model was often pinned to this sketch. The number of the atelier's specification sheet was also included, sometimes accompanied by notations.

"Reject" sketch
Croquis "non choix"

A "reject" is a sketch drawn for a collection by Yves Saint Laurent that did not ultimately result in the production of an actual garment. Rejects were sometimes experimental changes to a model that ended up being incorporated into the original sketch. Some represented models were rejected or abandoned during the development phase. The fabric swatches pinned to some rejects or the mention of an atelier number indicates that the model was dropped at a late stage in the design process.

Original print for patterned fabrics
Empreinte originale pour impression sur étoffe

This print was a working document used in producing prints on fabrics. An impression of the motif was made on paper before being printed on fabric to ensure quality control of the design and its colors. For each pattern, a sample of this test run was cut and sent to Yves Saint Laurent so that he could approve the coloring. It was then forwarded to the textile printer to use as a reference before the dyes were actually applied to the fabric.

Maison Abraham, a famous firm in Lyon, created a number of printed fabrics for the 1971 Spring–Summer collection. The prints for numbers 73 through 78, as well as the fabric used in the wedding gown, were the work of André Barrieu, one of Abraham's designers, who provided some of Yves Saint Laurent's finest printed fabrics. The motifs developed for these models were directly inspired by Greek red-figure vases from the fifth century BCE. They included:

Number 73: a cup depicting a banquet scene, attributed to the Brygos Painter (British Museum, London)

Numbers 74 and 84: oenochoe, attributed to the Shuvalov Painter (Altes Museum, Berlin)

Numbers 75 and 76: a krater known as the Niobid Krater, representing Heracles and the Marathon warriors (Musée du Louvre, Paris)

Numbers 77 and 78: an Attic cup representing the labors of Heracles, attributed to Euphronios (Staatliche Antikensammlungen, Munich)

The atelier's specification sheet
Fiche d'atelier

The atelier's specification sheet, of which the nickname "the Bible" attests to its importance, had a reproduction of the original sketch on a sheet of perforated graph paper with several fabric swatches pinned to it. In addition to information relating to the atelier and the mannequin assigned to wear the model, this document listed references to materials and colors, supplier names, and the exact accessories intended for the outfit. Any changes made during the garment's development were scrupulously documented. In 1982, Yves Saint Laurent began to mark these documents with "M" or later "Musée" to indicate which prototypes he wished to retain in the archives after the show.

Fashion show photograph
Photographie de défilé

A fashion show photograph is a photograph of an outfit taken as it was modeled during the actual fashion show. Seventy models from the 1971 Spring–Summer collection are thus documented thanks to the photographs held at the Fondation Pierre Bergé–Yves Saint Laurent.

Press kit photograph
Photographie de dossier de presse

Some of the collection's models were selected by the studio and the couture house to be photographed again immediately following the show. These posed photographs were primarily intended to be included in press kits, but they also sometimes served as references for clients or foreign buyers who wished to acquire reproduction rights for certain models. Twenty-eight models from the 1971 Spring–Summer collection were shot by Alain Figuié and Jean Michel, among others.

Photograph from the International Wool Secretariat
Photographie du Secrétariat international de la laine

The International Wool Secretariat, established in 1937, selected outfits to use in photographic campaigns intended to support and promote the wool industry. The Fondation Pierre Bergé–Yves Saint Laurent has six of these photographs taken at the 1971 Spring–Summer collection.

Collection board
Planche de collection

After the atelier made the toile (test garment) based on the original sketch, and completed the fabric selection and the fittings, the finished garment was drawn on heavyweight graph paper measuring 25½ x 19¾ inches (65 x 50 cm). Reproductions of the original sketches, names of the ateliers and the mannequins, the numbers from the atelier's specification sheets, and the numbers in the collection, as well as the fabric swatches for each model, were all mounted on the collection board. Names of suppliers, embroiderers, feather suppliers, specialized jewelry designers, and so on were also sometimes included.

The collection boards provided information related to the fabrication of a garment and its place in the show. They gave an overview of the entire event, presenting a survey of the show as a whole so that it could be fine-tuned and, if necessary, supplemented with additional styles. Each collection board was given a title by the studio, grouping the models by theme, from daytime outfits to evening garb. Yves Saint Laurent applied to his own couture house a work technique he had learned during his years with Christian Dior.

Flammarion Edition

Editorial director:
Sophie Laporte

Administrative manager:
Delphine Montagne

Editorial coordinator:
Colette Taylor-Jones

Art director:
Amélie Boutry

Translation:
Elizabeth Heard

Copy editing:
Sarah Kane

Proofreading:
Helen Downey
Angela Krieger

Production:
Barbara Jaegy

Photoengraving:
Bussière

*Yves Saint Laurent 1971:
La collection du scandale* first
published by Flammarion,
Paris, 2015

© Flammarion, Paris, 2015
Publication No:
L.01EBUN000513
ISBN: 9782081358836

© Fondation Pierre Bergé–Yves
Saint Laurent, Paris, 2015

Jacket cover: Photograph
of Willy Van Rooy by Hans
Feurer, published in Elle,
March 1, 1971.

Abrams Edition

Editor:
Sarah Massey

Design Manager:
Najeebah Al-Ghadban

Production Manager:
Kathleen Gaffney

Library of Congress Control
Number: 2016944887

ISBN: 978-1-4197-2465-7

Printed and bound in Slovenia

10 9 8 7 6 5 4 3

Abrams books are available
at special discounts when
purchased in quantity for
premiums and promotions as
well as fundraising or
educational use. Special
editions can also be created
to specification. For details,
contact specialsales@
abramsbooks.com or the
address below.

ABRAMS
The Art of Books

195 Broadway
New York, NY 10007
abramsbooks.com

Photo credits

© Alain Figuié: pp. 105 (bottom), 144 (bottom);
© Aline Mosby, UPI: pp. 49, 52–53; © Alison
Adburgham: p. 55; © Bob Richardson: pp. 26–31;
Bruno Barbey / Magnum Photos: p. 7; Jean
Shrimpton 1971 © David Bailey: pp. 32, 39; ©
ELLE/Scoop: p. 37; © Estate of Helmut Newton
/ Maconochie Photography: p. 25; © Fondation
Pierre Bergé–Yves Saint Laurent: pp. 1–4, 15, 17,
20, 23, 62–79, 82–84 (top), 86 (top), 87 (top), 88
(top), 89 (top), 90 (top), 92 (top), 95, 96 (bottom),
97 (top), 98 (top), 99–100, 103, 104 (top), 105
(top), 107 (top), 108 (top), 110 (top), 111 (top),
112 (top), 113 (bottom), 115–17, 119 (top), 120
(left), 121 (top), 122 (top), 124 (top), 125 (top),
126, 127 (top), 128, 129 (top), 130 (top), 132, 133
(top), 139, 140 (top), 141 (top), 144 (top), 145,
147 (top), 148 (top), 149, 151, 152 (top), 155 (top),
157 (top), 158 (top), 159 (top), 161, 163 (bottom);
© Hans Feurer / ELLE / Scoop: pp. 33–36; ©
International Herald Tribune / PARS International:
p. 40; © iws photos: pp. 81, 98 (bottom), 123; ©
Jean Michel: pp. 127 (bottom), 152 (bottom), 157
(bottom), 176; © *Le Figaro* / 30–31.01.1971: p. 51;
© *Le Journal du Dimanche* (for text), copyright (for
photographs): p. 50; © Sophie Carre / Fondation
Pierre Bergé–Yves Saint Laurent: pp. 85, 87
(bottom), 91, 93, 94, 102, 106, 108 (bottom), 114,
131, 135, 137–38, 141 (bottom), 142–43, 146, 148
(bottom), 150, 153–54, 156, 158 (bottom), 160,
162, 163 (top), 164–68; thanks to the newspaper
La Provence: p. 54; copyright: pp. 8, 12, 38, 47, 48,
52, 56, 84 (bottom), 86 (bottom), 88 (bottom), 89
(bottom), 90 (bottom), 92 (bottom), 96 (top), 97
(bottom), 101, 104 (bottom), 107 (bottom), 109,
110 (bottom), 111 (bottom), 112 (bottom), 113
(top), 118, 119 (bottom), 120 (right), 121 (bottom),
122 (bottom), 124 (bottom), 125 (bottom), 129
(bottom), 130 (bottom), 133 (bottom), 134, 136,
140 (bottom), 144 (bottom), 147 (bottom), 155
(bottom), 159 (bottom), 171–75.

Every effort has been made to identify and
acknowledge the photographers and to obtain
the rights to the images shown in this book. The
editor apologizes for any unintentional errors
or omissions, which will be corrected in future
editions of this book.

Opposite and following pages in
order as they appear:

The six models for the
fashion show:
Annie (outfit 13)
Marie-Thérèse (outfit 31)
Barbara (outfit 34)
Jacqueline (outfit 51)
Dominique (outfit 64)
Elsa (outfit 84)

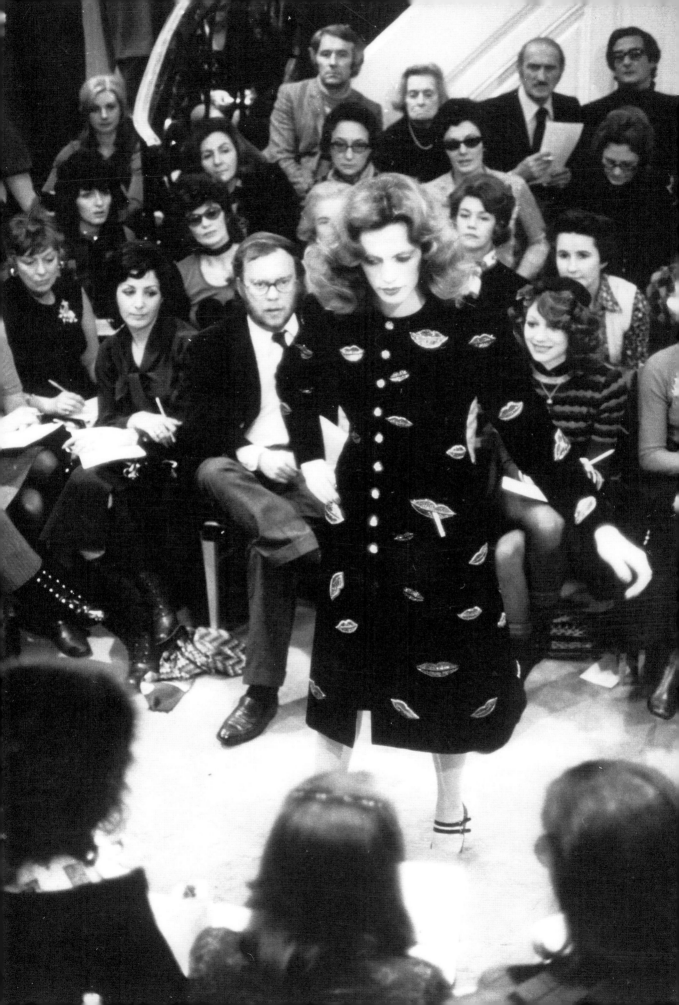

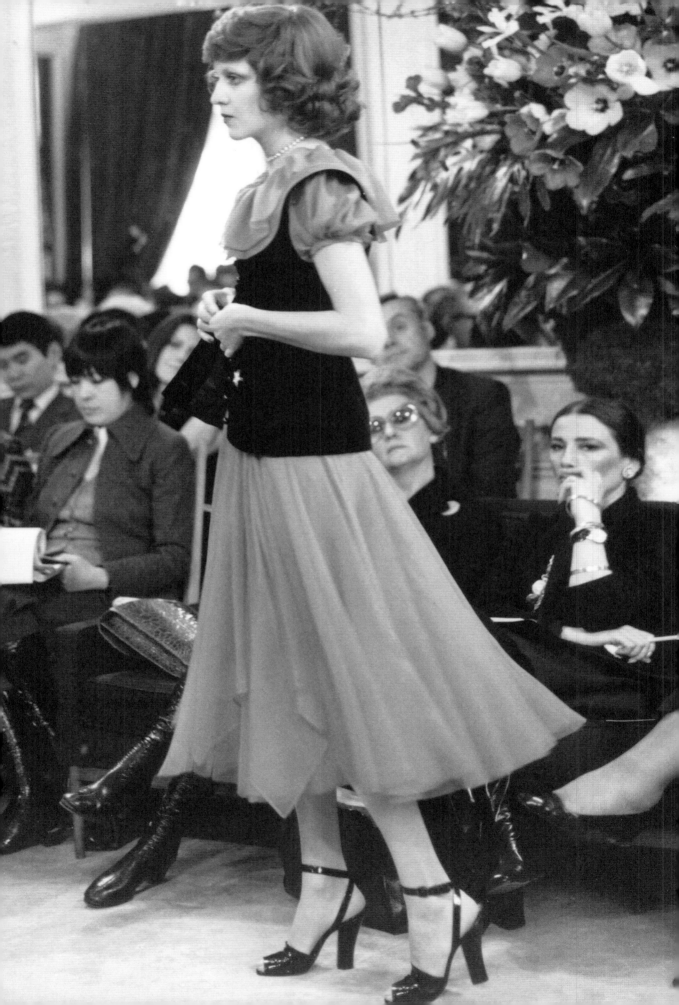

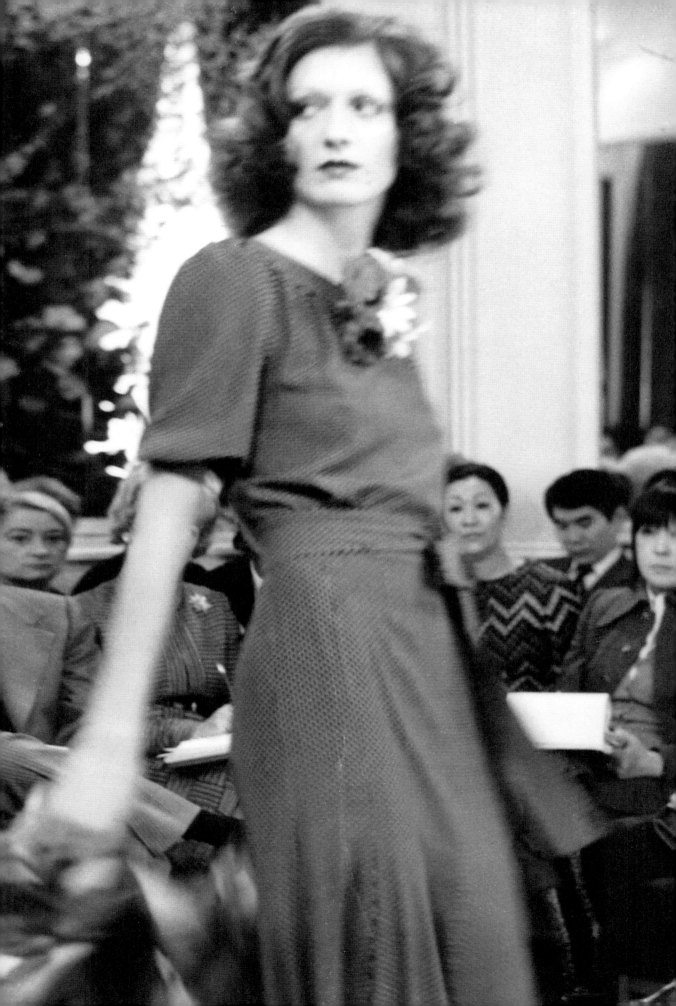

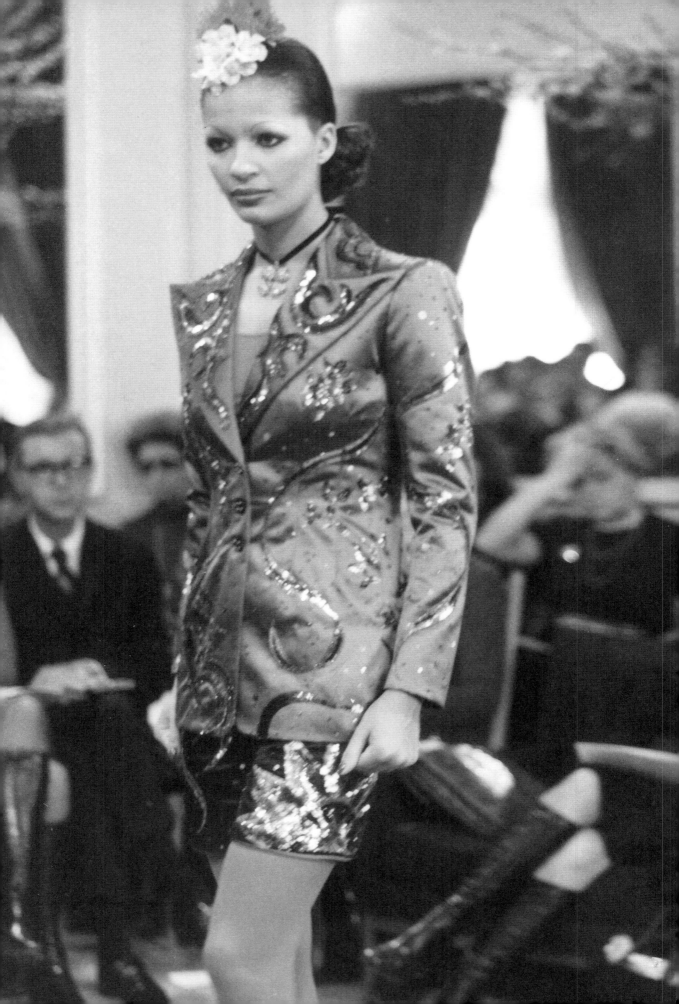

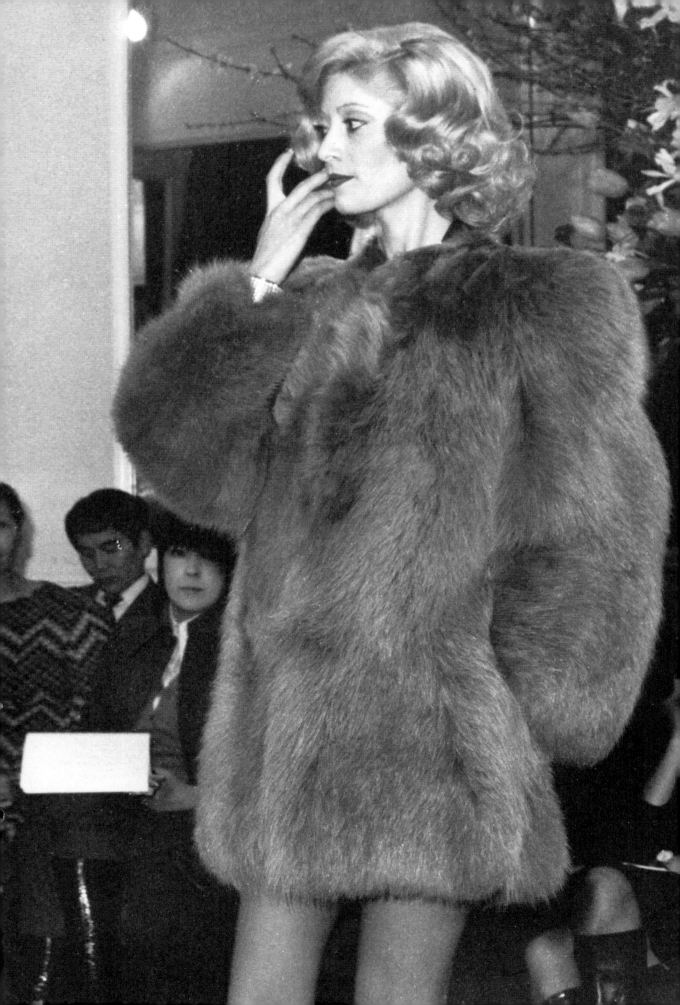

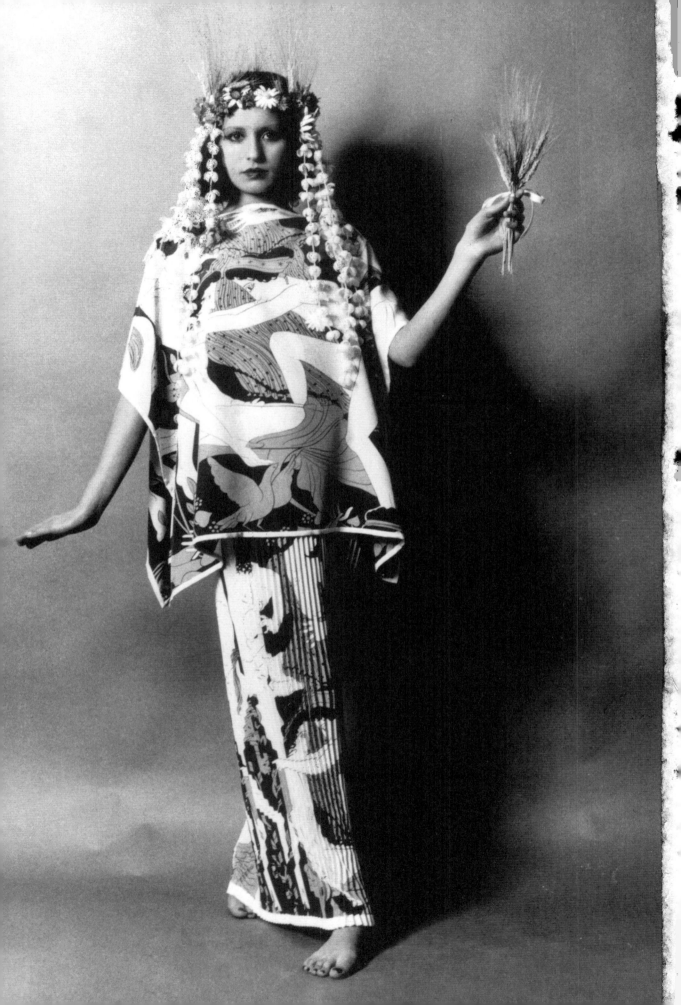